THE BEST OF 3D GRAPHICS

ROCKPORT

THE BEST OF 3D GRAPHICS

GLOUCESTER MASSACHUSETTS

EPIC SOFTWARE GROUP, INC.
EDITED BY VIC CHERUBINI

ROCKPORT PUBLISHERS

First published in the United States of America by
Rockport Publishers, Inc.
33 Commercial Street
Gloucester, Massachusetts 01930-5089
Telephone: (978) 282-9590
Fax: (978) 283-2742
www.rockpub.com

ISBN 1-56496-954-1

10 9 8 7 6 5 4 3 2 1

Design: Jerrod Janakus
Cover Images (from left to right, top to bottom):
Avatara Studios, mindworx, Meg McWhinney

Printed in China

DEDICATION

Creating awesome 3D graphics requires an understanding of both technology and aesthetics. This book is dedicated to those innovative 3D artists who are on a never-ending quest to bring their creative ideas to life on the computer. Sometimes they may fail, but through hard work, tenacity, and a wonderful sense of humor, they ultimately succeed in expressing themselves in this exciting new media. This book is dedicated to everyone with the curiosity and courage to try something that's never been done, and to whom "great" just isn't good enough.

ACKNOWLEDGMENTS

It takes an enormous amount of time and effort to put together a book like this. Many people contributed to the content, editing, and design, while others provided encouragement and support.

When I founded the epic software group, inc. in 1990, I realized the most successful projects would be team efforts, where each person would contribute his or her best work. And that was, indeed, the case with *The Best of 3D Graphics*. Without a doubt, it would have remained just another interesting idea had it not been for the combined efforts of this talented team. I would like to offer my heartfelt appreciation to the following people:

First and foremost, I would like to thank Danny Duhon, our creative director and lead 3D artist and animator. Danny is a consummate 3D artist and art historian. He understands what makes a 3D graphic an awesome work of art, from both a technical and aesthetic prospective. Danny will voice his opinion and stand by his convictions, and for that I am truly grateful.

Robert Bailey heads up our multimedia development department and is responsible for the CD-ROM that accompanies this book. Robert is a craftsman whose knowledge of Macromedia Director never ceases to amaze me. He continues to find ingenious ways to wring every ounce of power out of this incredible authoring tool. He is a joy to work with and puts 110 percent into everything he sets his mind on accomplishing. No matter how complex the project, Robert will finish it on time and within budget.

Next, I must thank Derek Hughes, our lead 2D artist. It is wonderful to watch concepts that come out of a brainstorming session magically appear in pencil sketches, storyboards, illustrations, and vector animations. Derek has made the move into 3D animation. His background in cartooning has resulted in a very unique style and the creation of some incredibly wonderful eye candy.

One of the most important aspects of any book is getting the details right. Our production manager, Sharon Howerton, kept us in line by checking, and rechecking every entry. The paper chase that is crucial in keeping accurate records for the works of hundreds of artists and entries from around the world is humbling indeed.

Special thanks also to our friends at Rockport Publishers. I would like to thank acquisitions editor Kristin Ellison for giving us the green light and for guiding us through the production process. We had been discussing this project with other publishers for years, but it was Rockport that made it happen.

Perhaps the folks we have to thank the most are the hundreds of 3D artists and animators that took the time to assemble their work and submit it for review. During the call for entries, it was truly exciting to go through the submissions received daily. We have made some wonderful new friends along the way and I am happy to report that the 3D community is, indeed, alive and well. And the good news is that it will grow and expand as 3D software and the hardware needed to run it, continues to drop in price. Hopefully, this book will serve as an inspiration for both budding and experienced 3D artists along with all of us who just love looking at incredible 3D graphics. Enjoy!

Vic Cherubini

CONTENTS

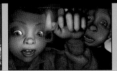
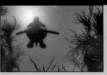

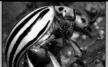

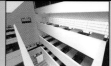

INTRODUCTION: WHAT MAKES A 3D GRAPHIC A "WORK OF ART"

"Art is an adventure into an unknown world, which can only be explored
by those willing to take the risks."

Mark Rothko (1903—1970), American abstract expressionist painter

If you want to get a lively discussion going, gather a group of folks together and ask them to define "great art." Make sure you have some artists, art critics, and art lovers in the group, then sprinkle in some laypeople. To really get things going make sure a bottle or two of fine wine is consumed prior to asking the question. Hopefully, the debate will remain at a civil level, but don't be surprised if it quickly degrades into an argument. People become very passionate expressing their feelings about art—in whatever form it takes.

So why would anyone undertake the task of trying to determine the best examples of an art form—in this case 3D graphics? Simply put, I just love looking at 3D imagery. And these days, beautiful 3D graphics are everywhere. Just look at feature films, television, print ads, or the Web. You'll find magical images that evoke the full range of emotions. Even so, the thought of an entire volume devoted to page after incredible page of 3D art was irresistible.

To make it happen, we asked artists from all over the world to send in samples of their work. Within a few short weeks entries arrived—first a trickle, then a flood—until we had several hundred samples to choose from. It was a little overwhelming at first, but as soon as we began opening the envelopes and reviewing the contents it got very exciting. Keeping track of each artist and their work gave me a new found respect for a special breed of art lovers—curators!

Once all the entries were cataloged, the truly difficult part of the job came—making the selections for what would ultimately be used in the book. The selection process was difficult because so many of the entries were really good. Since art critics and editors are always asked to explain their comments and choices, I wanted to provide you with some background information and ideas to ponder.

A WORKING DEFINITION OF ART

Before we can begin talking about great 3D art, it is important to have an understanding of what art is. Simply put, art is the attempt to define ourselves and, luckily, artists have a large number of ways to communicate their emotions. Visual artists traditionally have used charcoal, paint, clay, stone, sound, light, and dozens of other media. 3D artists work with powerful computers and complex software capable of producing art that ranges from the photorealistic to really abstract. Each creative expression can mirror reality or put forth new ideas. Modern art has greatly broadened the historic definition of art. Marcel Duchamp and the other Dada artists mocked the Renaissance tradition, which placed the artist in an exalted position. Duchamp declared that "anything the artist produces is art." Simply put art is what an artist does.

Formally, the *Encyclopedia Britannica* defines art as "the use of skill and imagination in the creation of aesthetic objects, environments, or experiences that can be shared with others."

In a dictionary, you will find the words "art" and "artificial" near one another, because art is manmade. Art is really the language of feelings. Art can reveal our innermost desires and bring to life what we see and feel. Can something be "art" to one person but not to another? Of course. A work of art is food for the soul. It often represents beauty and freedom. Through art we try to conceptualize our existence and see the world in a new way. We often use art to define ourselves.

LOOKING AT 3D GRAPHICS

Attempting to judge a work of art puts us on a slippery slope. Often, it is done by a consensus or by the opinion of an "expert." How can you possibly assign a value to something that is so personal and difficult to quantify? What we can determine is whether a work of art is successful in conveying the artist's idea. Trying to list the criteria for "great art" is filled with the pitfalls of personal opinion and one's politics. And like religion, everyone has their own view, which best fits their lifestyle.

When I look at 3D graphics, I ask myself if the artists were successful in two basic functions: First, was the artist successful in the application of certain principles of 3D? I am looking at their craftsmanship. Are they masters of their tools and techniques? How did they handle color, balance, lighting, texture, harmony, and rhythm?

Second, does this work demonstrate the aesthetic mastery of the composition and content? Was the artist able to transform the ordinary into the extraordinary? Does it evoke a sense of emotion and engage me? Does it make a statement by being strong and stirring? How is the subject matter related and connected to the world in which I live?

Neither technique nor aesthetics by themselves will result in a work of art that will span the test of time. When technique and aesthetics are blended together, an artist can achieve a degree of perfection that may be difficult to express in words—but you will know it when you see it!

YOUR TURN

As I mentioned previously, making the selections for this book was not easy. We carefully reviewed each entry many times to determine which works should be printed and which should remain on the editing table. Rockport Publishers then asked us to choose "the best of the best" for a special section at the back of the book to showcase the fifteen top 3D artists. The section of the book titled Concept to Creation, was created to provide you with further insight into the tools, techniques, and thought processes of the featured artists.

As you go through the book, you may be disappointed not to find a 3D graphic by your favorite artist. "How could they have left out (fill in the blank) in a book on the best of 3D graphics," you might ask? Well, it is not because we didn't try. Almost two thousand personalized emails were sent to 3D artists around the world. Notices for our call for entries were posted on 3D Web sites, and in trade publications. Since this book is a first in the world of 3D graphics, it had no history to build on. Even so, the work we received was excellent. So now it's your turn to look at some really beautiful art. To see if you agree with our choices for the book, just pop the CD into your computer (Mac or PC) and you can look at all of the entries we received.

Enjoy!
Vic Cherubini, Editor

GALLERY

"Art is an absolute mistress; she will not be coquetted with or slighted; she requires the most entire self-devotion, and she repays with grand triumphs."

Charlotte Saunders Cushman (1816-1876)

TITLE	Mode ni Kimeru (RYOKO)
ARTIST	Heiichi Yamaguchi
COMPANY	Yamag's Garage
COUNTRY	Japan
SOFTWARE	3D Studio Max, Metasequoia, Photoshop, Shade

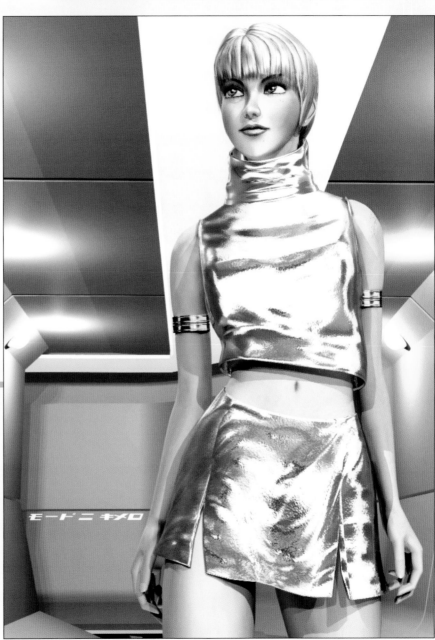

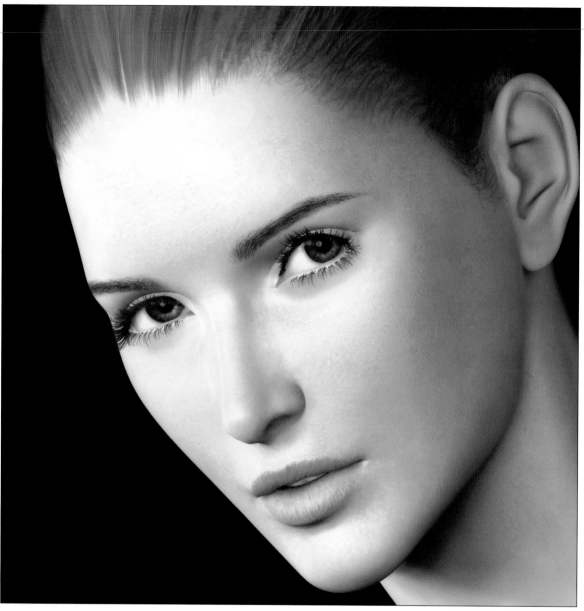

TITLE	Elle
ARTIST	Steven Stahlberg
COUNTRY	United States
SOFTWARE	Maya

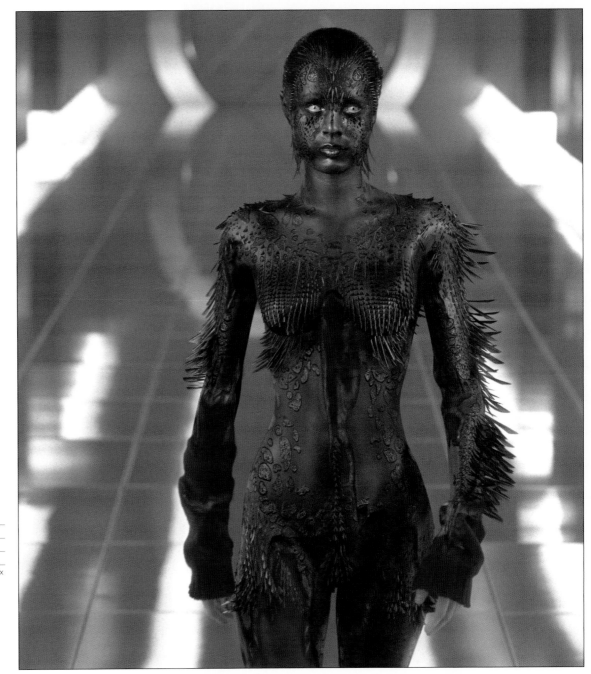

TITLE	X-Men
ARTISTS	Jeff Kleiser and Diana Walczak
COMPANY	Kleiser-Walczak
COUNTRY	United States
SOFTWARE	Maya, Chalice, Elastic Reality, Yannix

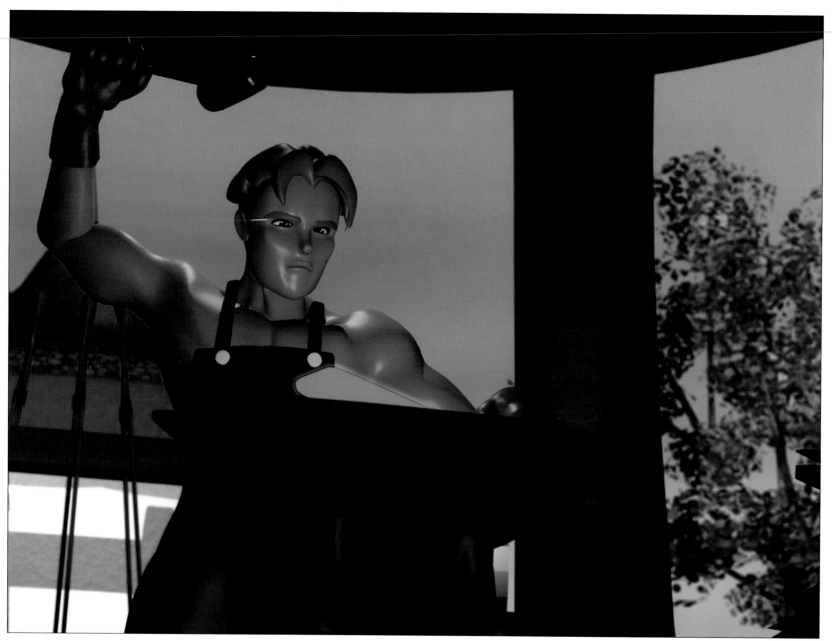

TITLE	The Blacksmith
ARTISTS	Danny Duhon, Derek Hughes
COMPANY	epic software group, inc.
COUNTRY	United States
SOFTWARE	LightWave, Photoshop

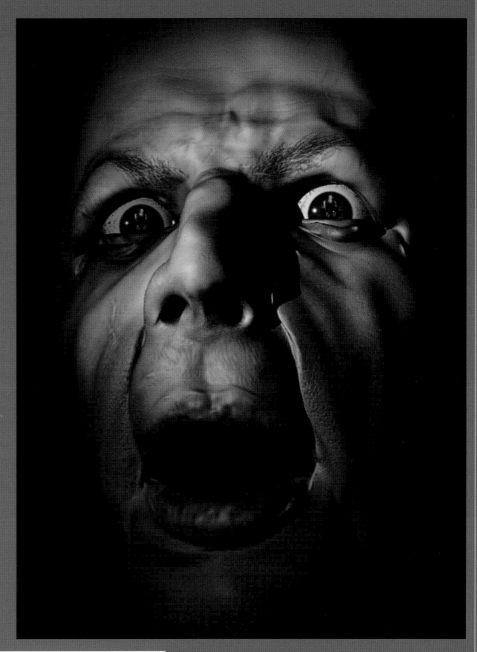

TITLE	Sandman-2
ARTIST	Louis Brochu
COUNTRY	Canada
SOFTWARE	Maya, Photoshop, Combustion

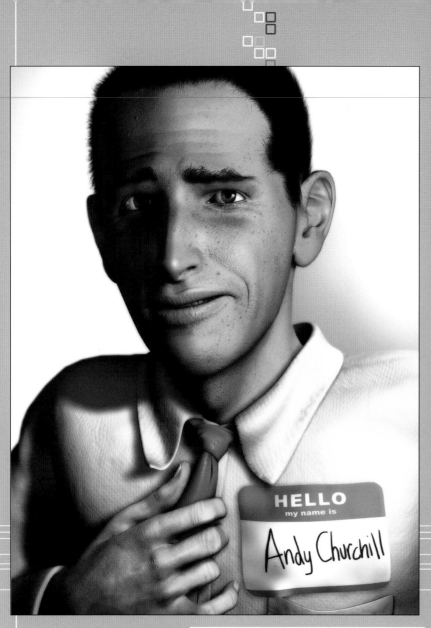

TITLE	Hello
ARTIST	Andrew Camenisch
COUNTRY	United States
SOFTWARE	Maya, Photoshop

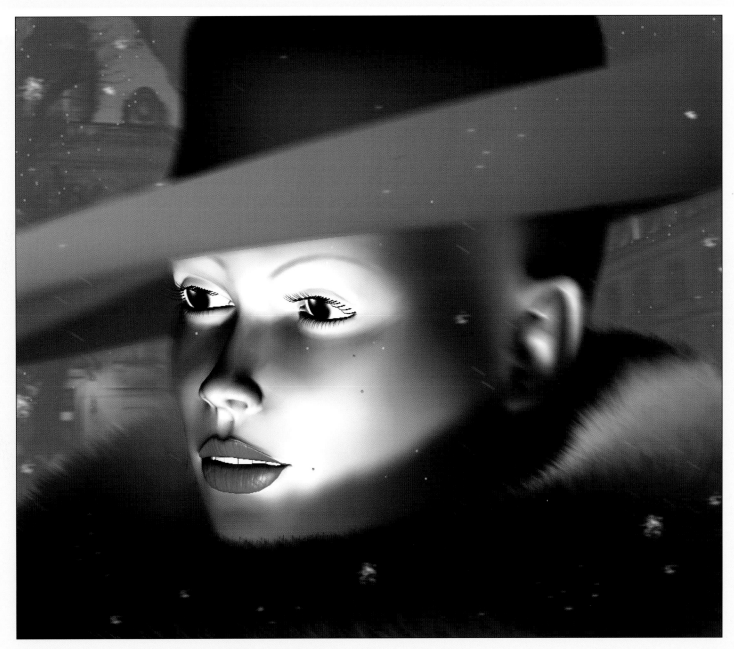

TITLE	Winter In Paris 2
ARTIST	Irina Carriger
COMPANY	Camber Corporation
COUNTRY	United States
SOFTWARE	3D Studio Max

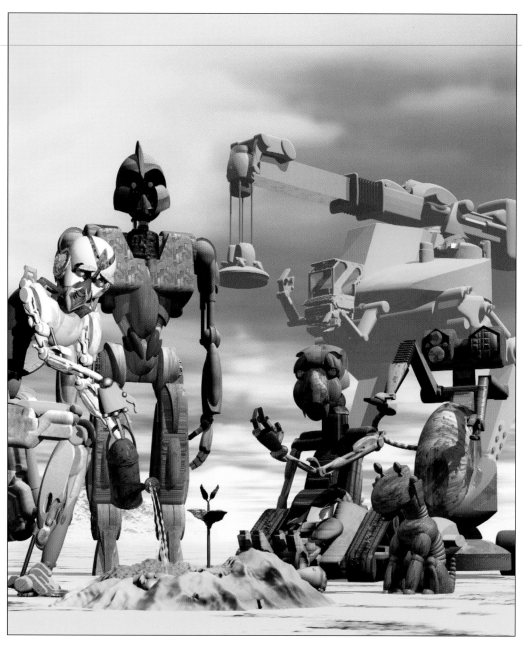

TITLE	New Beginning
ARTIST	Avijit Das
COMPANY	Industrial Hieroglyphics
COUNTRY	India
SOFTWARE	Bryce 4

TITLE	2K's Insights
ARTIST	Michael Scaramozzino
COMPANY	DreamLight Incorporated
COUNTRY	United States
SOFTWARE	FormZ, Electric Image

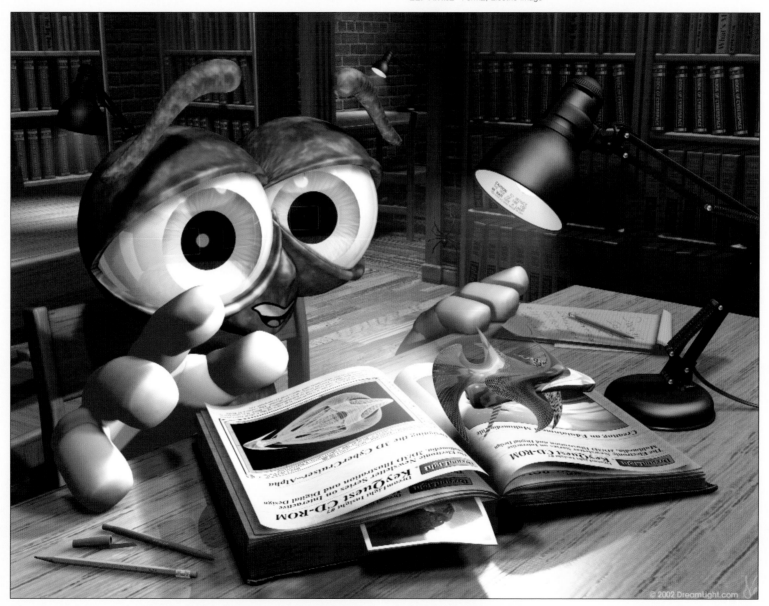

© 2002 DreamLight.com

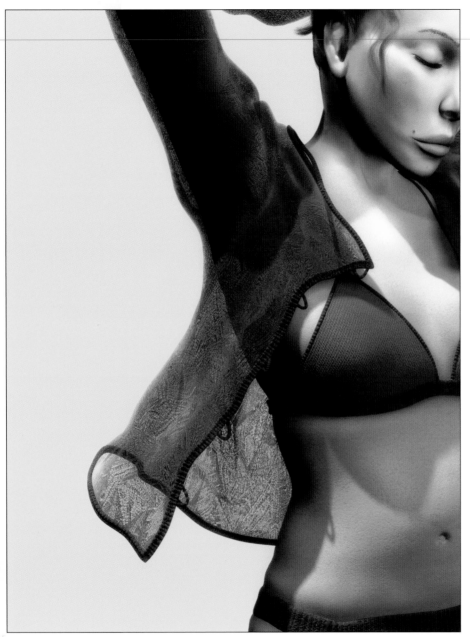

TITLE	Pret-a-porter
ARTIST	Michael Koch
COMPANY	mindworx
COUNTRY	Germany
SOFTWARE	3D Studio Max, Photoshop

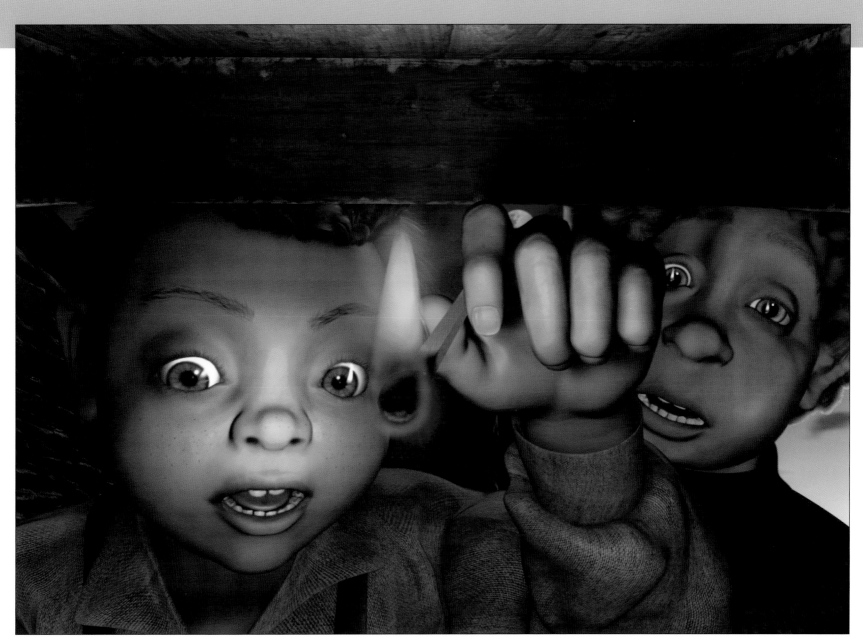

TITLE	Corkscrew Hill
ARTISTS	Jeff Kleiser and Diana Walczak
COMPANY	Kleiser-Walczak
COUNTRY	United States
SOFTWARE	SensAble's FreeForm, Maya, Electrosonic, Paraform

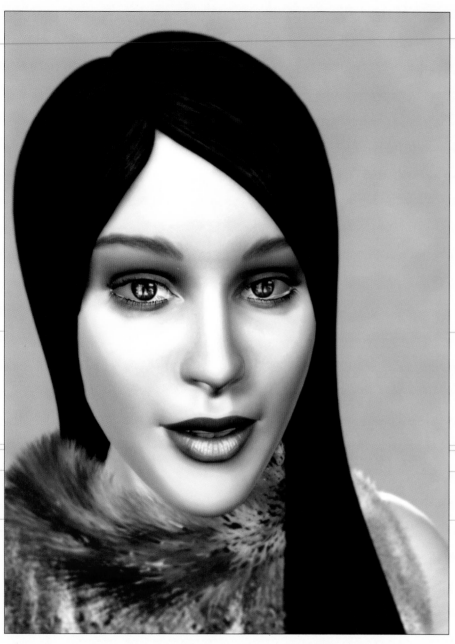

TITLE	Mia
ARTIST	Robert Kuczera
COMPANY	3D Characters
COUNTRY	Germany
SOFTWARE	Maya, Photoshop

TITLE	Forever Knight
ARTIST	Adam McCarthy
COUNTRY	United States
SOFTWARE	3D Studio Max

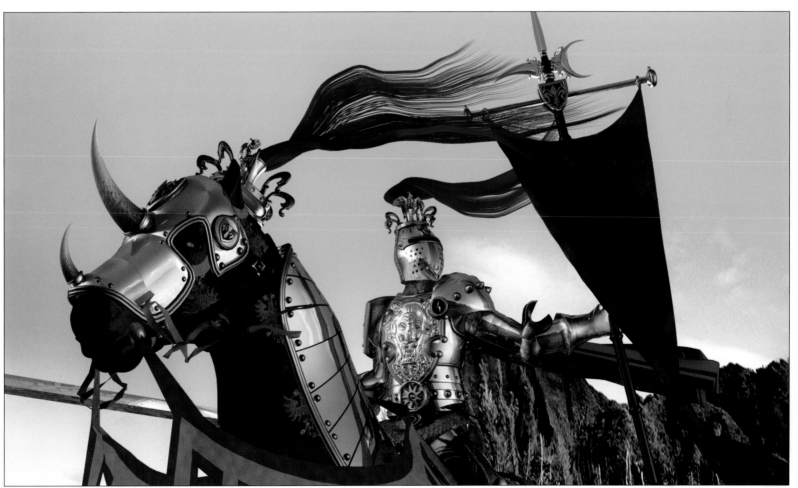

TITLE	Spaceman
ARTISTS	Kim and James Neale
COMPANY	Promotion Studios
COUNTRY	Australia
SOFTWARE	3D Studio Max, Photoshop

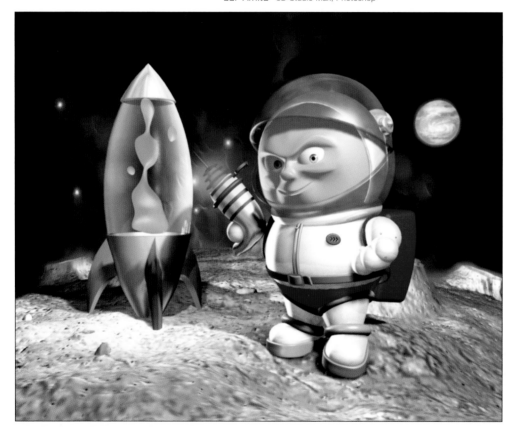

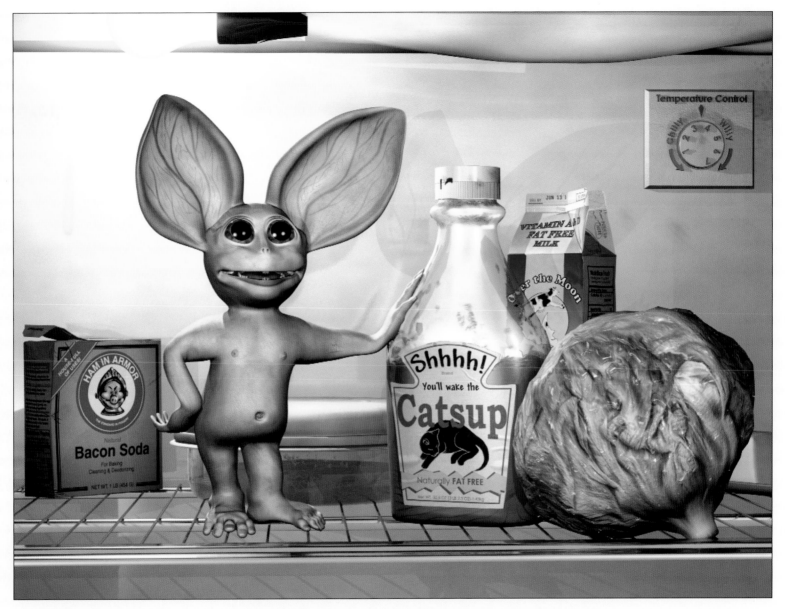

TITLE	Switch A. Roo
ARTIST	Kim Oravecz
COUNTRY	United States
SOFTWARE	LightWave 3D, Photoshop

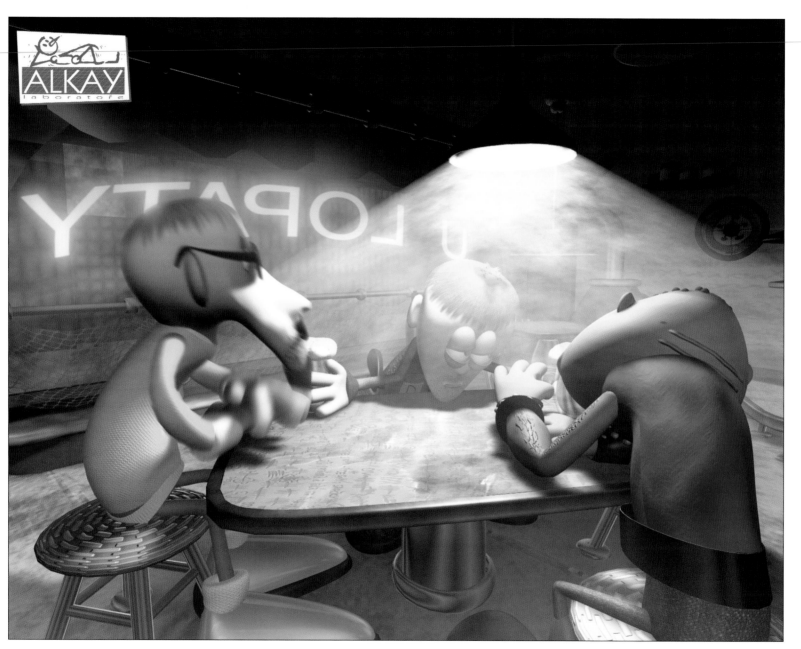

TITLE	Pakarna–pilot (Madhouse)
ARTISTS	Jiri Plass, Petr Horak, Martin Melichar, Richard Jirsak, Vlastimil Stejskal
COMPANY	Laboratore Alkay s.r.o.
COUNTRY	Czech Republic
SOFTWARE	Maya, After Effects

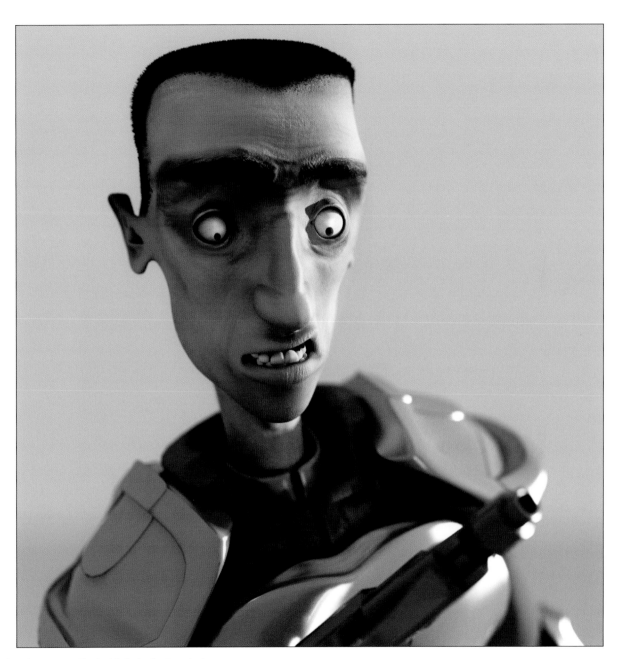

TITLE	Sgt. Cray Contemplates Blowing His Brains Out Once Again
ARTIST	Ruairi Robinson
COMPANY	Zanita Films
COUNTRY	Ireland
SOFTWARE	3D Studio Max, Character Studio, Arnold GI Renderer

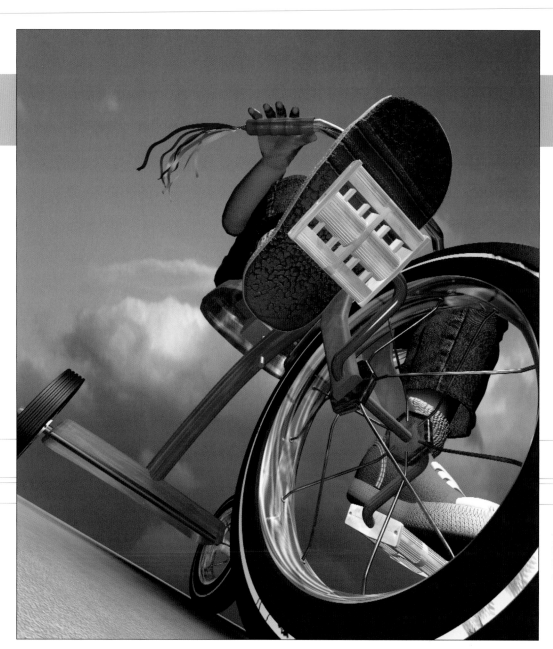

TITLE	Tricycle
ARTIST	Michael Steiner
COUNTRY	United States
SOFTWARE	3D Studio Max

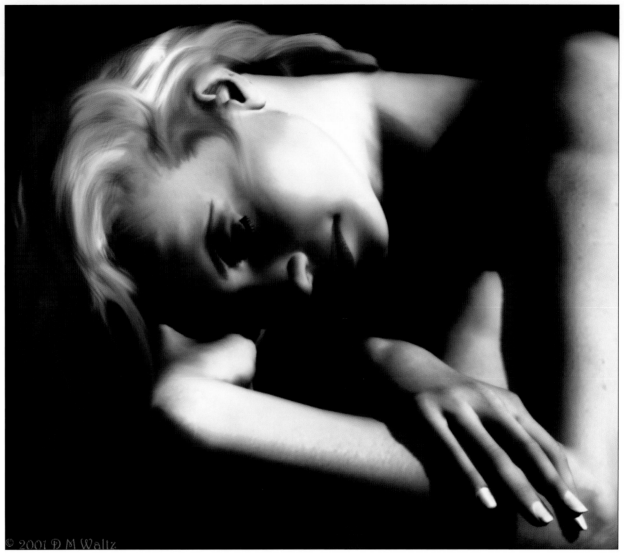

© 2001 D M Waltz

TITLE	Tired
ARTIST	Donna M. Waltz
COMPANY	Pierian Piaffe
COUNTRY	United States
SOFTWARE	Poser, Photoshop

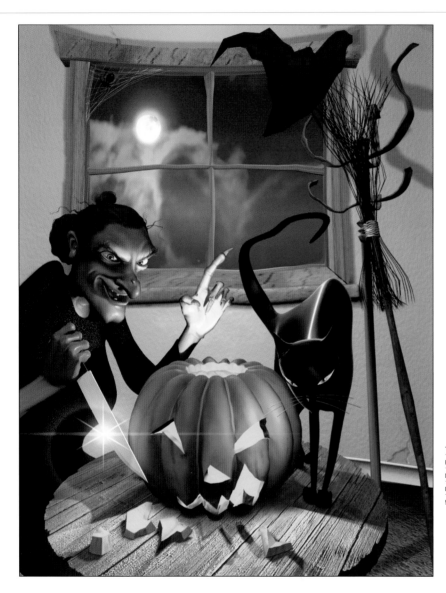

TITLE	Halloween
ARTISTS	Kim and James Neale
COMPANY	Promotion Studios
COUNTRY	Australia
SOFTWARE	3D Studio Max, Photoshop

TITLE	Beauty Scan Two
ARTIST	Michael Koch
COMPANY	mindworx
COUNTRY	Germany
SOFTWARE	3D Studio Max, Photoshop

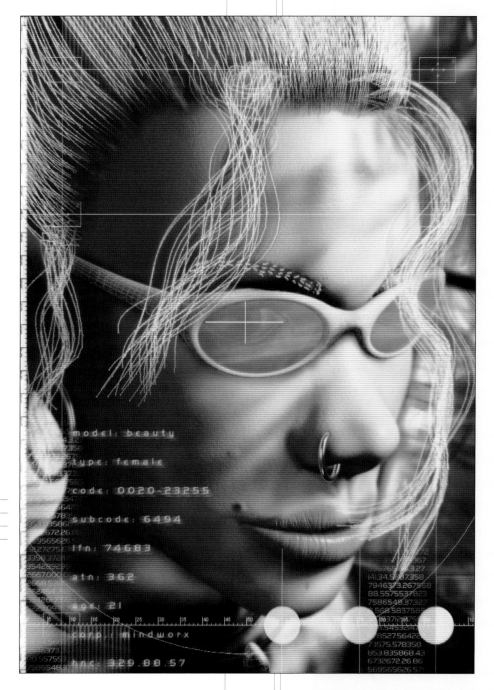

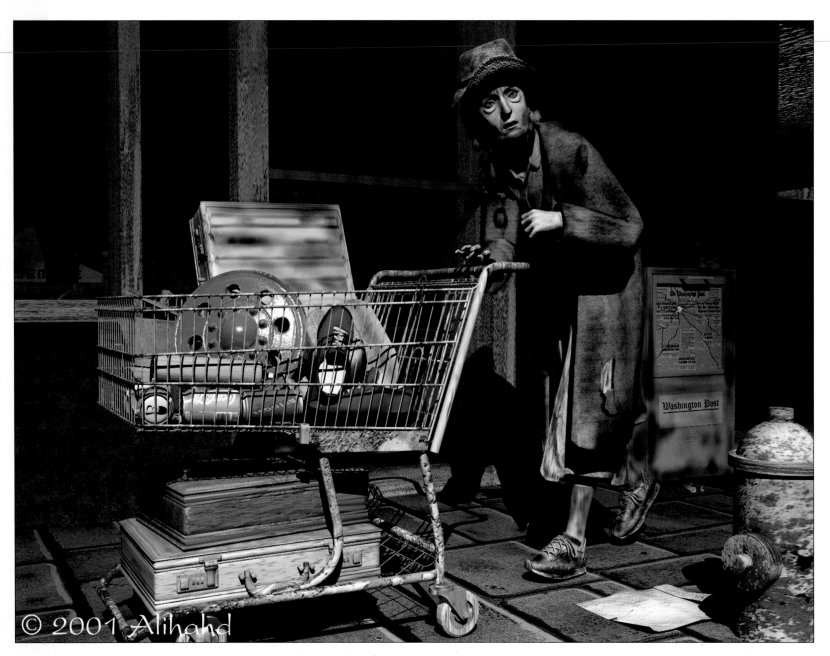

© 2001 Alihahd

TITLE	Mom…?
ARTIST	Andrae Martyna
COUNTRY	Germany
SOFTWARE	Bryce, Photoshop

TITLE	Santa Lights Up New York
ARTISTS	Jeff Kleiser and Diana Walczak
COMPANY	Kleiser-Walczak
COUNTRY	United States
SOFTWARE	SensAble FreeForm, Paraform, Maya

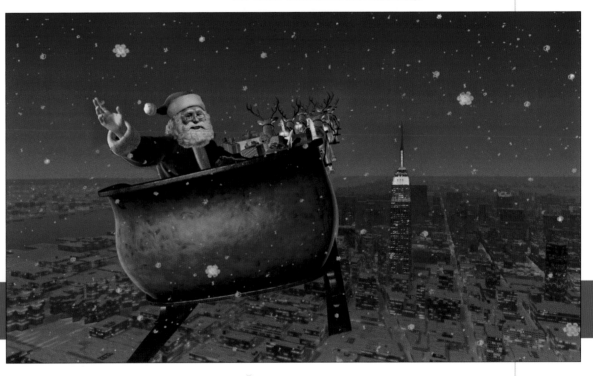

TITLE	Little Miss Spider: Lost and Found
ARTISTS	Jeff Kleiser and Diana Walczak
COMPANY	Kleiser-Walczak
COUNTRY	United States
SOFTWARE	SensAble FreeForm, Paraform, Maya

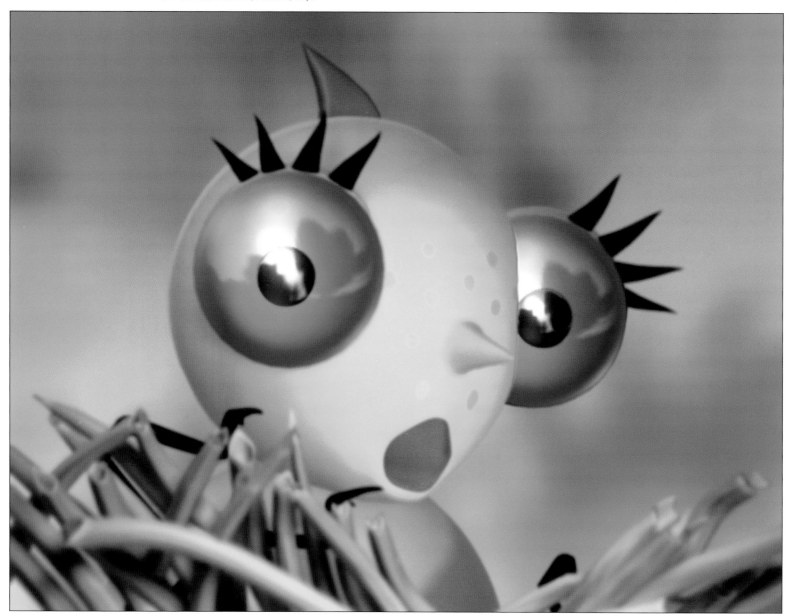

"The work of art, just like any fragment of human life considered in its deepest meaning, seems to me devoid of value if it does not offer the hardness, the rigidity, the regularity, the luster on every interior and exterior facet, of the crystal."

Andre Breton (1896-1966)

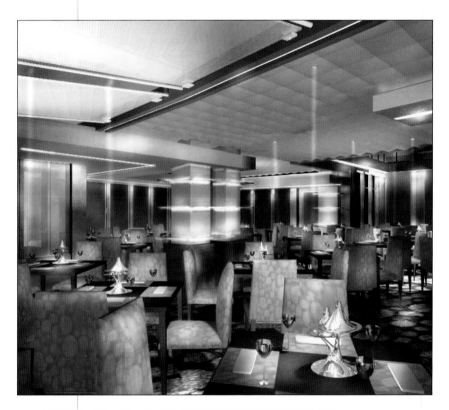

TITLE	Colony Tennis and Beach Resort Interior Design
ARTIST	David Sumner
COMPANY	David Sumner Design
COUNTRY	United States
SOFTWARE	FormZ, Photoshop

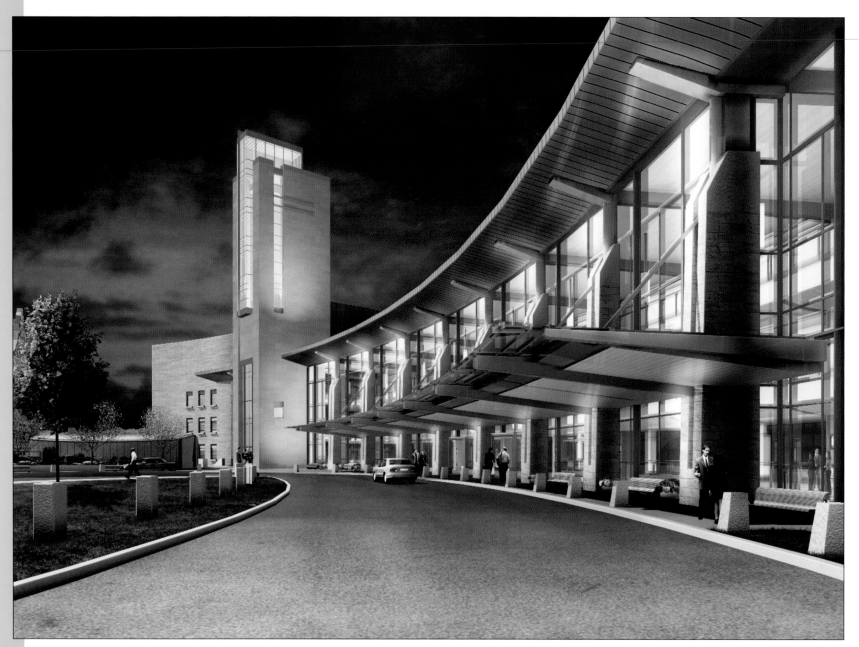

TITLE	Fletcher Allen Healthcare Design
ARTIST	Lon R. Grohs
COMPANY	Neoscape, Inc.
COUNTRY	United States
SOFTWARE	AutoCAD, 3D Studio Max, Photoshop

TITLE	Adler Planetarium
ARTIST	David Maloney
COMPANY	Avatara Studios
COUNTRY	United States
SOFTWARE	Intergraph EMS, ModelView

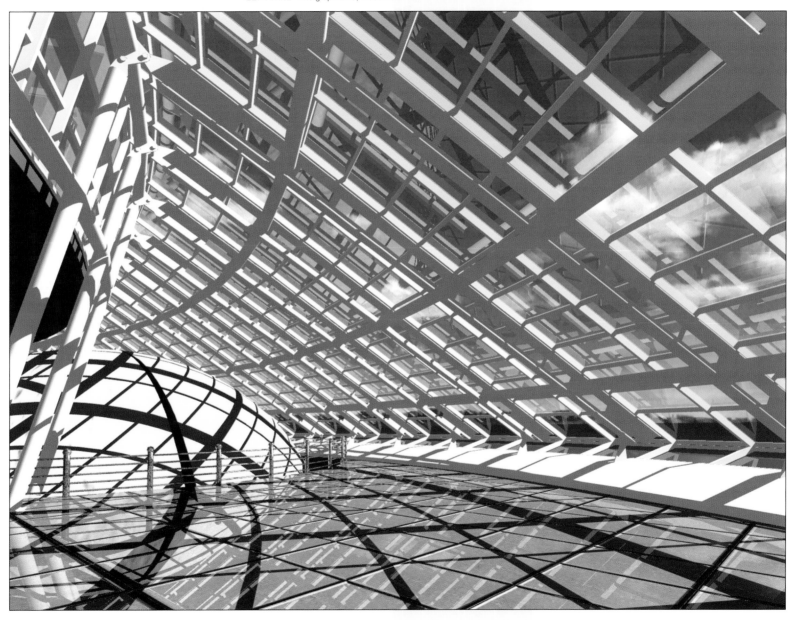

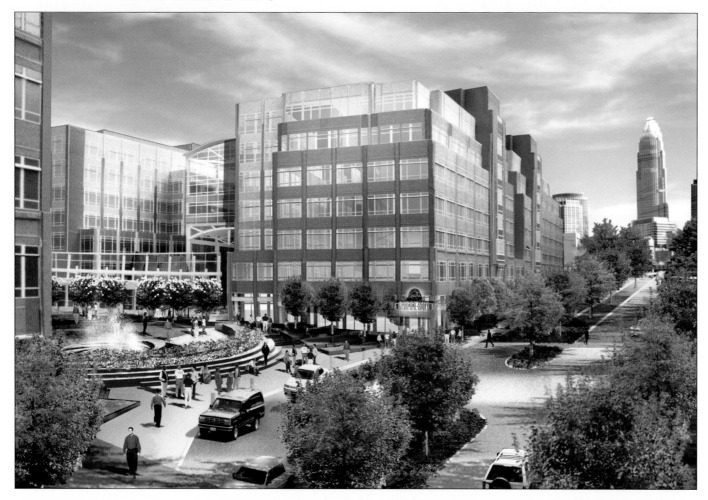

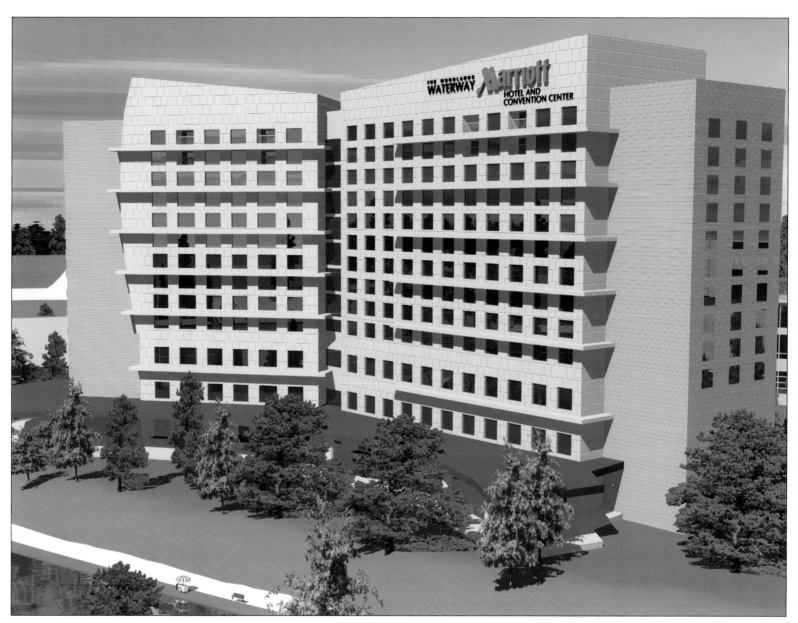

TITLE	Waterway Marriott
ARTIST	Danny Duhon
COMPANY	epic software group, inc.
COUNTRY	United States
SOFTWARE	LightWave, Photoshop

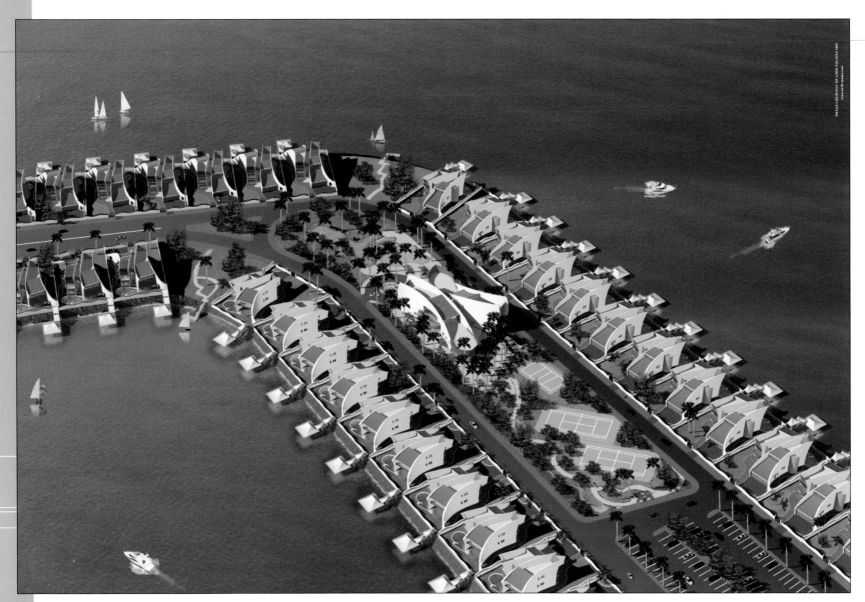

TITLE	Villa Compound in Abu Dhabi
ARTIST	Amir Youssef
COMPANY	Swift-Render
COUNTRY	Egypt
SOFTWARE	AutoCAD, LightWave, Photoshop

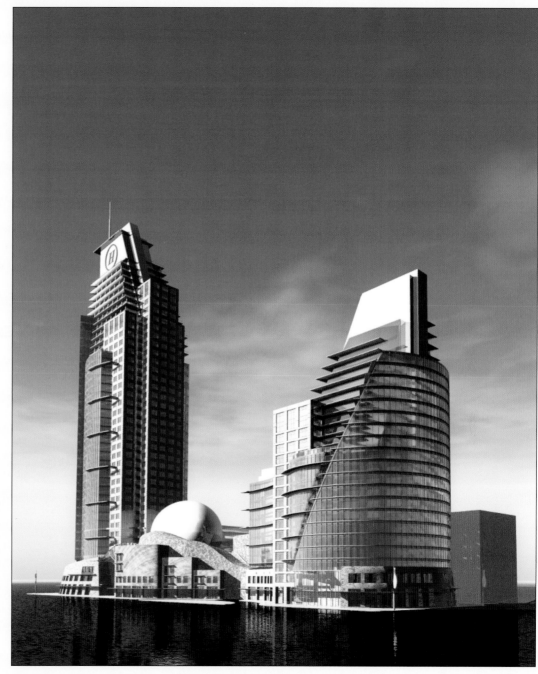

TITLE	Zion's Social Center Hall, Salt Lake City
ARTIST	Scott Baumberger
COMPANY	BaumbergerStudio
COUNTRY	United States
SOFTWARE	AutoCAD, Bryce

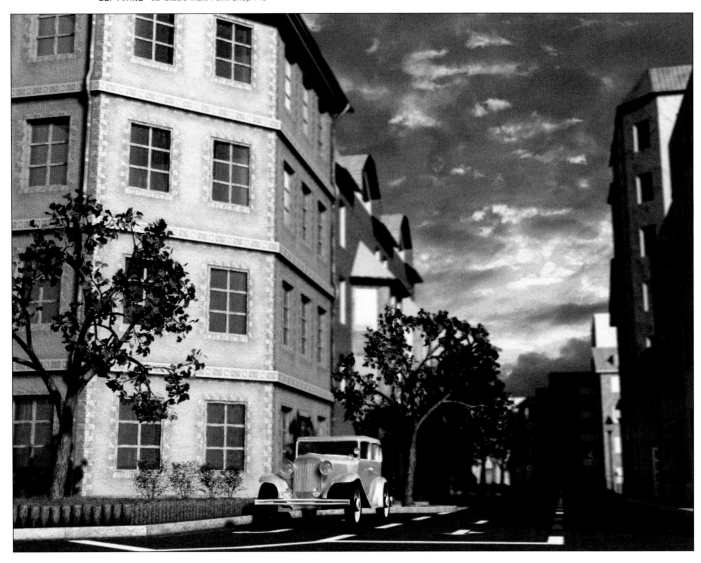

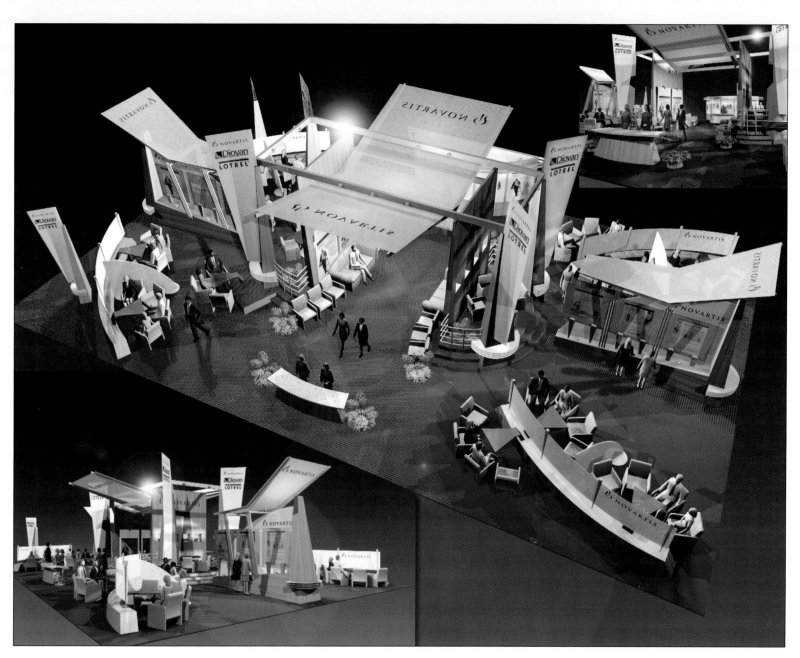

TITLE	Novartis 50' x 80' Tradeshow Exhibit
ARTIST	Tom Cameron
COMPANY	Cameron & Company, Corp.
COUNTRY	United States
SOFTWARE	FormZ, Photoshop

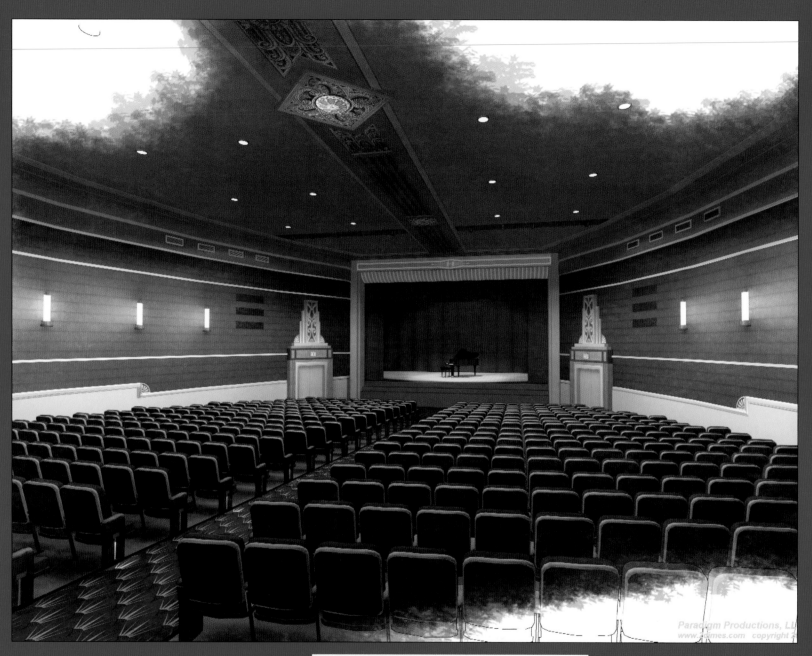

Paradigm Productions, LLC
www.ppmes.com copyright

TITLE	Henrico Theater
ARTIST	Charles T. Gaushell, AIA
COMPANY	Paradigm Productions, LLC
COUNTRY	United States
SOFTWARE	LightWave 3D, Piranesi, Paint Shop Pro

TITLE	Aquarium Glamor Shot
ARTIST	Nils Norgren
COMPANY	Neoscape, Inc.
COUNTRY	United States
SOFTWARE	Lightscape, 3D Studio Max, Photoshop

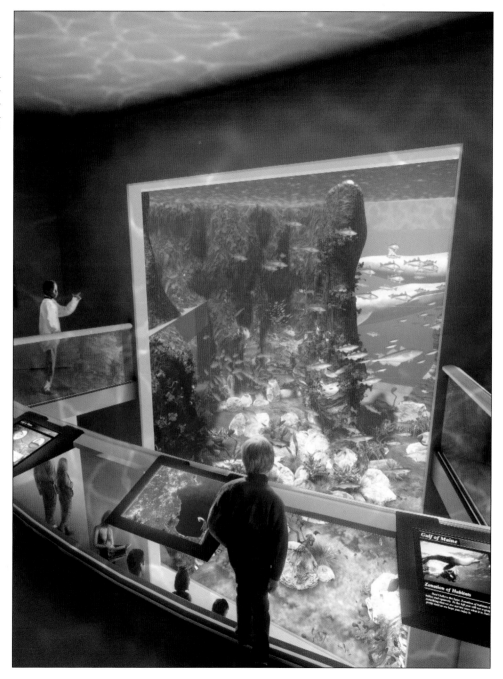

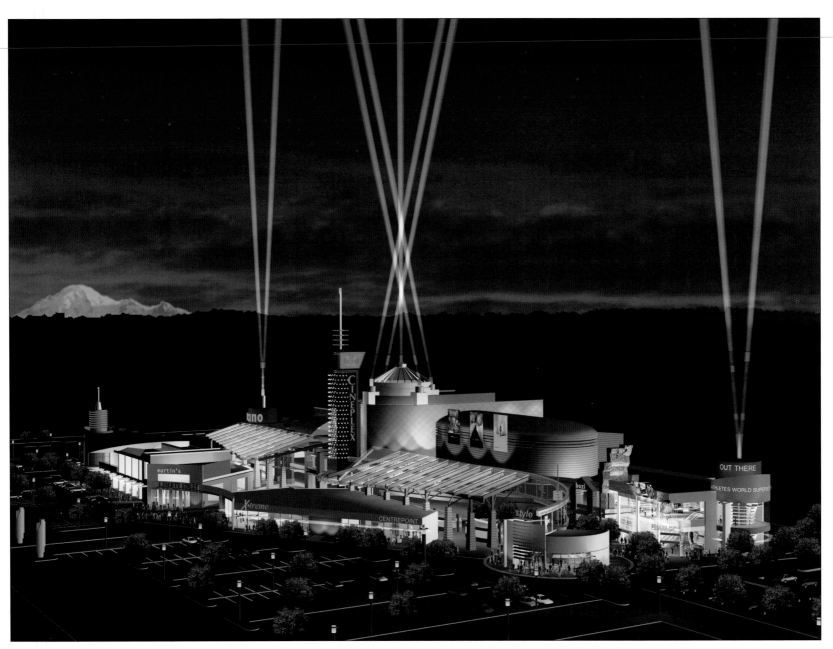

THE BEST OF 3D GRAPHICS

TITLE	Liberty Street Shopping and Urban Entertainment Centre
ARTIST	Eugene Radvenis
COMPANY	E. V. Radvenis, Inc.
COUNTRY	Canada
SOFTWARE	3D Studio Max, Hi-Res QFX

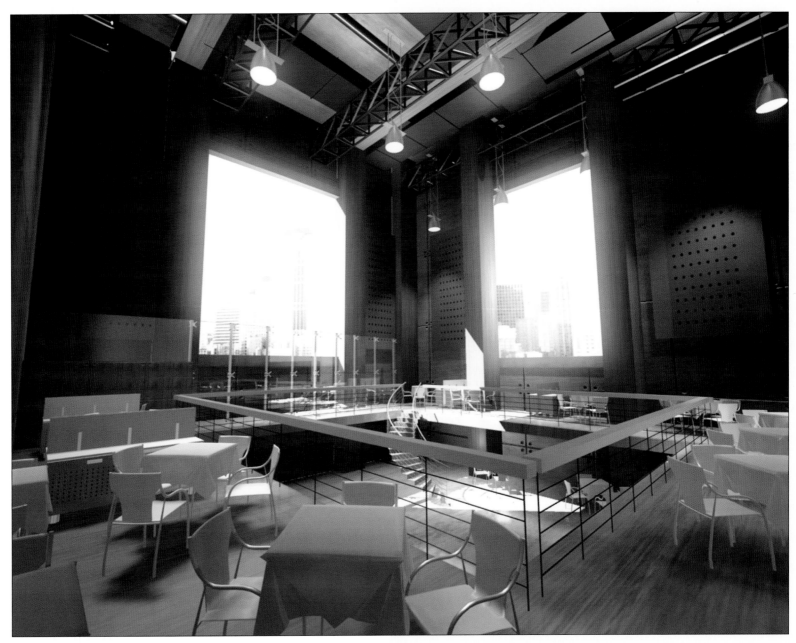

TITLE	Restaurant Century 21
ARTIST	Montree Termrattanasirikul
COUNTRY	Singapore
SOFTWARE	3D Studio Max

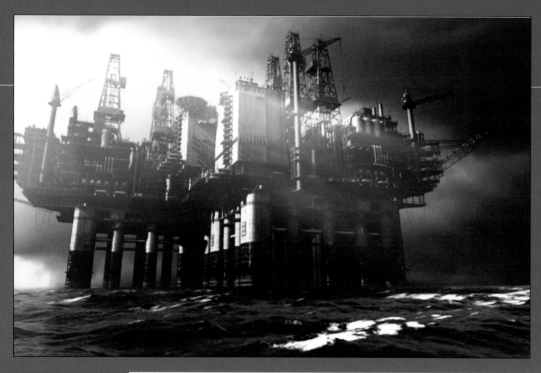

TITLE	Oil Platform–Operation Noah
ARTISTS	Martin Gessner and Piet Hohl
COMPANY	UPSTART! GmbH
COUNTRY	Germany
SOFTWARE	3D Studio Max, Softimage, Digital Nature Tools, RenderWorld, Media Illusion

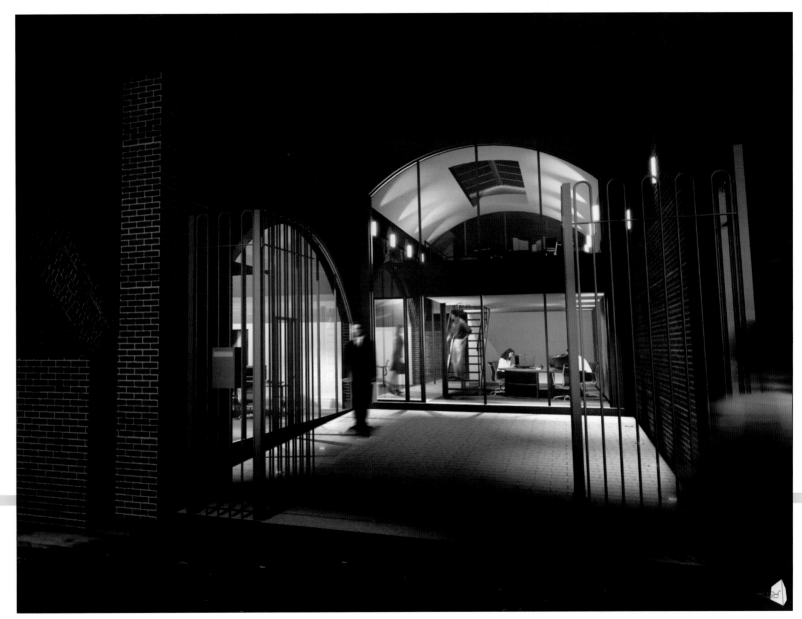

TITLE	Railway Arches Office
ARTIST	Chris Grew
COMPANY	HUSH Design Limited
COUNTRY	England
SOFTWARE	3d Studio Max, Photoshop

TITLE Cattedrale
ARTIST Marco Giubelli
COUNTRY Italy
SOFTWARE 3D Studio Max, Photoshop

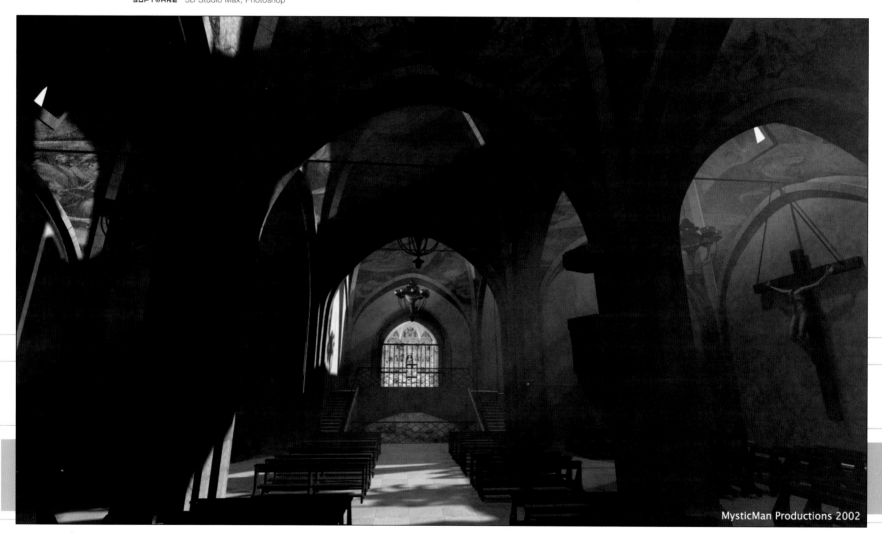

MysticMan Productions 2002

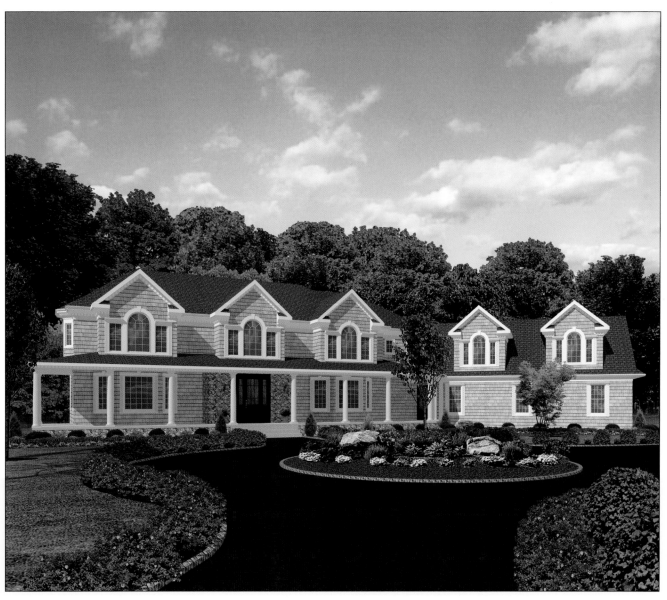

TITLE	The Brandywine
ARTIST	Dean Eckman
COMPANY	DME Drafting Service
COUNTRY	United States
SOFTWARE	Softplan, Paint Shop Pro

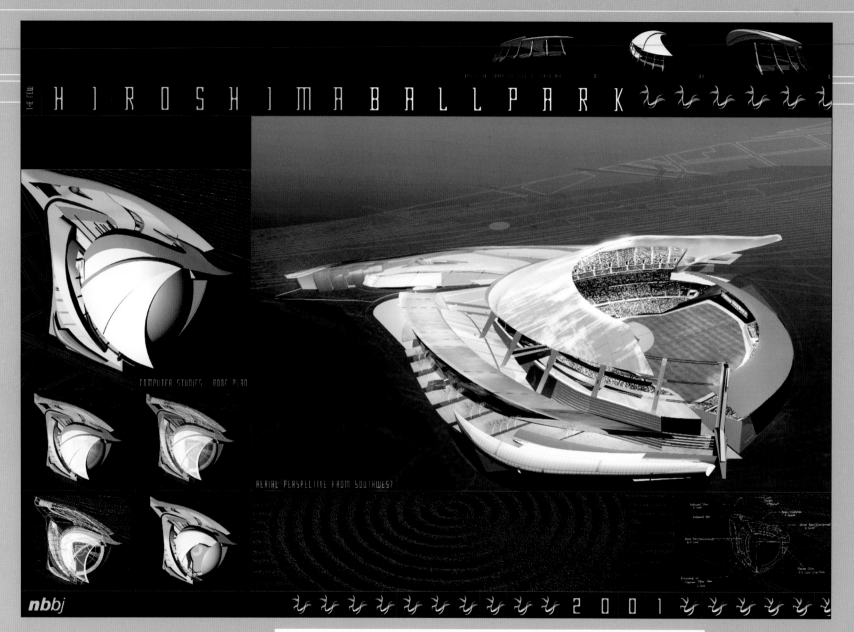

THE HIROSHIMA BALLPARK

COMPUTER STUDIES - ROOF PLAN

AERIAL PERSPECTIVE FROM SOUTHWEST

nbbj

2001

TITLE	Hiroshima Ballpark
ARTISTS	Mika Amaya, Paul Davis, Jamie Gaskins, Andy Ku, Dan Mies, Ted Ngai, Duncan Patterson, Jin Ah Park, Sanam Simzar, Nnamdi Ugenyi, Jonathan Ward
COMPANY	nbbj
COUNTRY	England
SOFTWARE	MicroStation Triforma, Wavefront, Photoshop

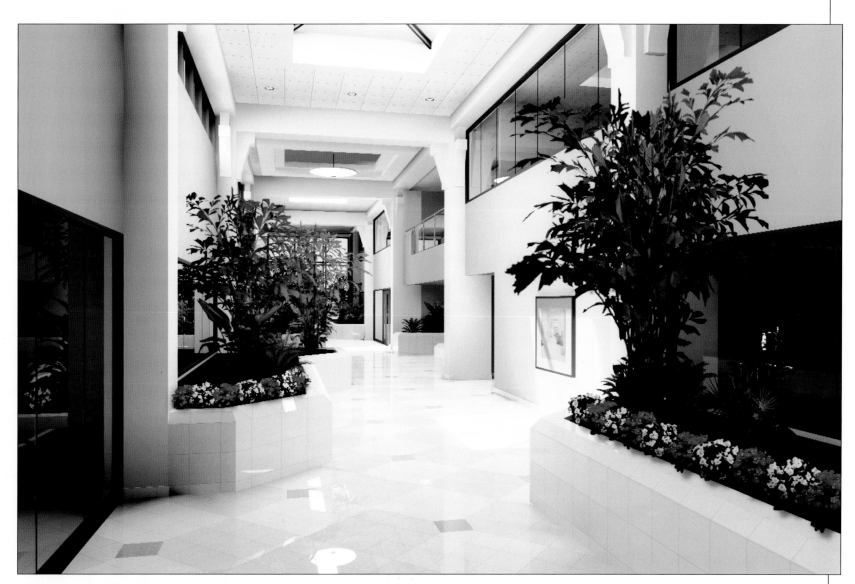

TITLE	Proposed Suburban Office Corridor
ARTIST	Rick Schweet
COMPANY	Kinetic Vision
COUNTRY	United States
SOFTWARE	3D Studio Max, Lightscape, Photoshop

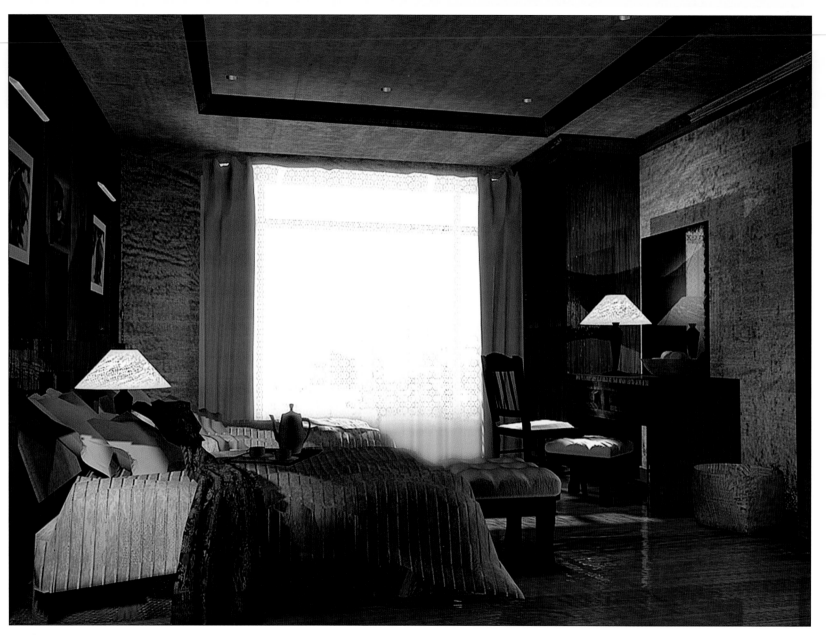

TITLE	Bedroom
ARTIST	Montree Termrattanasirikul
COUNTRY	Singapore
SOFTWARE	3D Studio Max

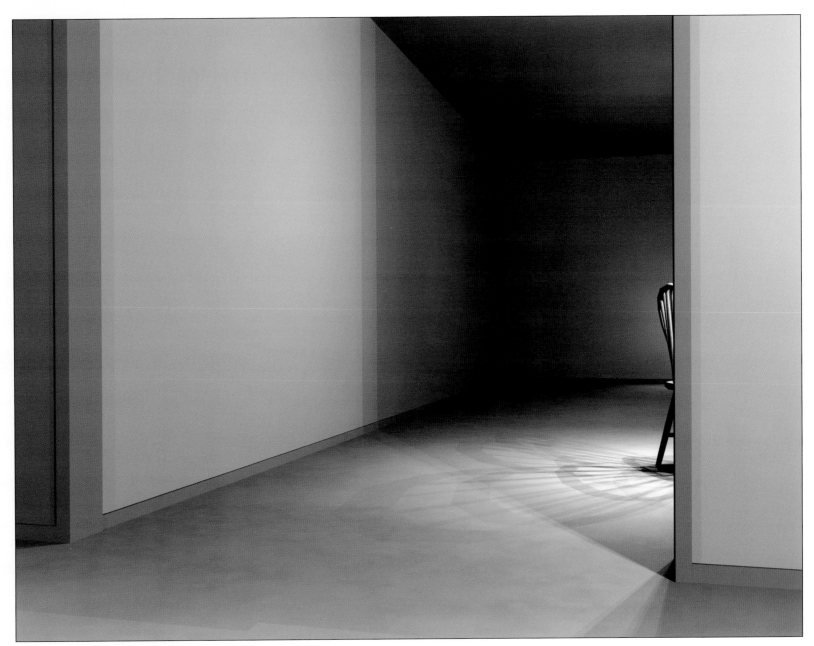

TITLE	Intersection No. 7
ARTIST	Kyle Riedel
COMPANY	Gustavus Adolphus College
COUNTRY	United States

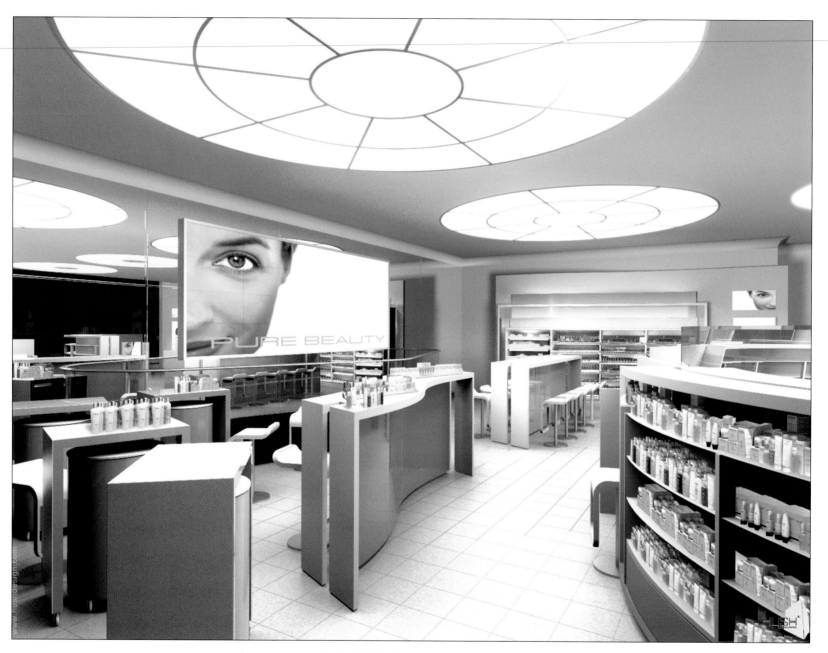

PURE BEAUTY

TITLE	Pure Beauty (internal)
ARTIST	Matt Wynne
COMPANY	HUSH Design Limited
COUNTRY	England
SOFTWARE	3D Studio Max, RenderDrive, Photoshop

TITLE	Pure Beauty (external)
ARTIST	Matt Wynne
COMPANY	HUSH Design Limited
COUNTRY	England
SOFTWARE	3D Studio Max, RenderDrive, Photoshop

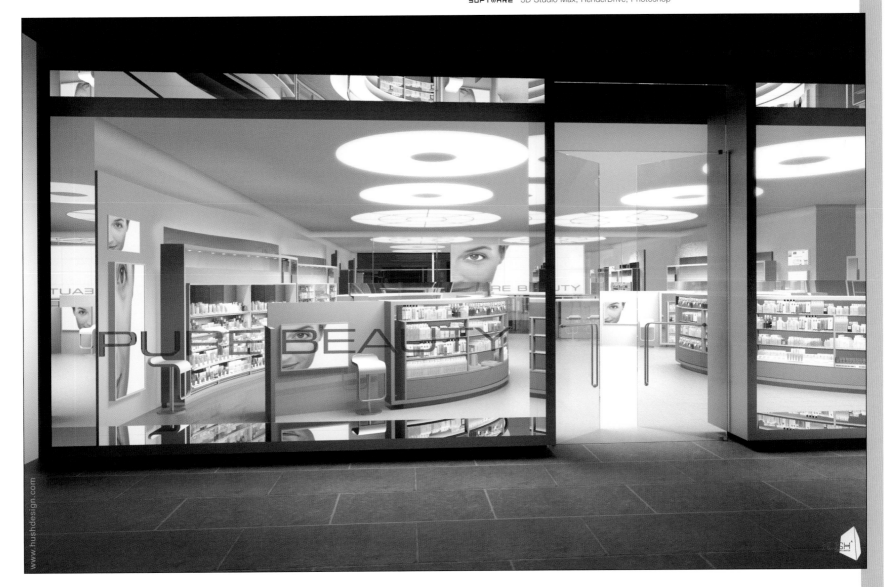

www.hushdesign.com

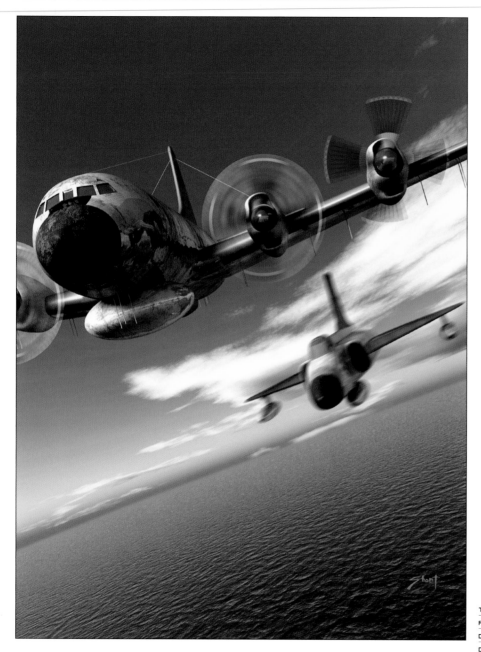

"Art is man's expression
of his joy in labour."

William Morris (1834-1896)

TITLE	China's Dangerous Game
ARTIST	Christopher Short
COMPANY	Cyr Studio
COUNTRY	United States
SOFTWARE	LightWave, Terragen

TITLE	Rockford Fosgate Truck Spread
ARTIST	Frank Vitale
COUNTRY	United States
SOFTWARE	3D Max, Photoshop

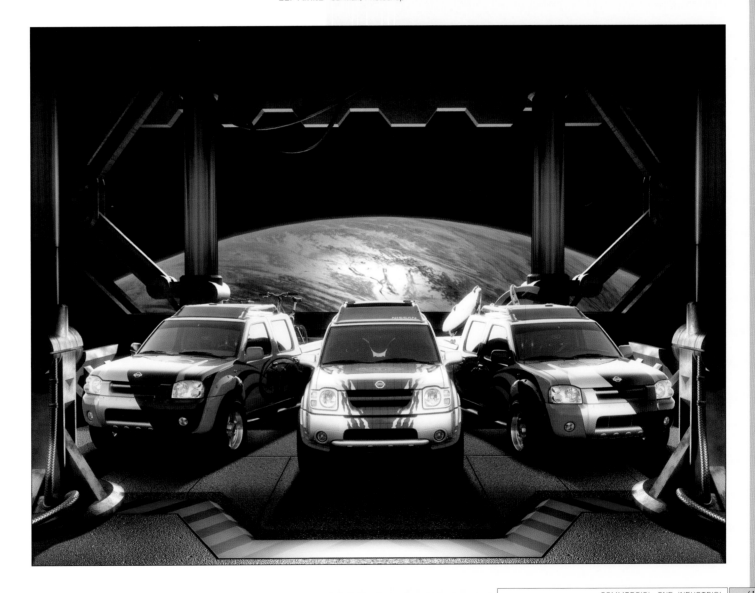

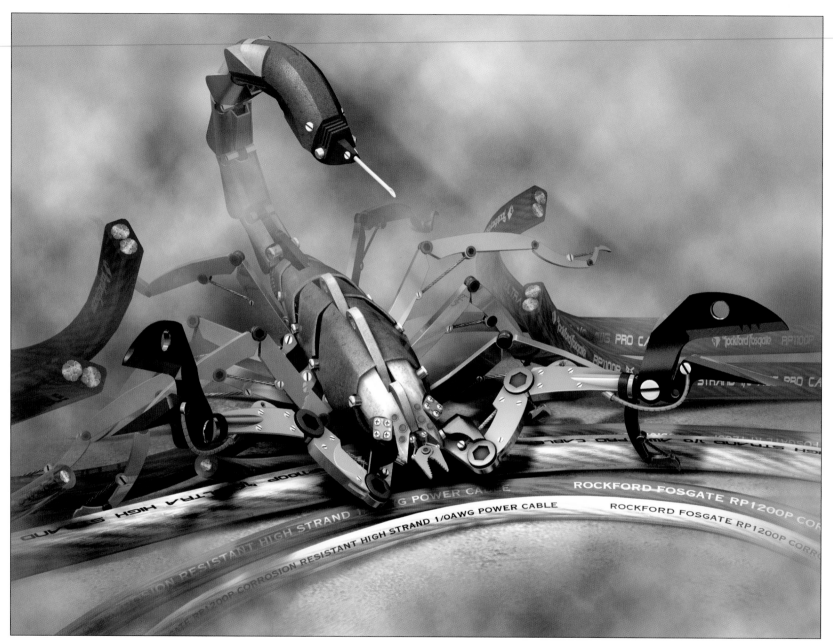

TITLE	Mechanical Scorpion 2001
ARTIST	Frank Vitale
COUNTRY	United States
SOFTWARE	Cinema 4D, Photoshop

TITLE	The Bugs Have Arrived
ARTIST	Steve Bishop
COUNTRY	United States
SOFTWARE	Cinema 4D, Photoshop

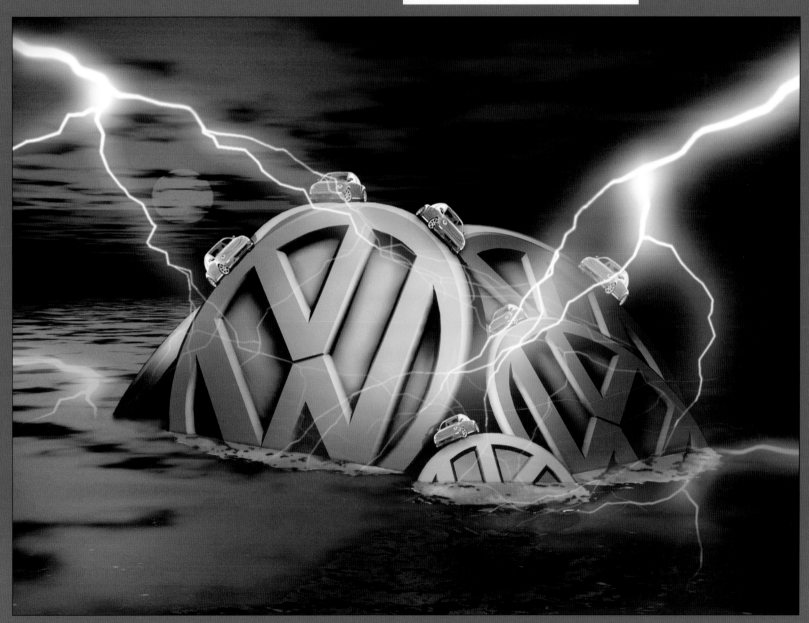

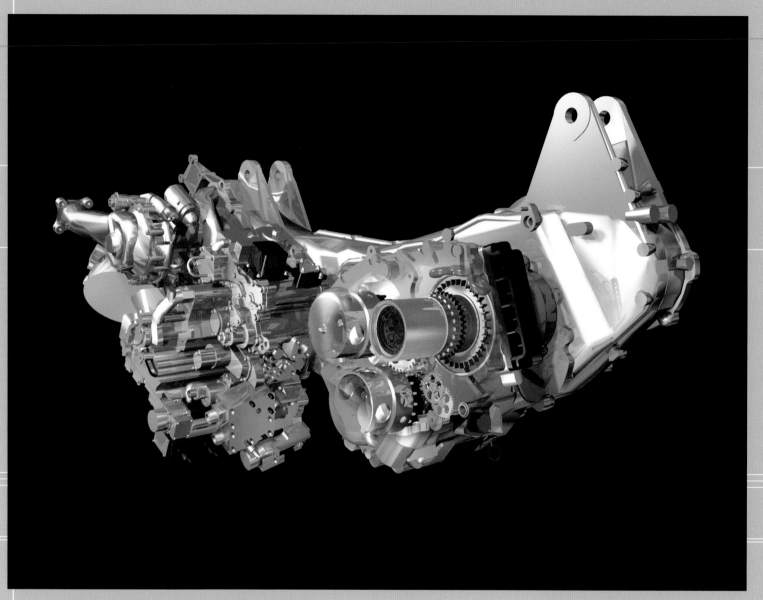

TITLE	Jet Engine Generator
ARTIST	Rick Schweet
COMPANY	Kinetic Vision
COUNTRY	United States
SOFTWARE	3D Studio Max, Photoshop

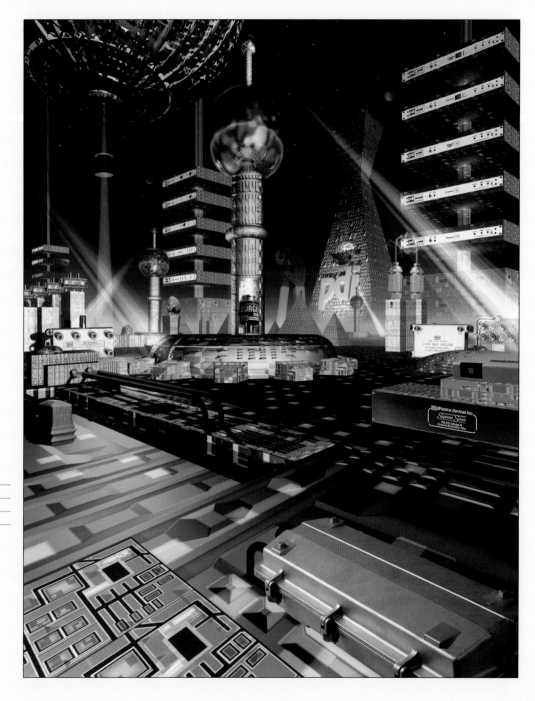

TITLE	Future City 1
ARTIST	Kort Kramer
COMPANY	PDI Communications Inc.
COUNTRY	United States
SOFTWARE	Bryce, Photoshop

TITLE	Audi
ARTIST	Robert Kuczera
COMPANY	3D Characters
COUNTRY	Germany
SOFTWARE	Maya, Photoshop

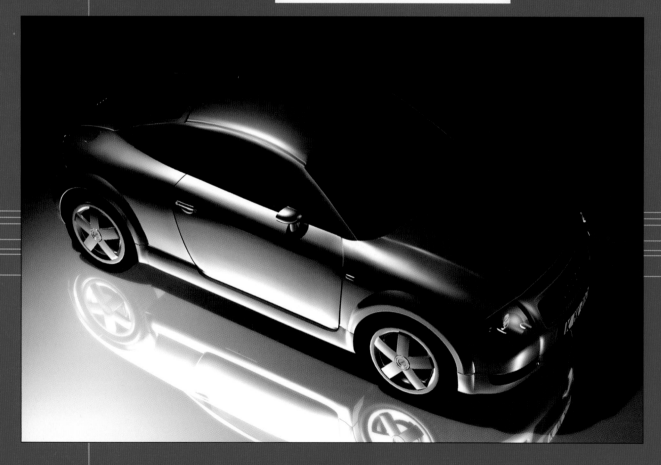

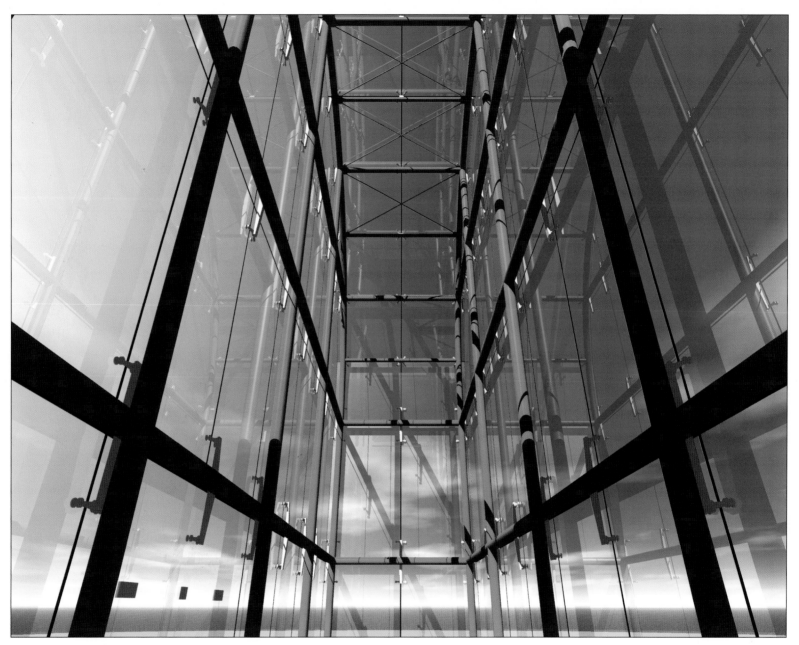

TITLE	Glass Wall Entryway
ARTIST	David A. Maloney
COMPANY	Avatara Studios
COUNTRY	United States
SOFTWARE	Intergraph EMS, ModelView

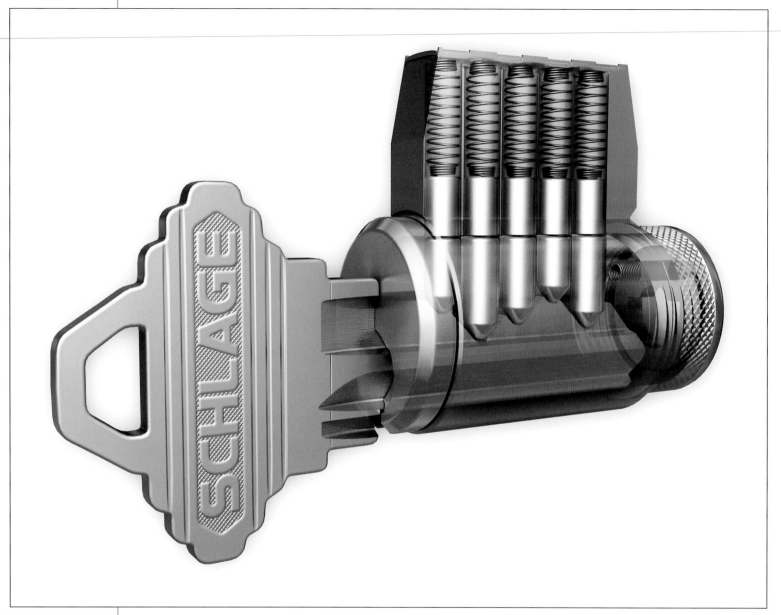

TITLE	See-Through Lock
ARTIST	James Darknell
COMPANY	Mutant-Pixel Digital Labs
COUNTRY	United States
SOFTWARE	LightWave 3D, Photoshop

TITLE	Bose 3D Auto
ARTIST	Michael Scaramozzino
COMPANY	DreamLight Incorporated
COUNTRY	United States
SOFTWARE	MacroModel, Macromedia 3D

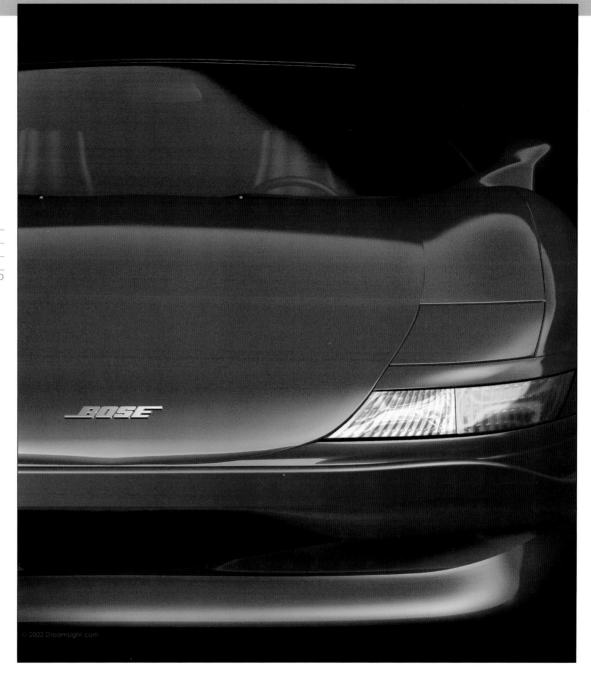

© 2002 DreamLight.com

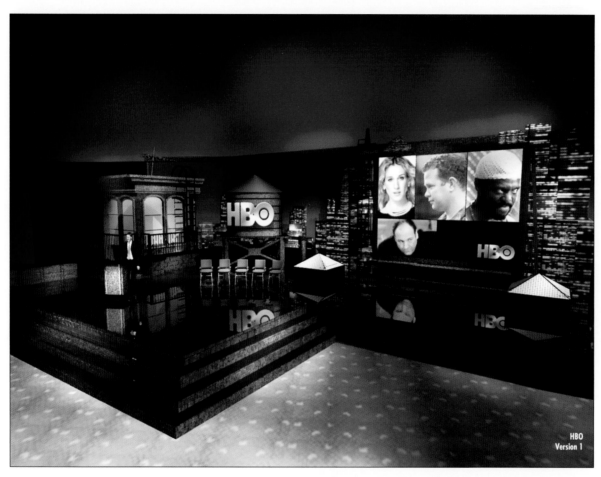

HBO
Version 1

TITLE	HBO Corporate Meeting Set Design Proposal
ARTIST	David Sumner
COMPANY	David Sumner Design
COUNTRY	United States

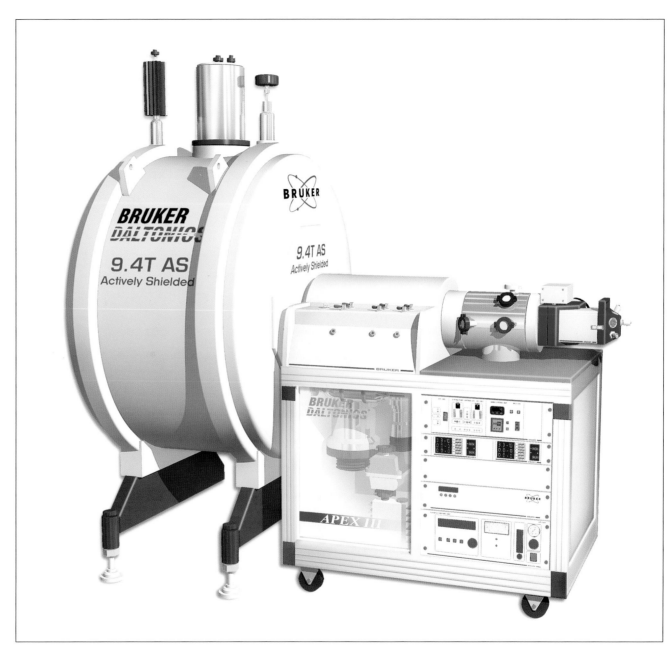

TITLE	Apex III
ARTIST	Anthony Velleco
COMPANY	Evolution Design
COUNTRY	United States
SOFTWARE	FormZ, Photoshop

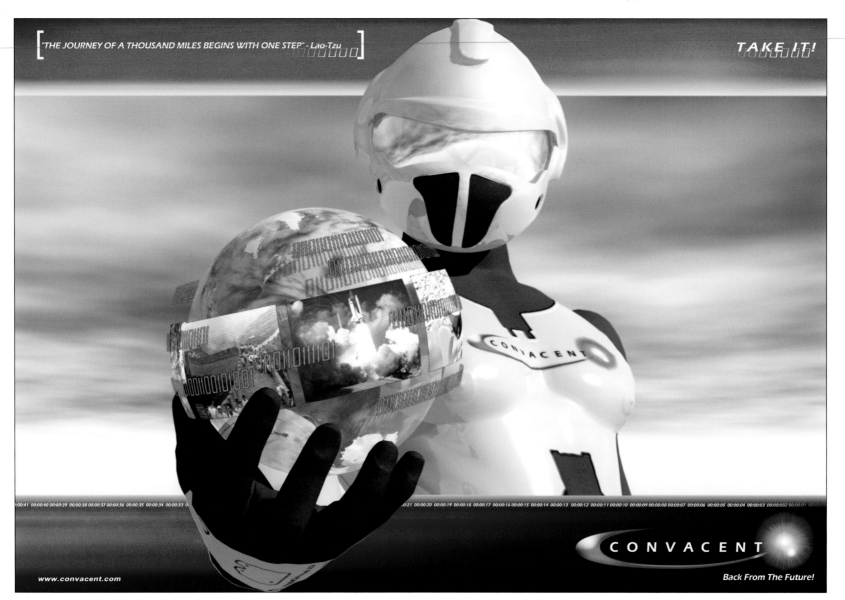

TITLE	Convacent Ad
ARTIST	Joshua Bevan
COMPANY	Convacent
COUNTRY	United States
SOFTWARE	Bryce, Poser, Photoshop

TITLE	Dove Dining Furniture
ARTIST	Peter Cybulski
COMPANY	PC Graphic Design, Inc.
COUNTRY	United States
SOFTWARE	FormZ, Renderzone

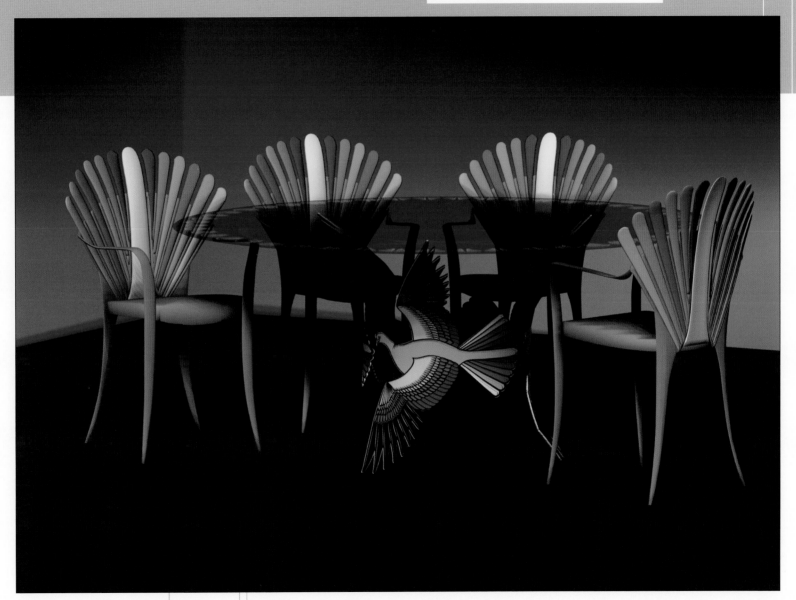

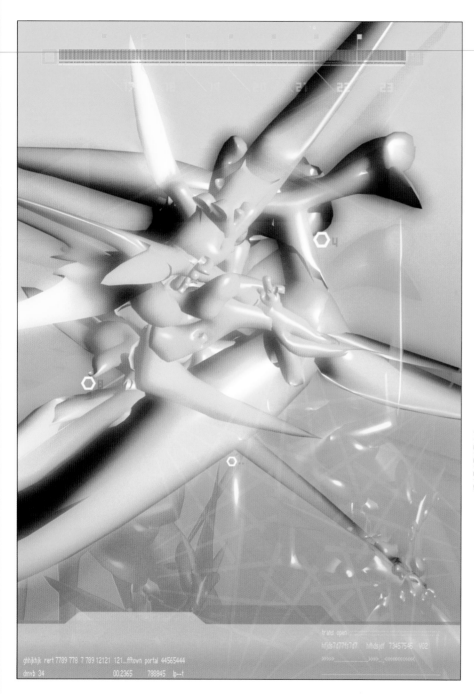

TITLE	Philter
ARTIST	Frank Townsend
COMPANY	fTown Design
COUNTRY	United States
SOFTWARE	LightWave, Fireworks, Photoshop

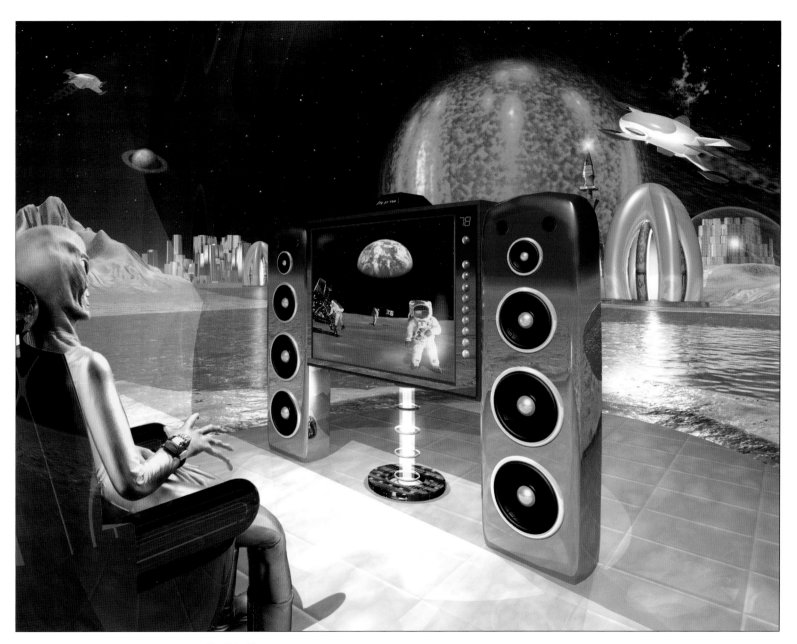

TITLE	Alien Living Room
ARTIST	Kort Kramer
COMPANY	PDI Communications Inc.
COUNTRY	United States
SOFTWARE	Bryce, Photoshop

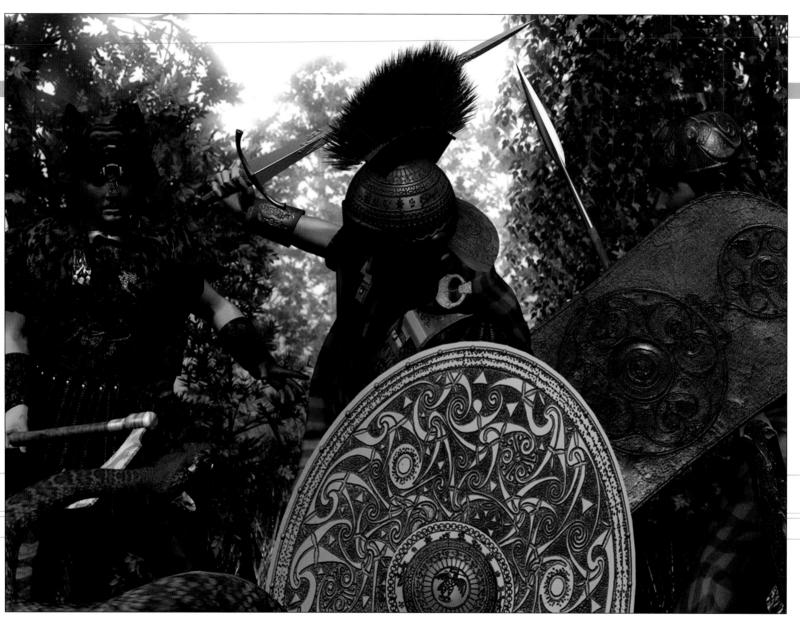

TITLE	Snake in the Grass
ARTIST	Les Still
COMPANY	Mystic Realms
COUNTRY	United Kingdom
SOFTWARE	3D Studio Max, Photoshop

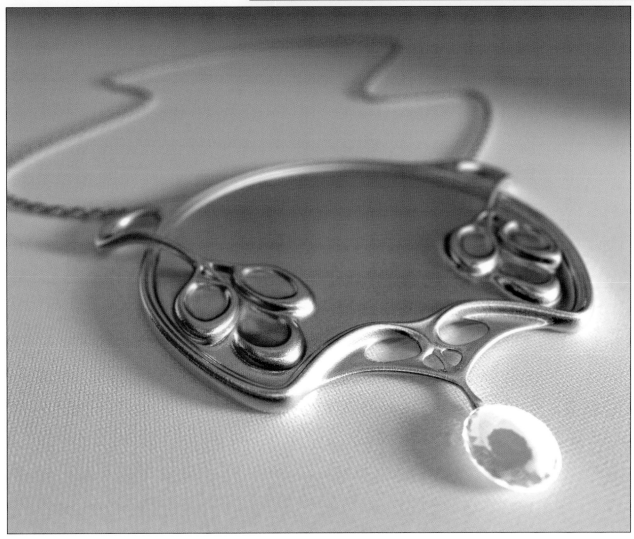

"Art is not a study
of positive reality,
it is the seeking
for ideal truth."

George Sand (1804-1876)

TITLE	Jewel
ARTIST	Miguel Miraldo
COUNTRY	Portugal
SOFTWARE	3D Studio Max, Mental Ray

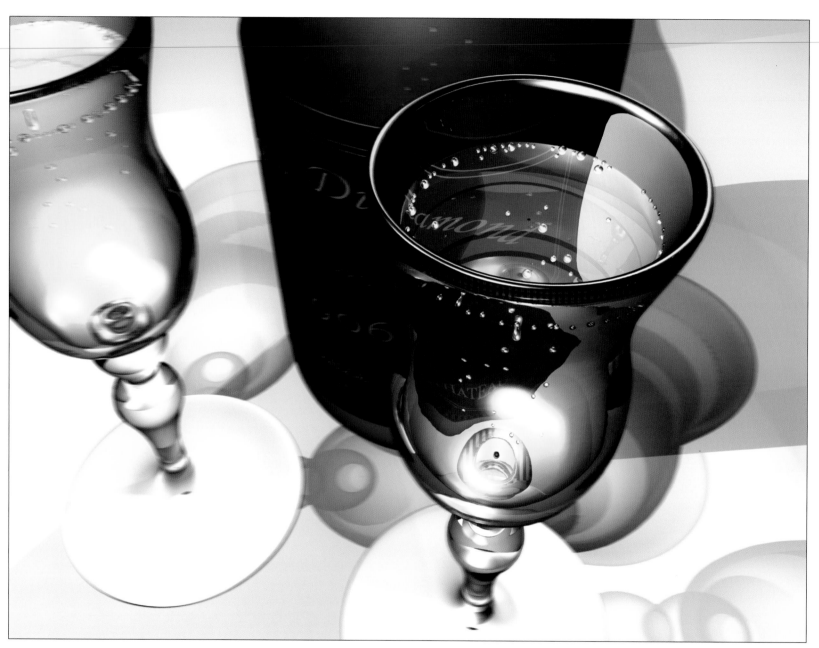

TITLE	Wine
ARTIST	Irina M. Carriger
COMPANY	Camber Corporation
COUNTRY	United States
SOFTWARE	Maya

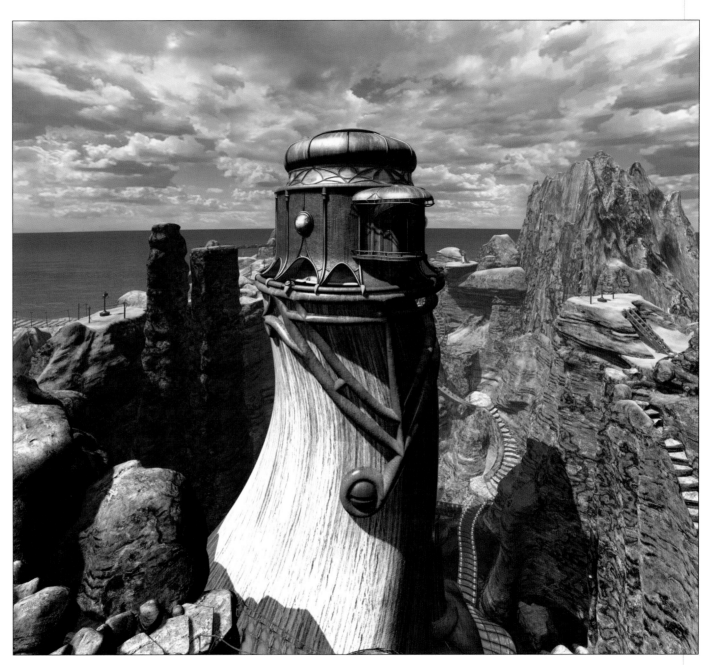

TITLE	Myst III: Exile—J'nanin Age
COMPANY	Presto Studios, Inc.
COUNTRY	United States
SOFTWARE	3D Studio Max, Combustion, Final Cut Pro, Photoshop

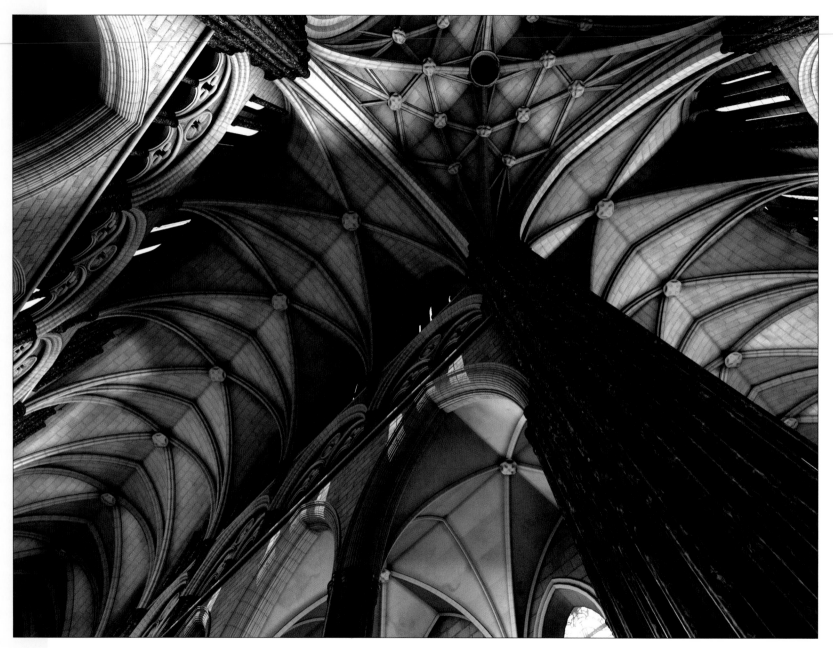

TITLE	Cathedral
ARTIST	Philip Emery
COUNTRY	United Kingdom
SOFTWARE	TrueSpace, Paint Shop Pro, Symbiont

TITLE Retro Saucer

ARTIST James Darknell

COMPANY Mutant-Pixel Digital Labs

COUNTRY United States

SOFTWARE LightWave 3D, Photoshop, Illustrator

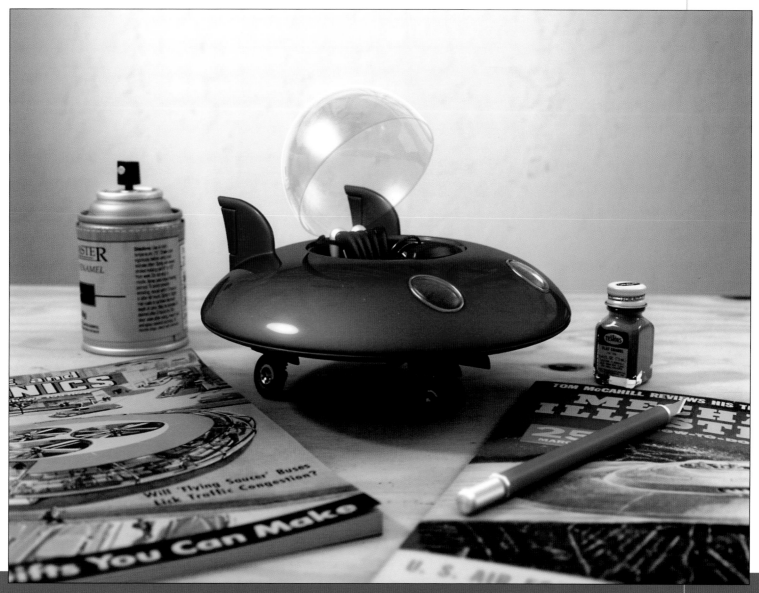

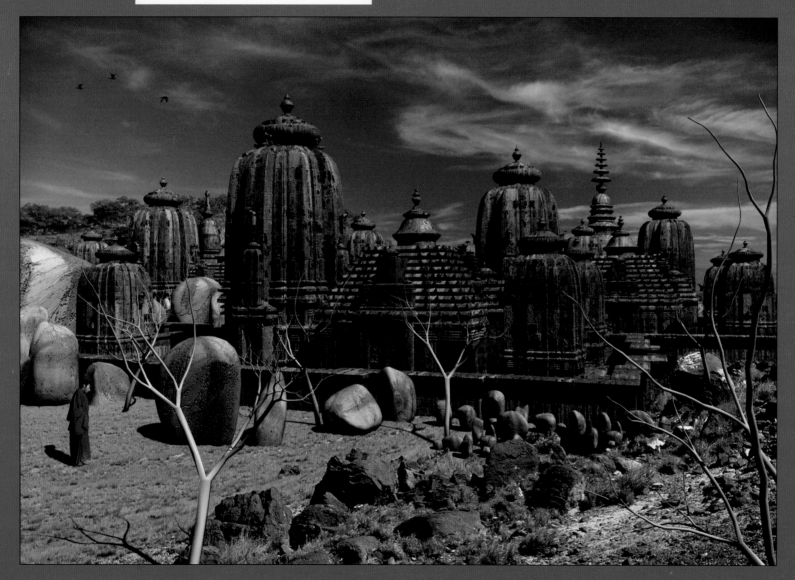

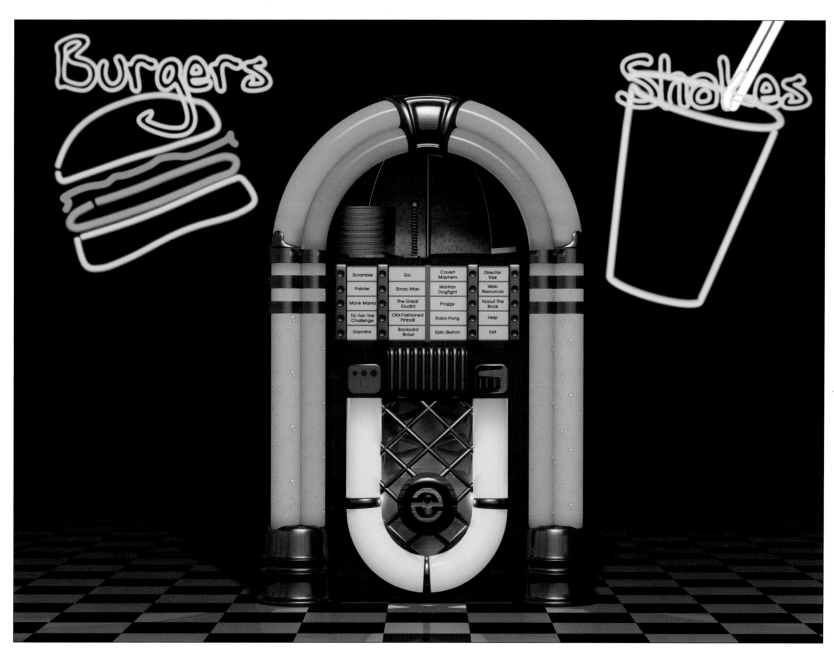

TITLE	Jukebox
ARTIST	Danny Duhon
COMPANY	epic software group, inc.
COUNTRY	United States
SOFTWARE	LightWave, Photoshop

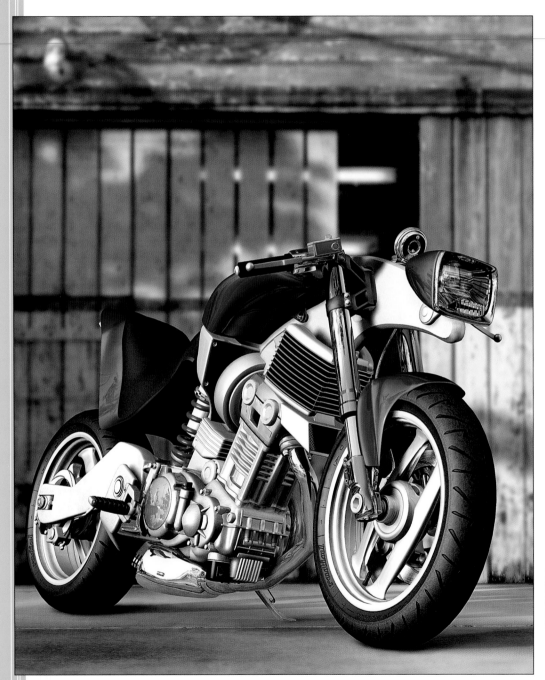

TITLE	Skeletor
ARTIST	Tim Cameron
COMPANY	Tim Cameron Design
COUNTRY	Australia
SOFTWARE	LightWave, Photoshop

TITLE	Angie
ARTIST	Ralph Manis
COMPANY	Infinitee Design
COUNTRY	United States
SOFTWARE	Poser, Bryce, Photoshop

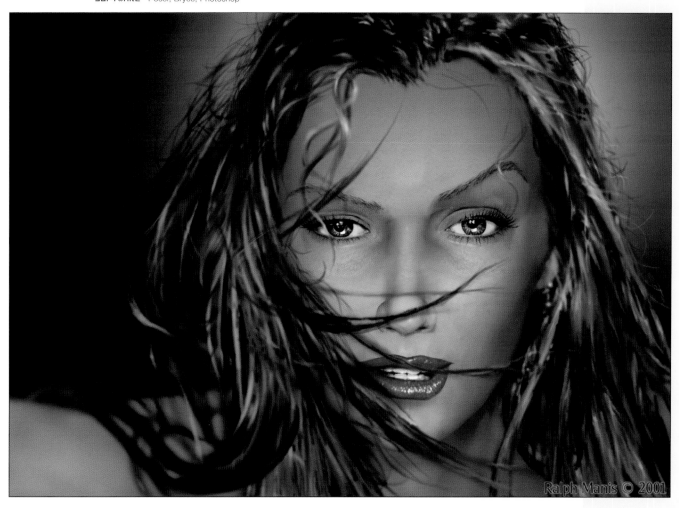

Ralph Manis © 2001

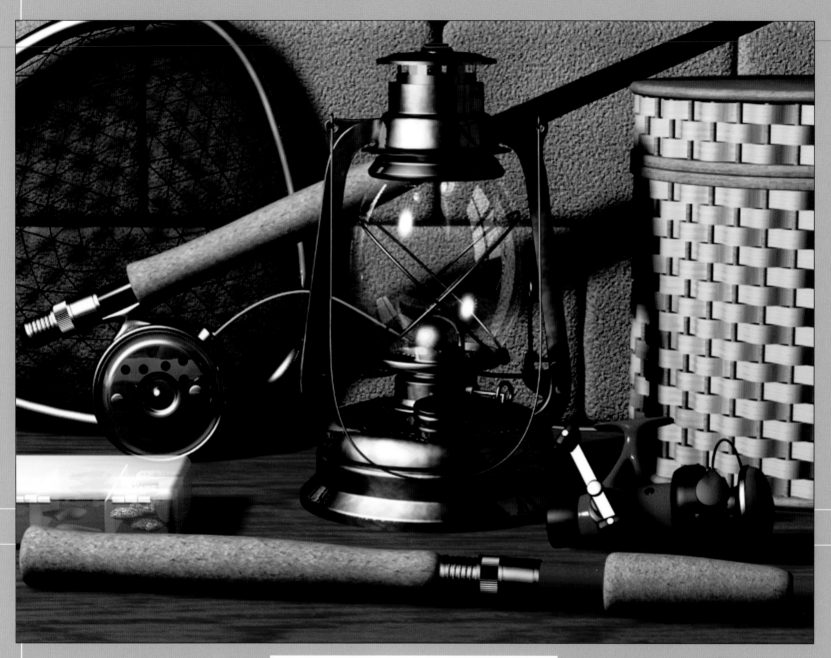

TITLE	Fishing Tackle
ARTIST	Alexis Francou
COUNTRY	Mexico
SOFTWARE	3D Studio Max, ExpertCAD 3D, Photo Studio

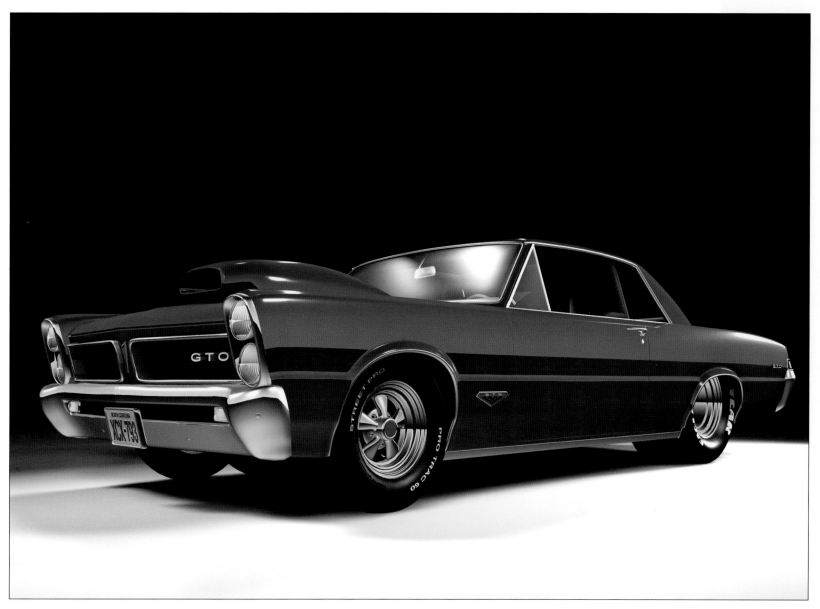

TITLE	Joe's Garage—'65 GTO
ARTIST	Joseph F. Jarman
COMPANY	Planet 3 Animation Studio
COUNTRY	United States
SOFTWARE	PowerAnimator, Maya

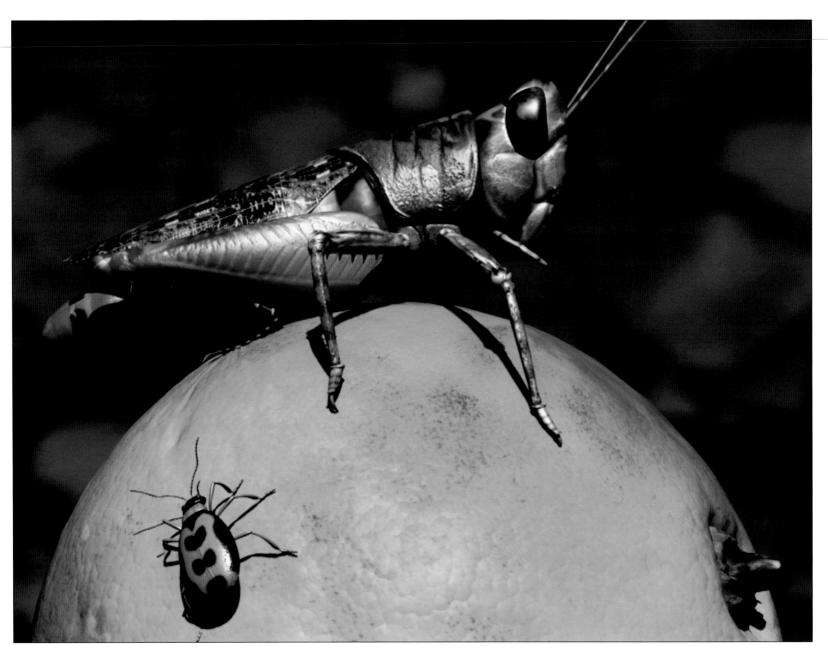

TITLE	Orange Feast
ARTIST	Alexis Francou
COUNTRY	Mexico
SOFTWARE	3D Max, Expert CAD 3D, Photostudio

TITLE	A Buggy Day
ARTIST	Miguel Miraldo
COUNTRY	Portugal
SOFTWARE	3D Studio Max

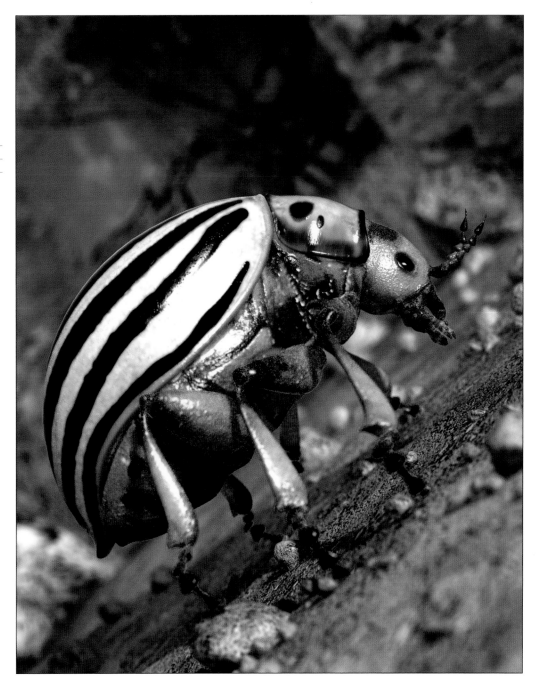

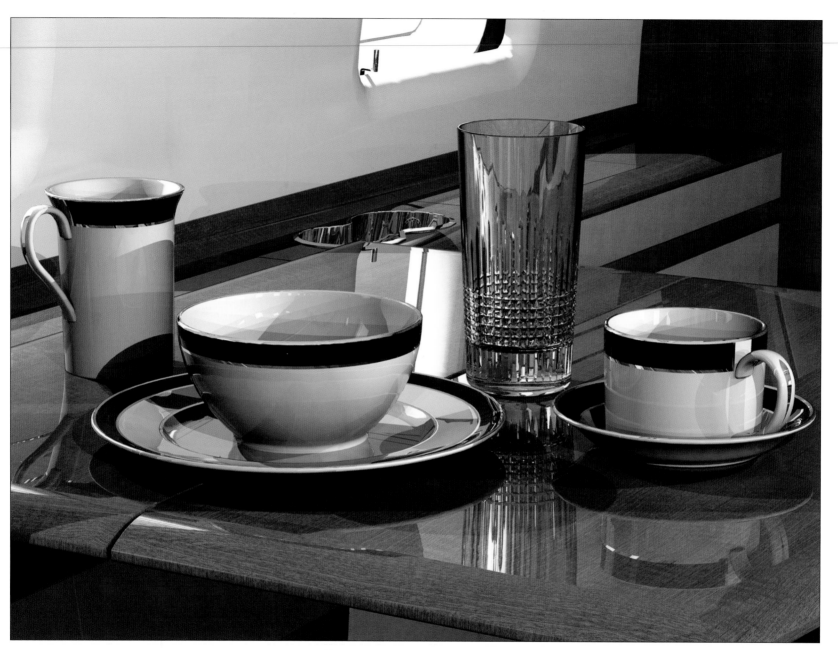

TITLE	China Crystal
ARTIST	Dave Slama
COMPANY	Studio Southwest Designs
COUNTRY	United States
SOFTWARE	Mechanical Desktop, 3D Studio Max

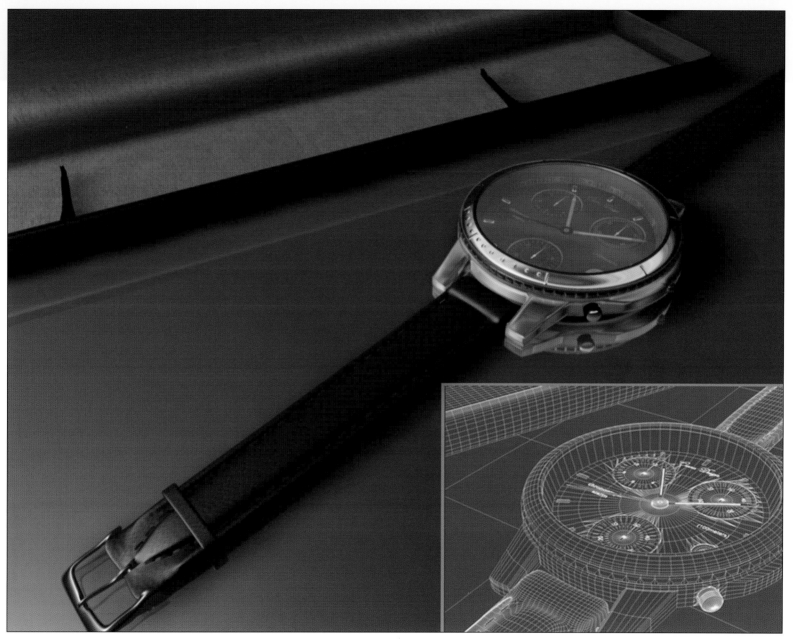

TITLE The Watch

ARTIST Massimo Zuanazzi

COUNTRY Italy

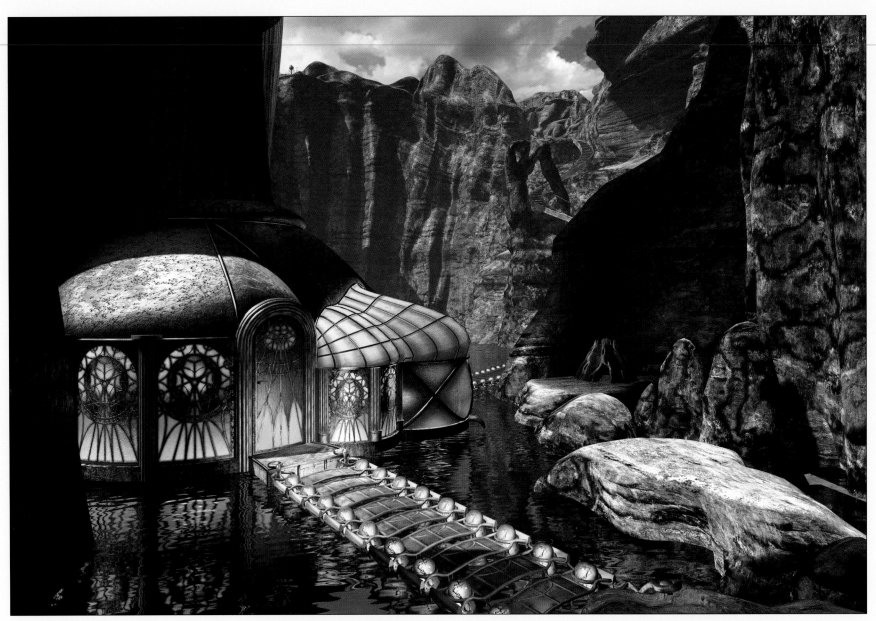

TITLE	Myst III: Exile—J'nanin Lagoon
COMPANY	Presto Studios, Inc.
COUNTRY	United States
SOFTWARE	3D Studio Max, Combustion, Final Cut Pro, Photoshop

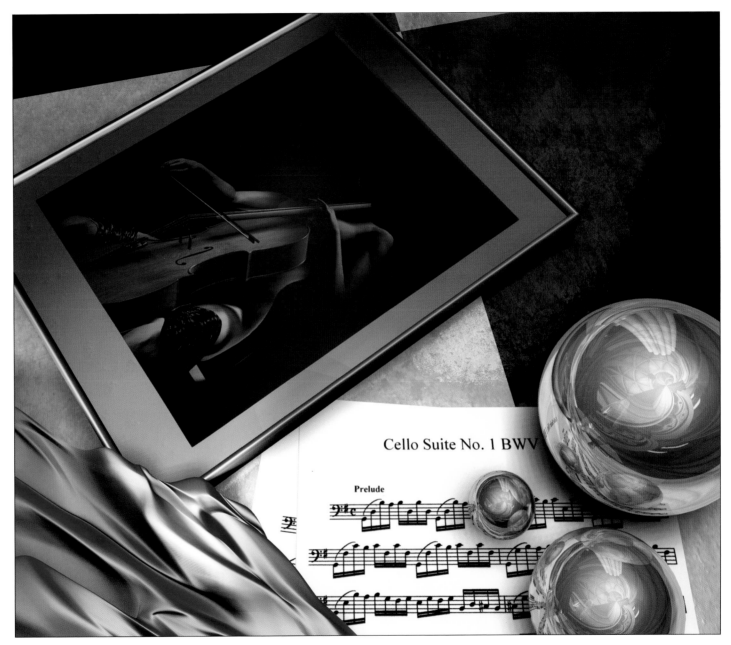

TITLE	Music
ARTIST	Philip Emery
COUNTRY	United Kingdom
SOFTWARE	trueSpace, Paint Shop Pro, DarkTree Symbiont, Poser

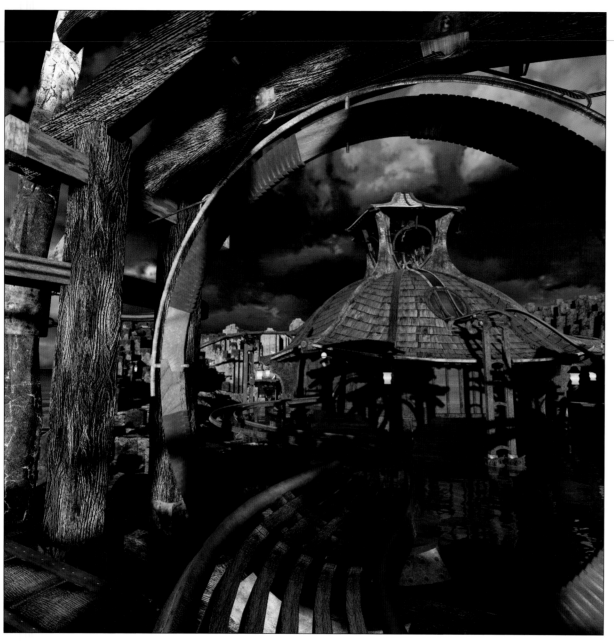

TITLE	Myst III: Exile—Amatera Age
COMPANY	Presto Studios, Inc.
COUNTRY	United States
SOFTWARE	3D Studio Max, Combustion, Final Cut Pro, Photoshop, Code Warrior, Visual C++, Microsoft Word, Microsoft Excel, Microsoft Project, Digidesign Pro Tools

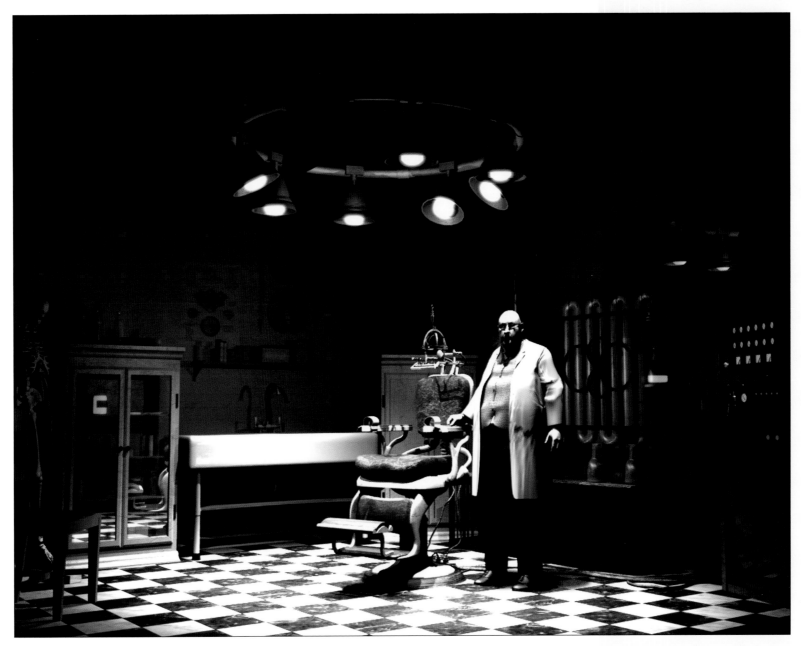

TITLE	Exam Room
ARTIST	David Grzybowski
COUNTRY	United States
SOFTWARE	LightWave

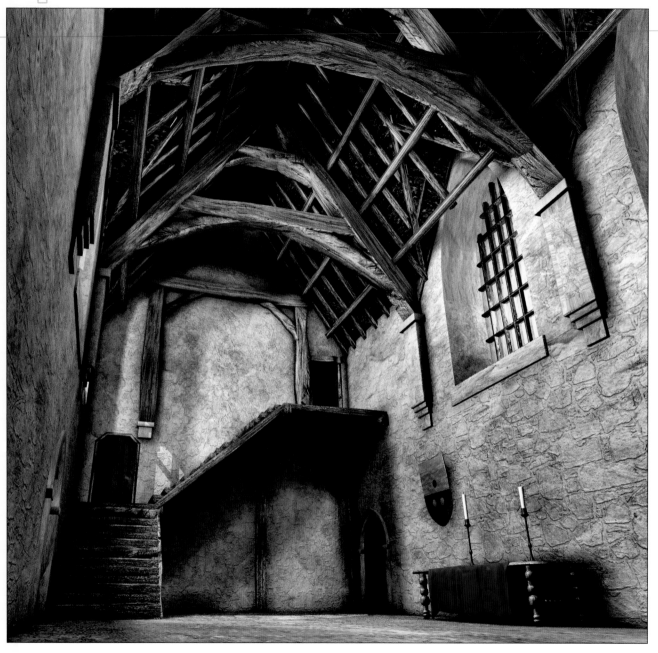

TITLE	Hall
ARTIST	Philip Emery
COUNTRY	United Kingdom
SOFTWARE	TrueSpace, Paint Shop Pro

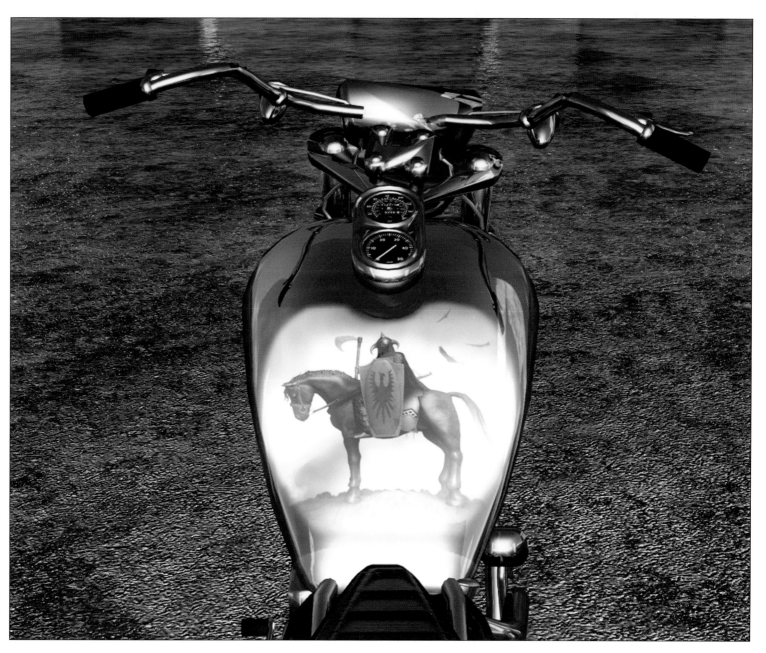

TITLE	Death Dealer Harley
ARTIST	Les Still
COMPANY	Mystic Realms
COUNTRY	United Kingdom
SOFTWARE	3D Studio Max, Photoshop

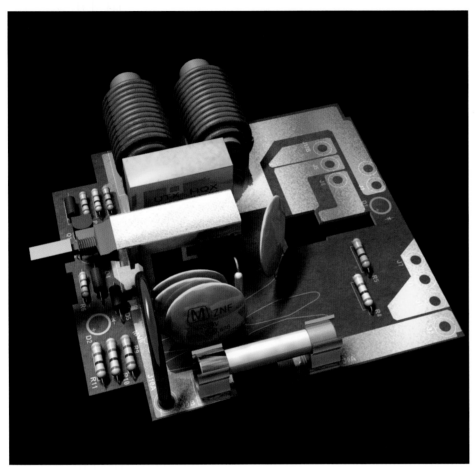

"Art is science made clear."

Jean Cocteau (1889-1963)

TITLE	Circuit
ARTIST	Christopher Short
COMPANY	Cyr Studio
COUNTRY	United States
SOFTWARE	LightWave

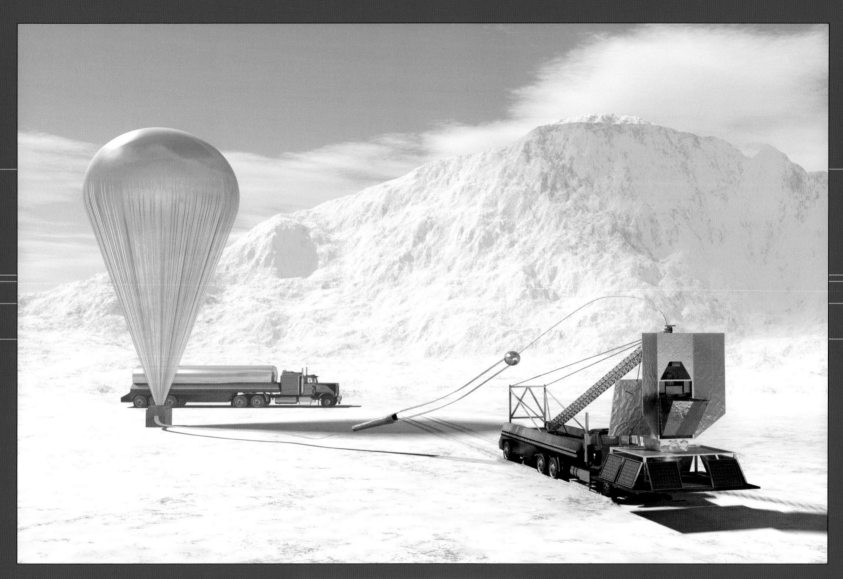

TITLE	Boomerang Telescope
ARTIST	Christopher Short
COMPANY	Cyr Studio
COUNTRY	United States
SOFTWARE	LightWave, Terragen

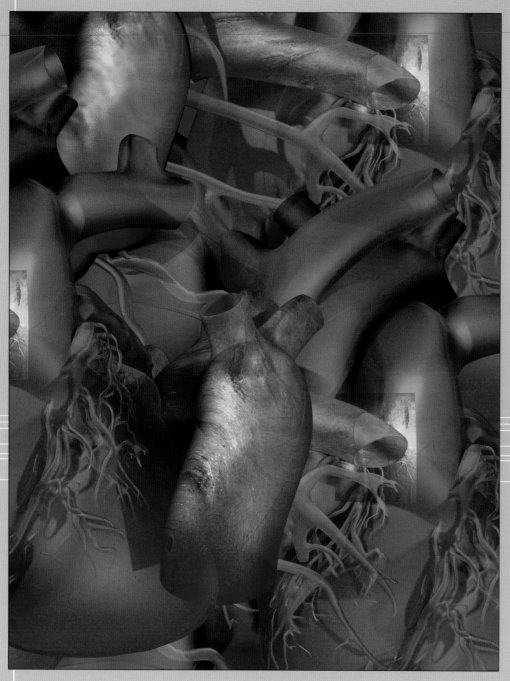

TITLE	Heart Composition
ARTIST	Fran Holt
COMPANY	Thoughtcam
COUNTRY	United States
SOFTWARE	LightWave, Photoshop

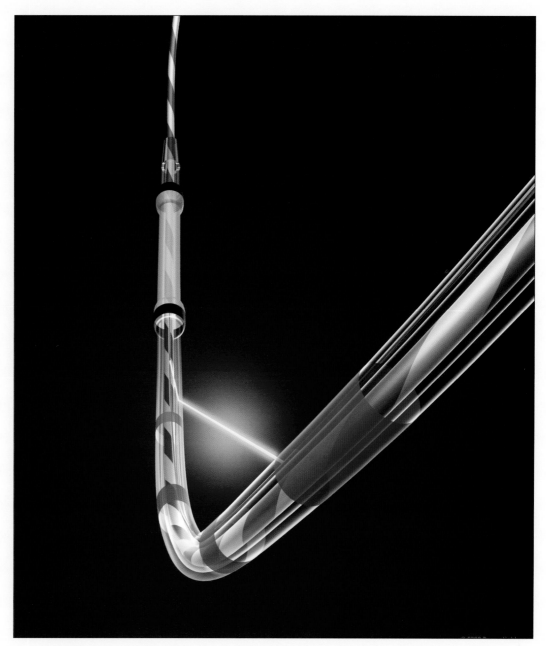

TITLE	Zebra Medical Catheter
COMPANY	DreamLight Incorporated
COUNTRY	United States
SOFTWARE	FormZ, Studio Pro

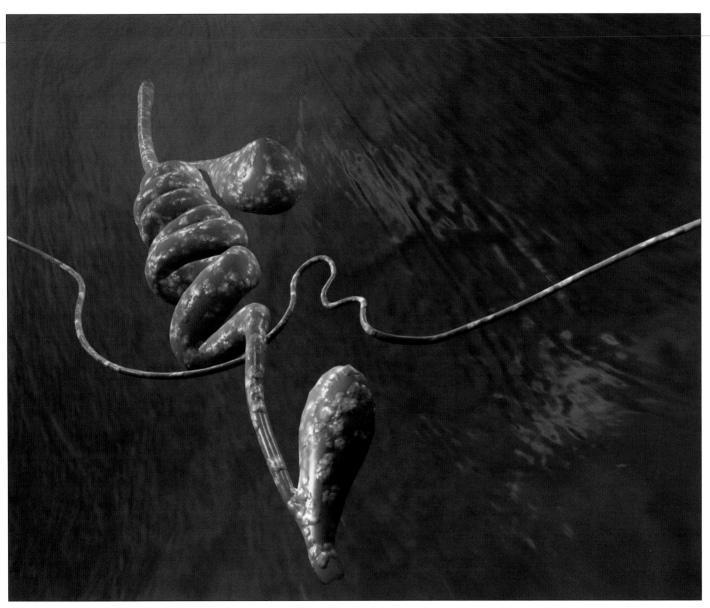

TITLE	Alimentary Canal of a Moth
ARTIST	James Abraham
COMPANY	Optigon Studios
COUNTRY	United States
SOFTWARE	3D Studio Max, Photoshop

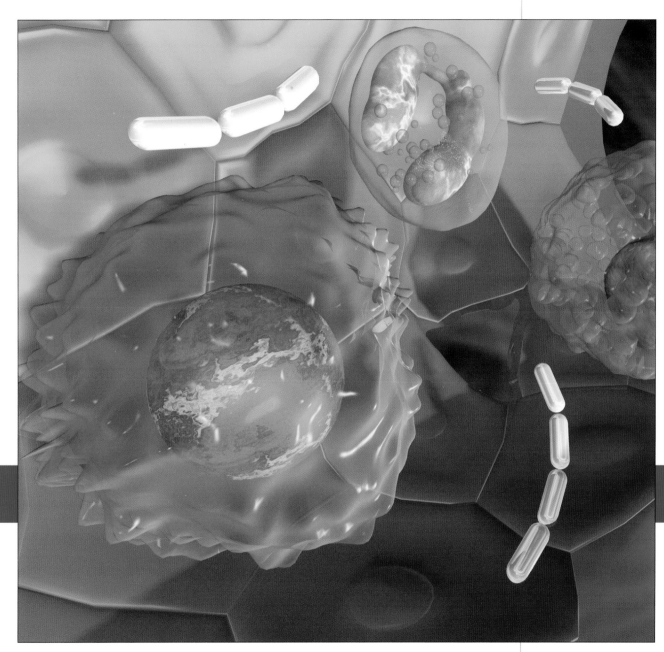

TITLE Macro Bacteria
COMPANY Blausen Medical Communications, Inc.
COUNTRY United States
SOFTWARE 3D Studio Max

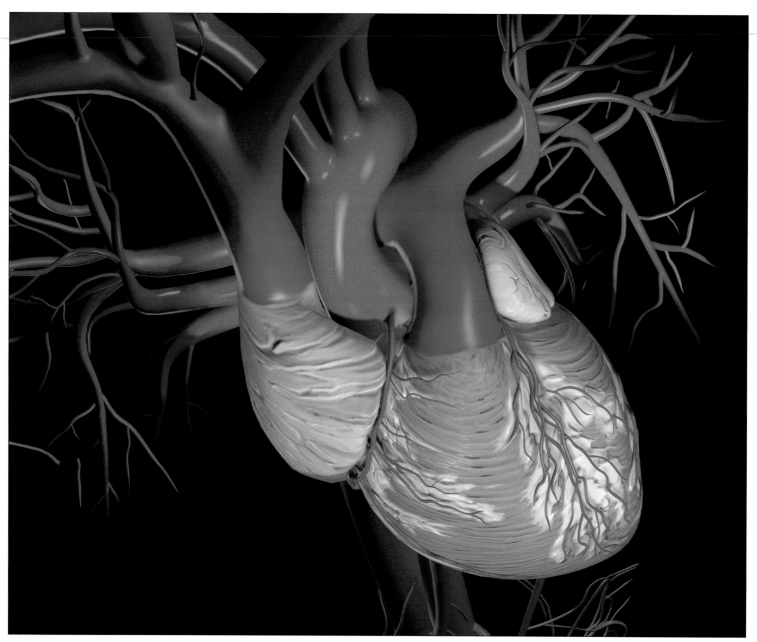

TITLE	Heart
COMPANY	Blausen Medical Communications, Inc.
COUNTRY	United States
SOFTWARE	3D Studio Max

TITLE	Bone Morphogenic Proteins
ARTIST	Gary Carlson
COMPANY	Gary Carlson Illustration
COUNTRY	United States
SOFTWARE	Amorphium, FormZ, Photoshop

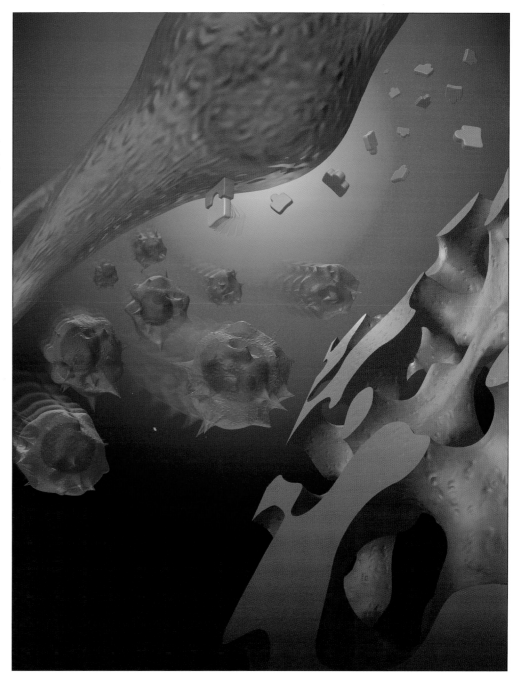

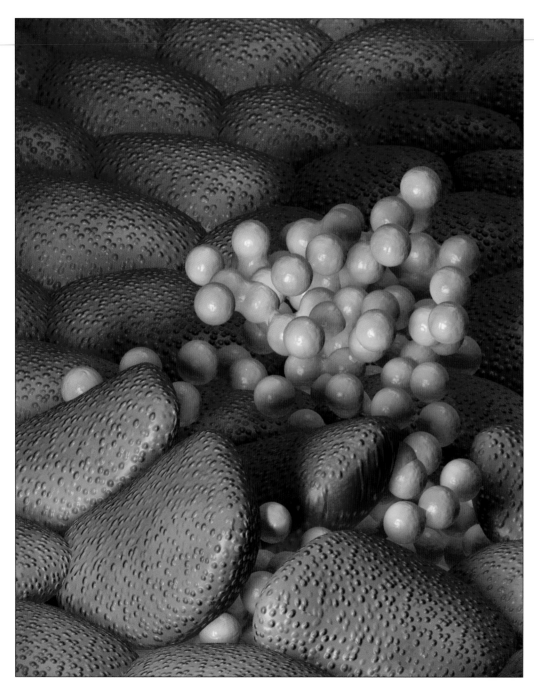

TITLE	Staph in Nasal Epithelium
ARTIST	Gary Carlson
COMPANY	Gary Carlson Illustration
COUNTRY	United States
SOFTWARE	TextureScape, FormZ, Photoshop

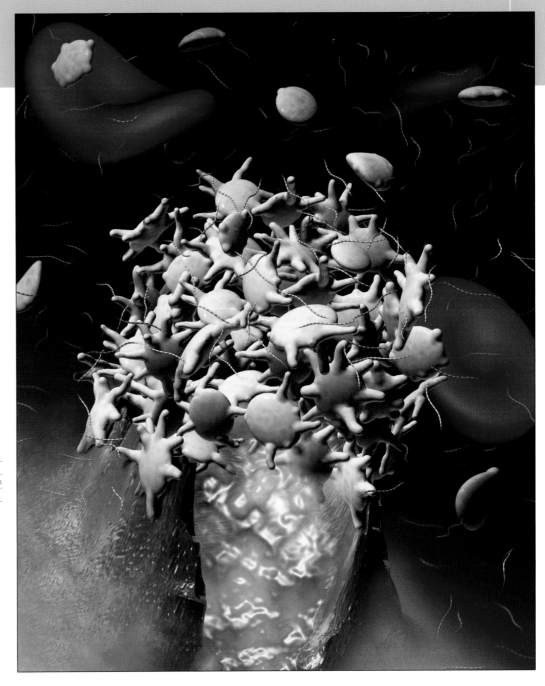

TITLE	Aggregating Platelets
ARTIST	Gary Carlson
COMPANY	Gary Carlson Illustration
COUNTRY	United States
SOFTWARE	FormZ, Photoshop

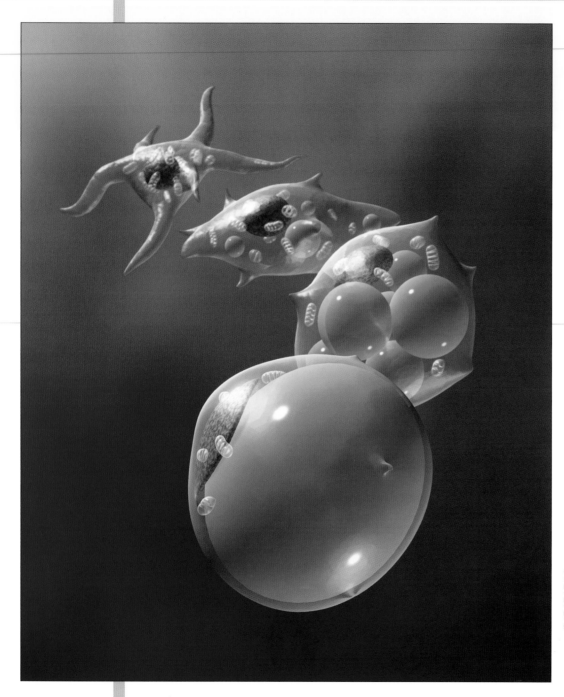

TITLE	Apidogenesis
ARTIST	Gary Carlson
COMPANY	Gary Carlson Illustration
COUNTRY	United States
SOFTWARE	LightWave, Photoshop

"A work of art
is above all
an adventure
of the mind."

Eugène Ionesco (1912-1994)

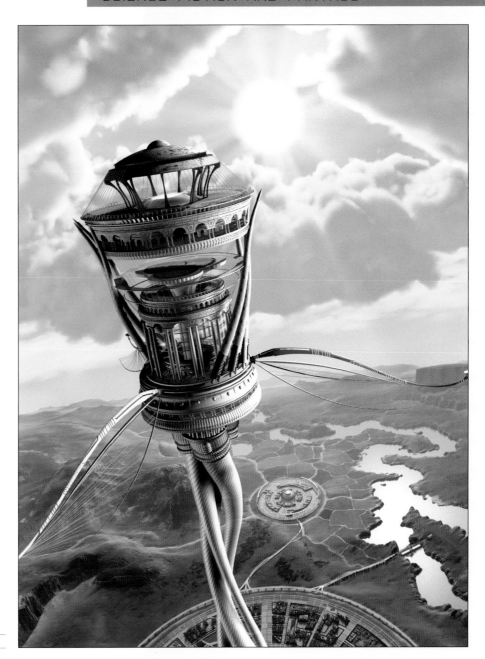

TITLE	Sky Tower
ARTIST	Peter Syomka
COUNTRY	Ukraine
SOFTWARE	3D Studio Max

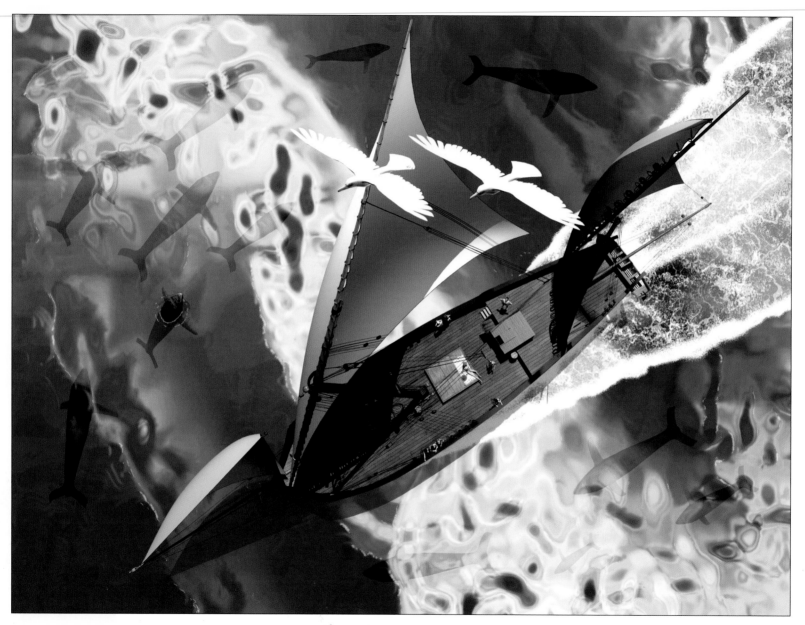

TITLE	Communion
ARTIST	William Watson de Barros
COUNTRY	Brazil
SOFTWARE	Bryce, Poser, Photoshop

TITLE	Sunset in Kerala
ARTIST	Miguel Miraldo
COUNTRY	Portugal
SOFTWARE	3D Studio Max, Photoshop

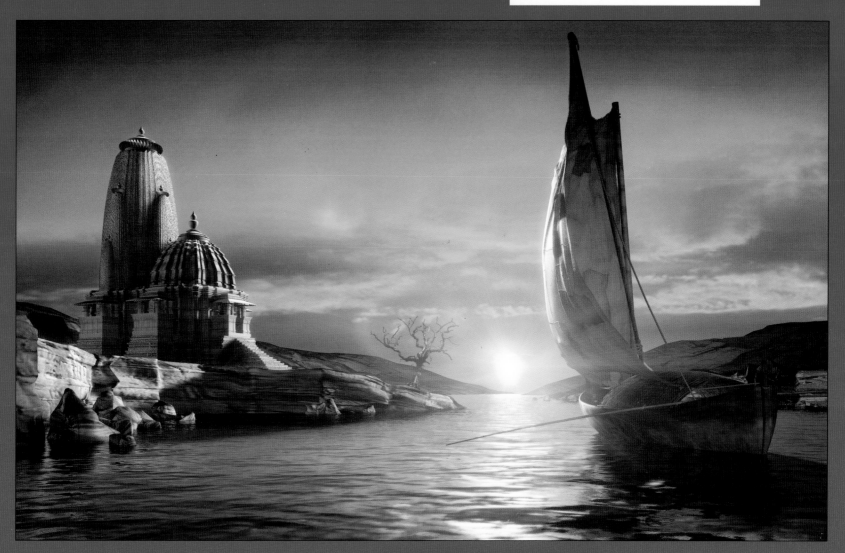

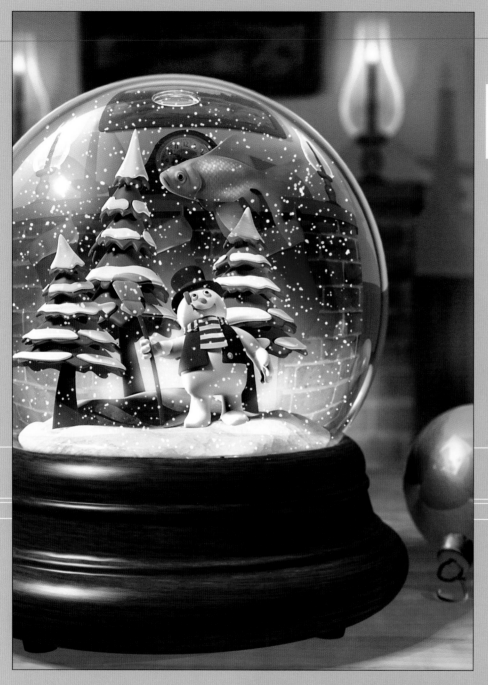

TITLE	Snow Globe
ARTIST	James Darknell
COMPANY	Mutant-Pixel Digital Labs
COUNTRY	United States
SOFTWARE	LightWave 3D, Photoshop

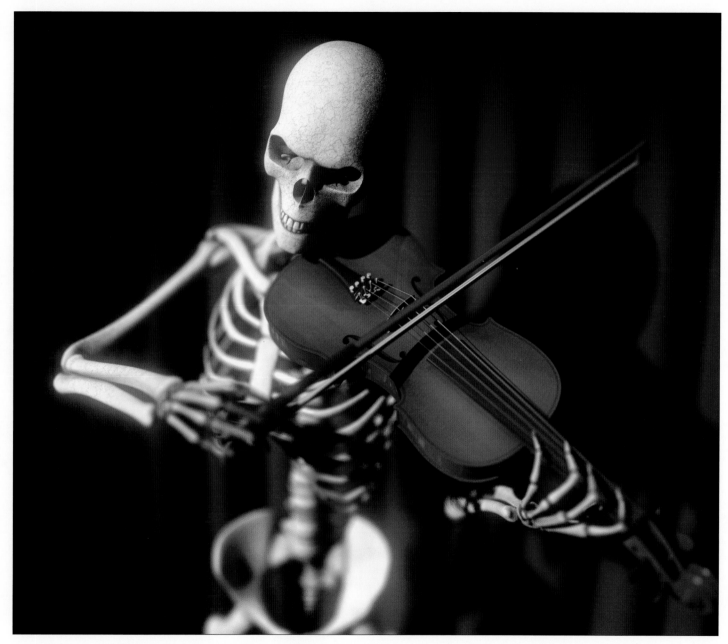

TITLE	Skeleton Playing a Violin
ARTIST	James Darknell
COMPANY	Mutant-Pixel Digital Labs
COUNTRY	United States
SOFTWARE	LightWave 3D, Photoshop, Poser

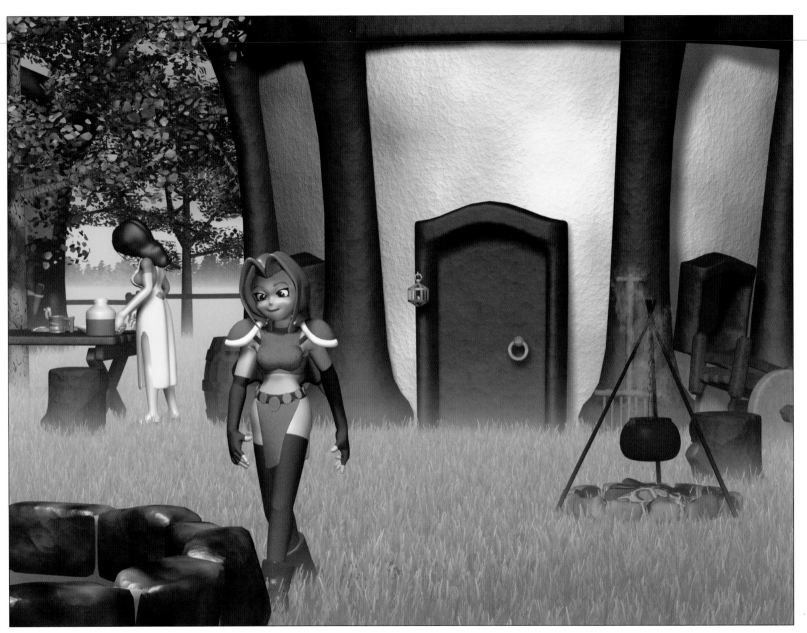

TITLE	Hut at Dawn
ARTIST	Derek Hughes
COMPANY	epic software group, inc.
COUNTRY	United States
SOFTWARE	LightWave, Photoshop

TITLE	Celcius
ARTIST	Justin Owens
COMPANY	www.bluebionics.com
COUNTRY	United States
SOFTWARE	Maya, Photoshop

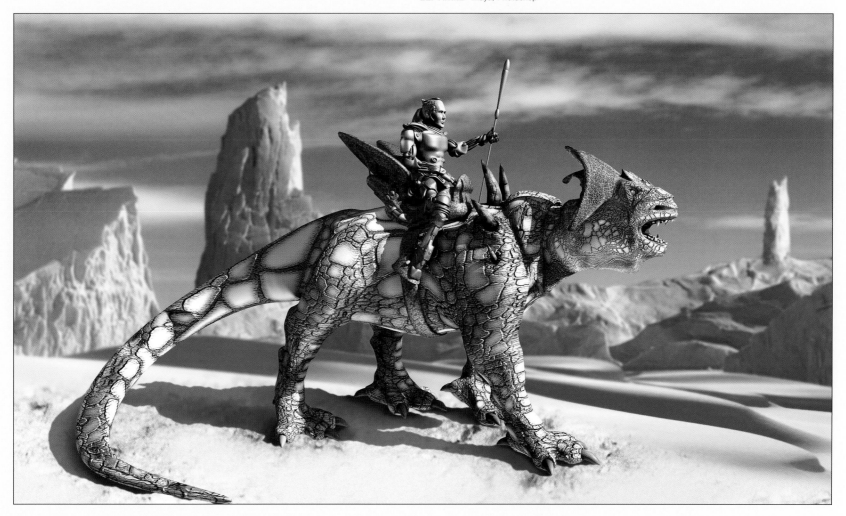

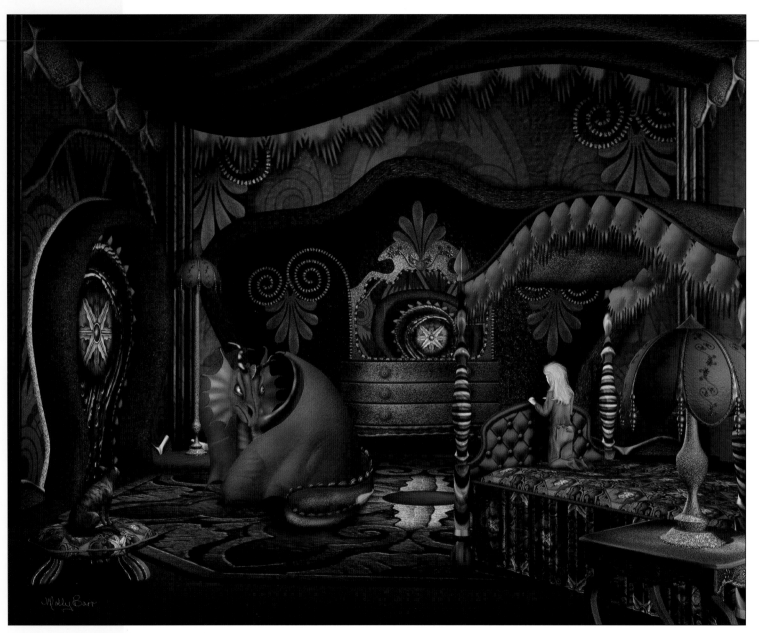

TITLE	Night Visitor
ARTIST	Molly Barr
COMPANY	Dragon Tree
COUNTRY	United States
SOFTWARE	3D Studio Max, Poser, Photoshop

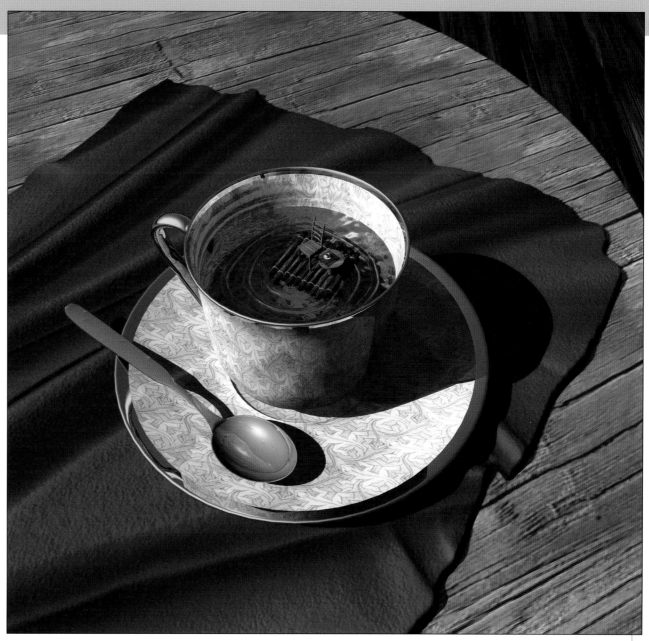

TITLE	Infinitea
ARTIST	Cynthia Frederick
COUNTRY	United States
SOFTWARE	Bryce, Photoshop

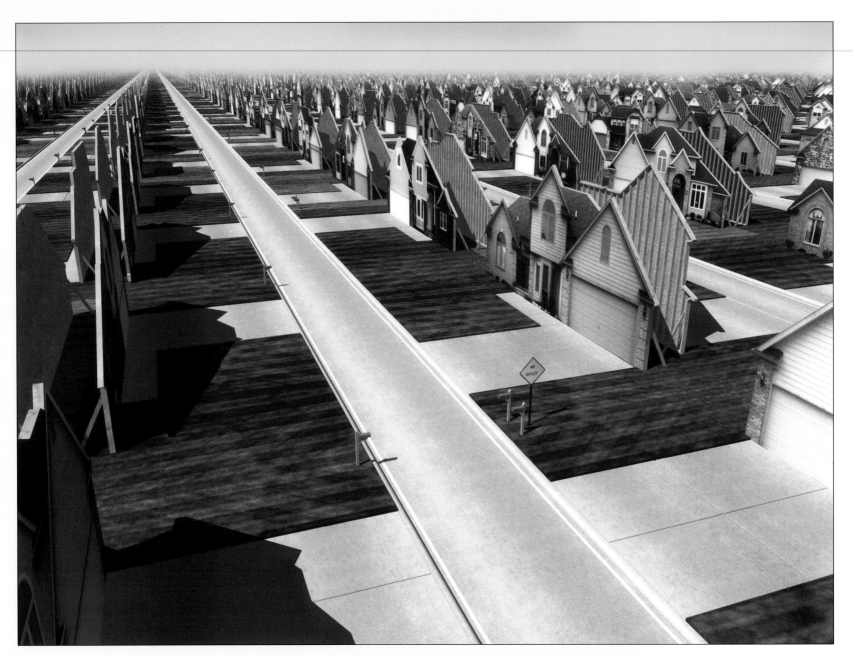

TITLE	Suburbia
ARTIST	Brent Holly
COUNTRY	United States
SOFTWARE	FormZ, Renderzone, Photoshop

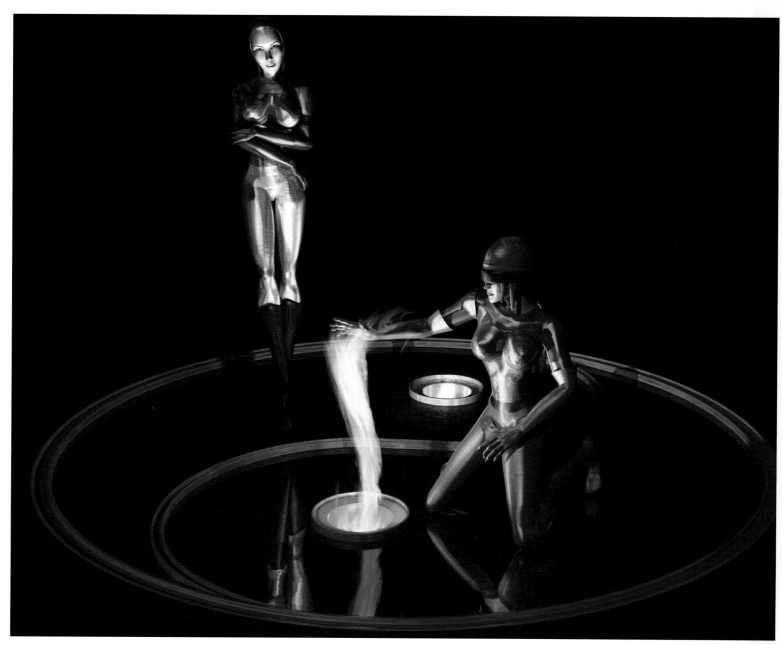

TITLE	Fire and Ice
ARTIST	Reed Kindt
COMPANY	Spectral Custom Art & Graphic Design
COUNTRY	Canada
SOFTWARE	Animation: Master, Photoshop

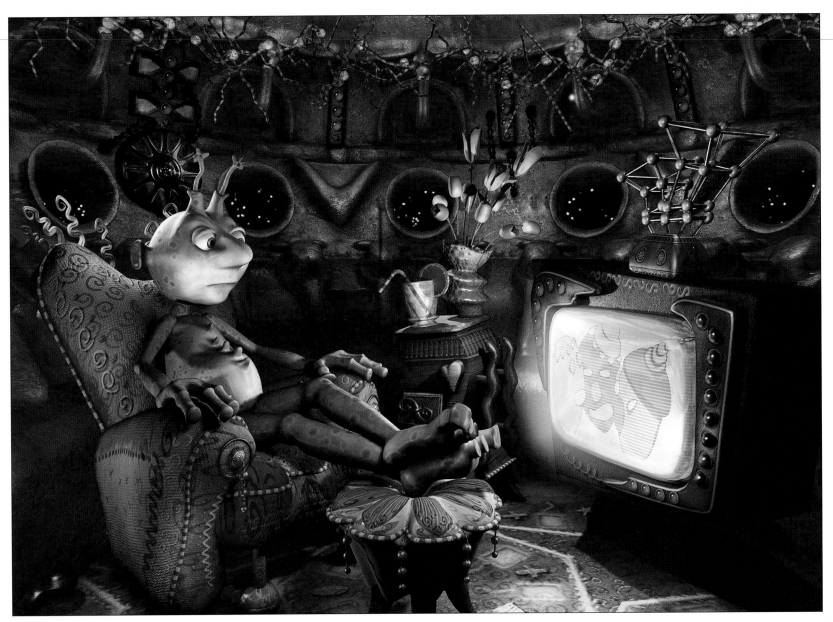

TITLE	Resident Alien
ARTIST	Eni Oken
COUNTRY	United States
SOFTWARE	3D Studio Max, Painter, Photoshop, Nendo

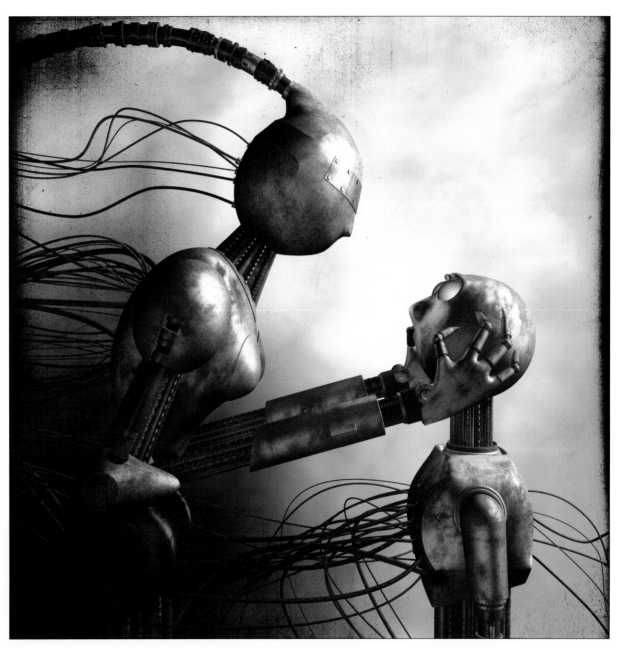

TITLE	Dark Seduction
ARTIST	Neil Blevins
COUNTRY	United States
SOFTWARE	3D Studio Max, Photoshop

TITLE	The Summons
ARTIST	Ali Ries
COMPANY	Casperium Graphics
COUNTRY	United States
SOFTWARE	Bryce, Poser, Picture Publisher, PhotoImpact

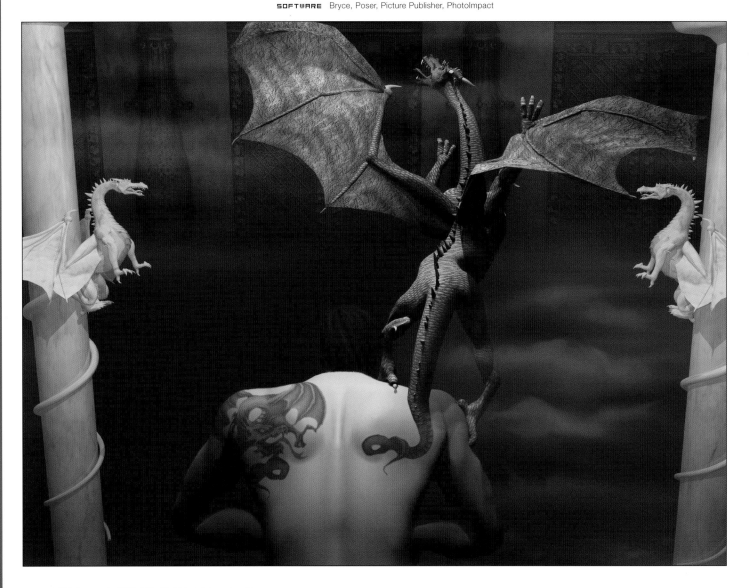

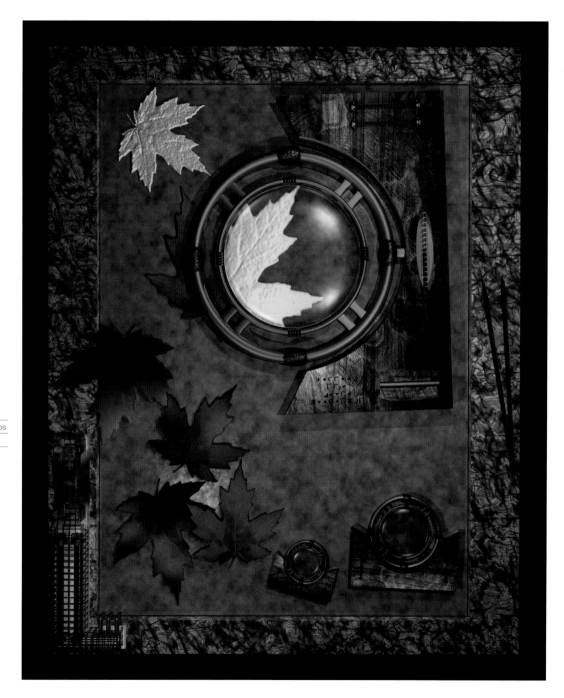

TITLE	Alchemy
ARTIST	William Watson de Barros
COUNTRY	Brazil
SOFTWARE	Bryce, Photoshop

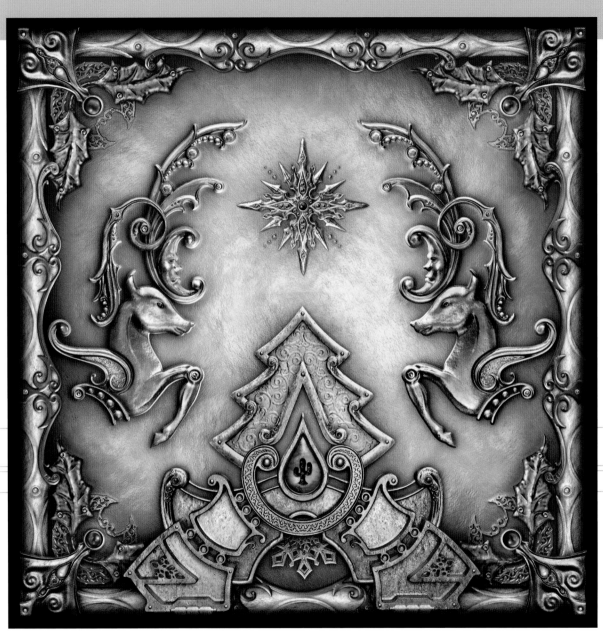

TITLE	A Teardrop of Light on the Twenty-Fourth Night
ARTIST	Mark Gedrich
COUNTRY	United States
SOFTWARE	Bryce, Photoshop

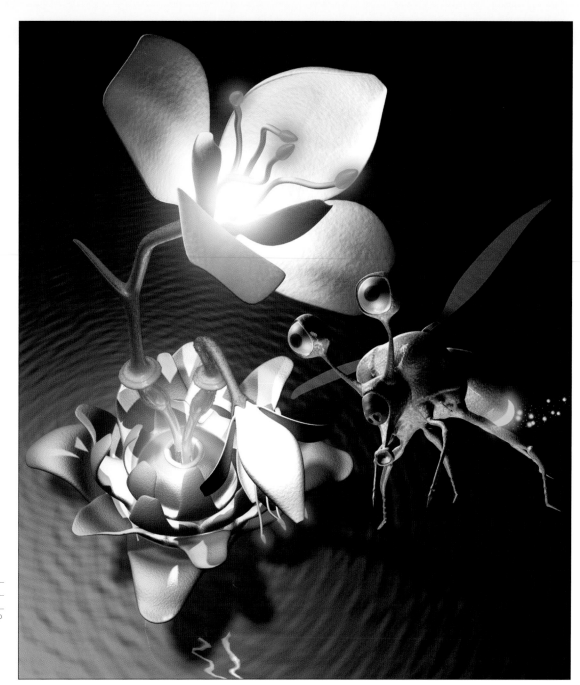

TITLE Splashing Lampyris
ARTIST Gabriele Fabbri
COUNTRY Italy
SOFTWARE 3D Studio Max, Photoshop

TITLE	Xulu City 1
ARTIST	Eric Hanson
COMPANY	Digital Fiction
COUNTRY	United States
SOFTWARE	Maya

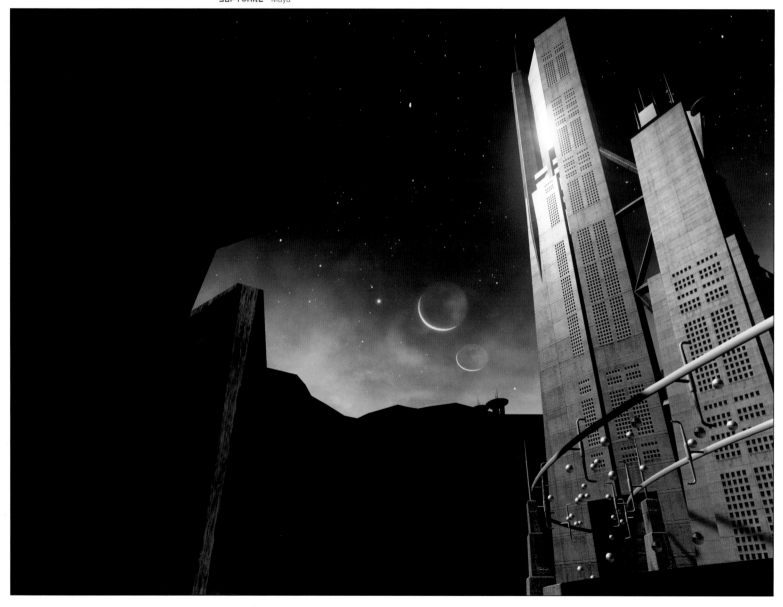

TITLE	Hatred 4
ARTIST	Neil Blevins
COUNTRY	United States
SOFTWARE	3D Studio Max, Digital Fusion, Photoshop

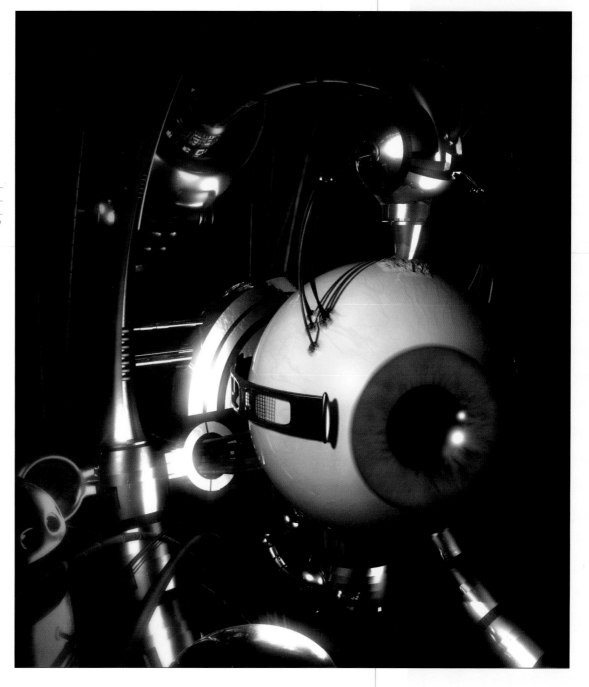

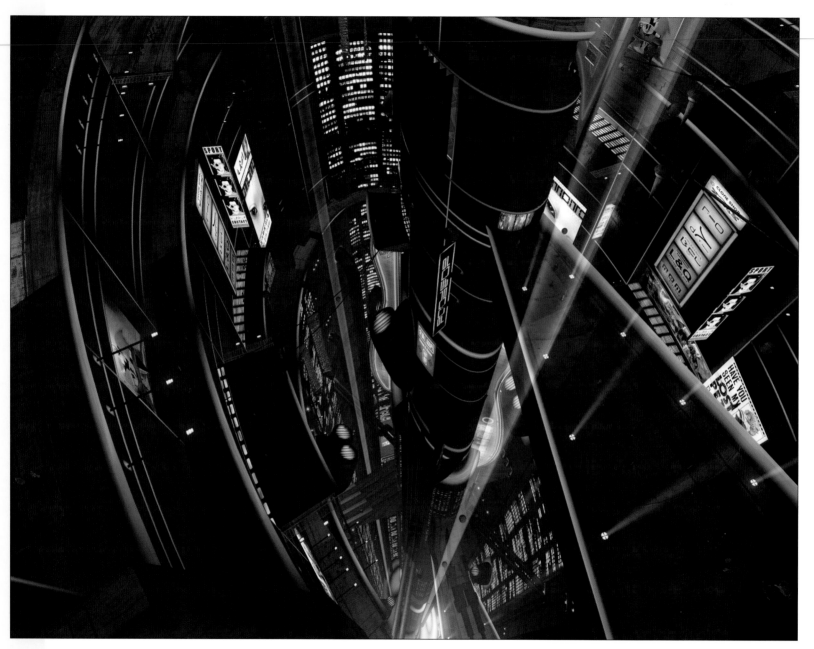

TITLE	Xulu City 3
ARTIST	Eric Hanson
COMPANY	Digital Fiction
COUNTRY	United States
SOFTWARE	Maya

TITLE Passage to Salvador
ARTIST William Watson de Barros
COUNTRY Brazil
SOFTWARE Bryce, Photoshop

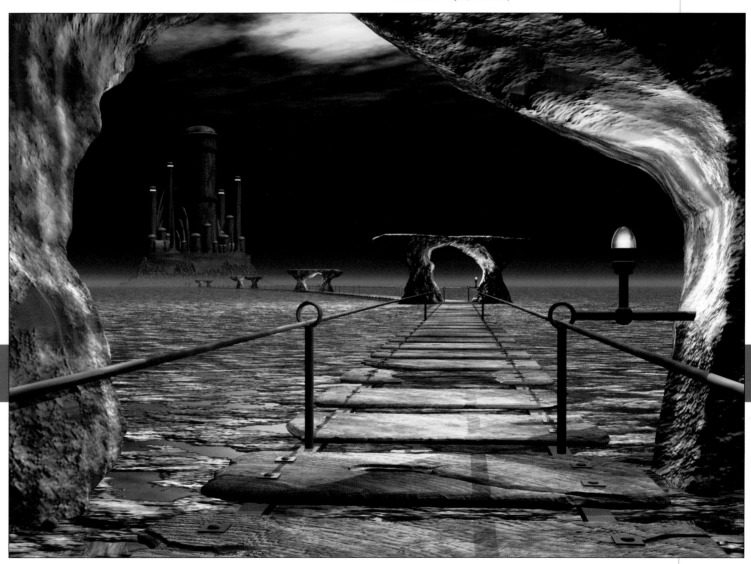

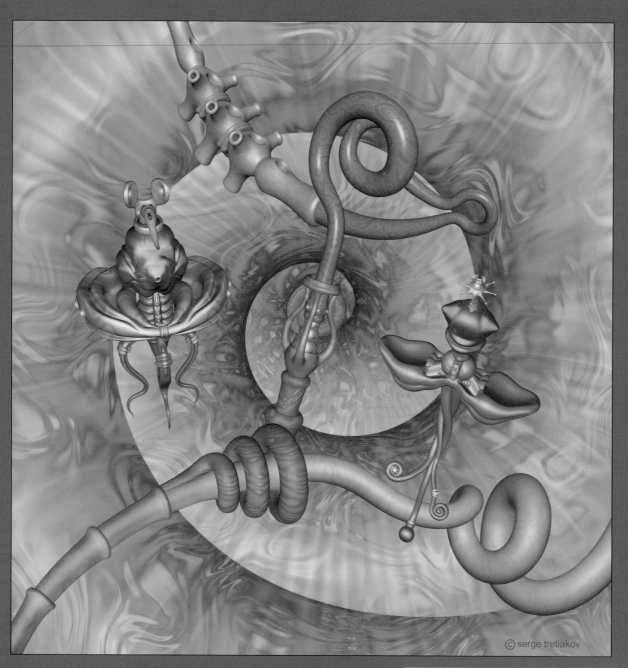

© serge tretiakov

TITLE	Undines
ARTIST	Serge Tretiakov
COUNTRY	United States
SOFTWARE	3D Studio Max, Photoshop

"Through art we express our conception of what nature is not."

Pablo Picasso (1881-1973)

TITLE	Jellyfish
ARTIST	Meg McWhinney
COUNTRY	United States
SOFTWARE	LightWave, Photoshop, Illustrator

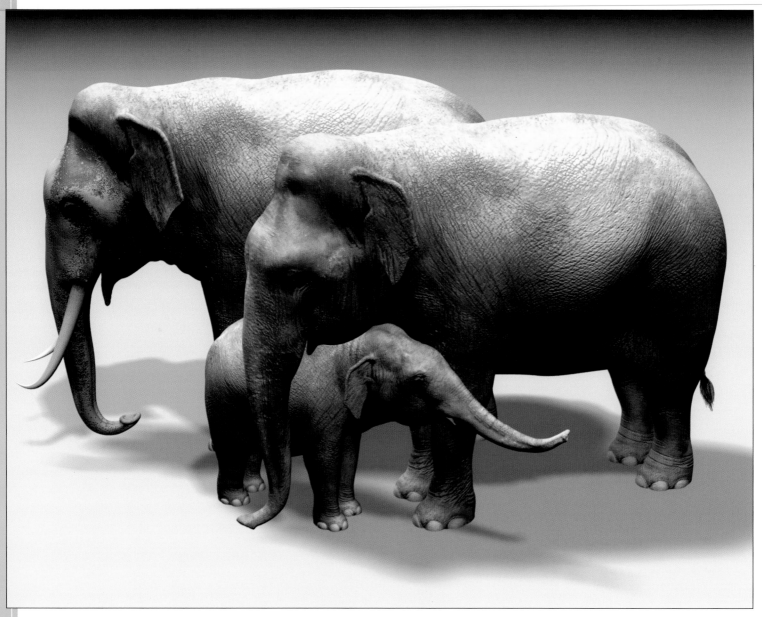

TITLE	Asian Mainland Elephant Family
ARTISTS	Matt, Ann, and Jessi Poitra
COMPANY	Poitra Visual Communications, LLC
COUNTRY	United States
SOFTWARE	3D Studio Max, Clay Studio Pro, Bones Pro, Photoshop

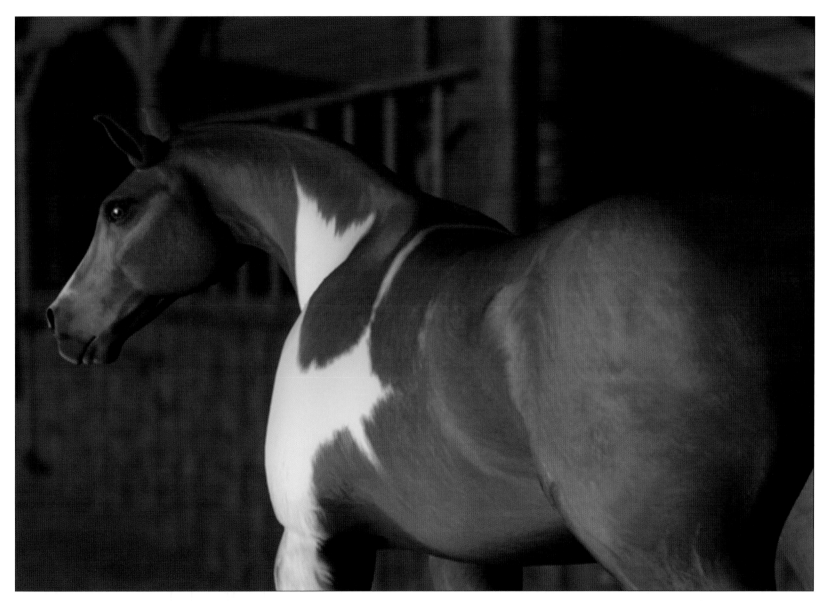

TITLE	Horse
ARTIST	Rosina Killian
COUNTRY	United States
SOFTWARE	Maya, Photoshop, Shake

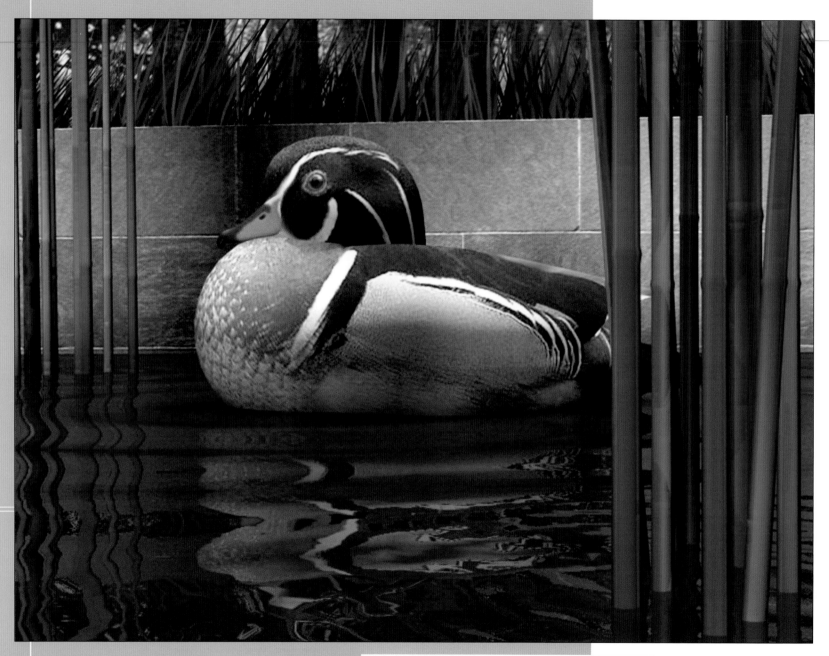

TITLE	Life in the Park
ARTIST	Alexis Francou
COUNTRY	Mexico
SOFTWARE	3D Studio Max, ExpertCAD 3D, Photo Studio

TITLE	Beetle
ARTIST	James Abraham
COMPANY	Optigon Studios
COUNTRY	United States
SOFTWARE	3D Studio Max, Photoshop

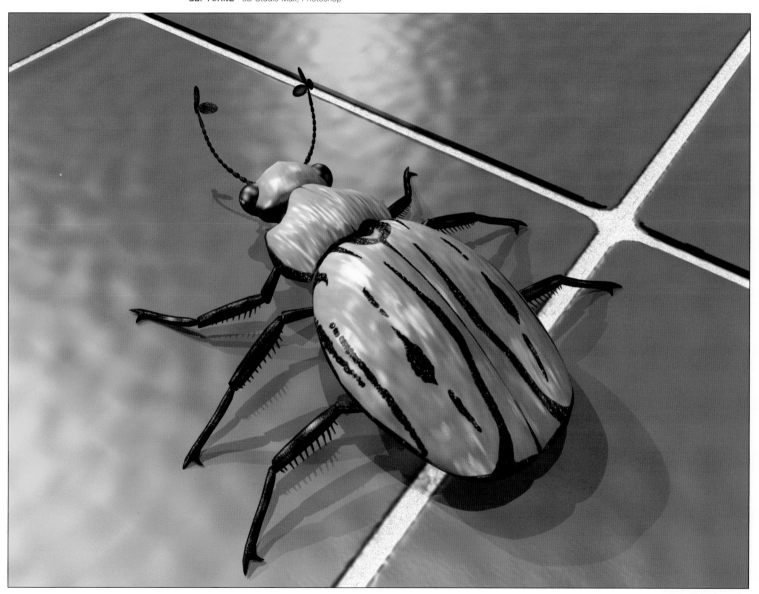

TITLE	Inconsolable
ARTIST	Stephen Hilyard
COUNTRY	United States
SOFTWARE	Bryce, Rhino 3D, Inspire 3D, Media 100

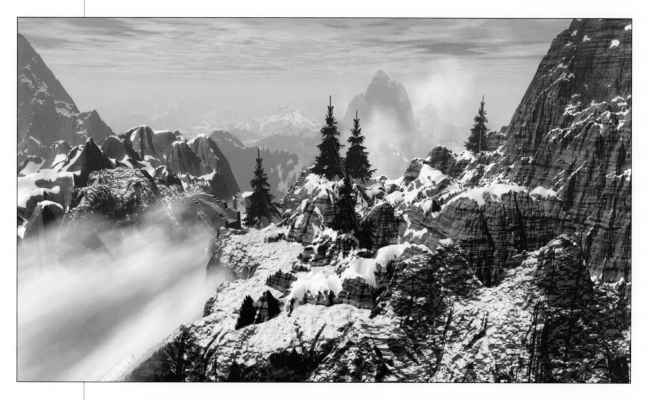

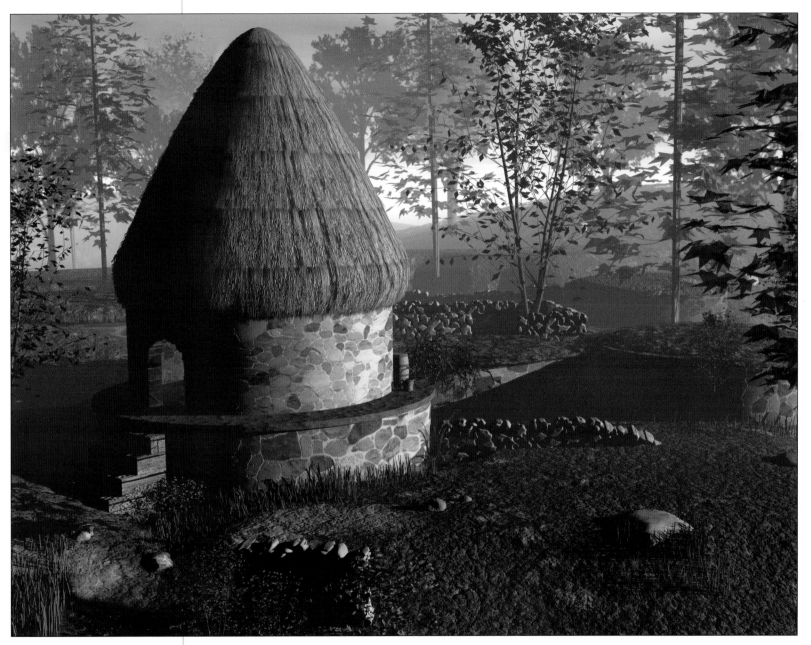

TITLE	Sanctuary
ARTIST	Cynthia Frederick
COUNTRY	United States
SOFTWARE	Bryce

TITLE Strangalia Maculata

ARTIST Marco Giubelli

COUNTRY Italy

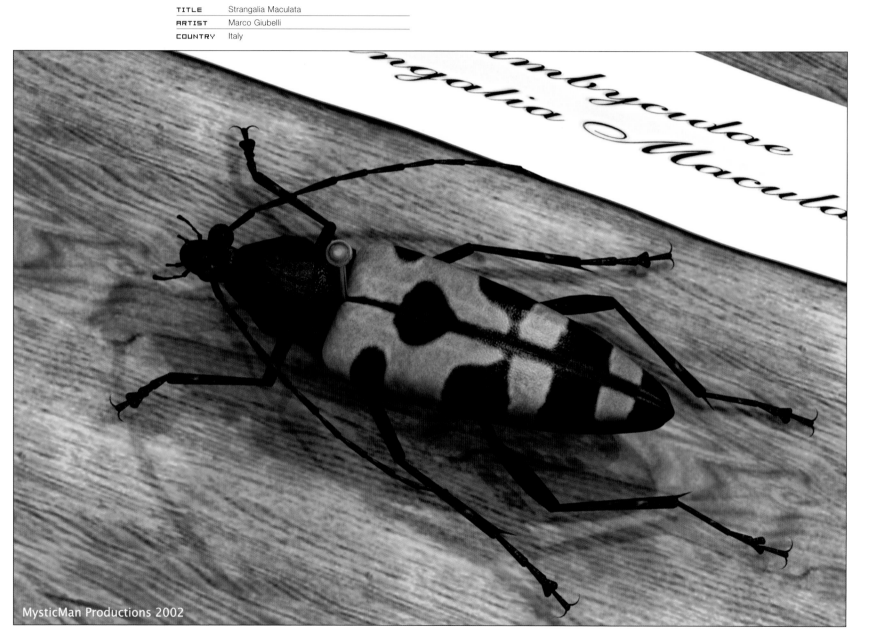

MysticMan Productions 2002

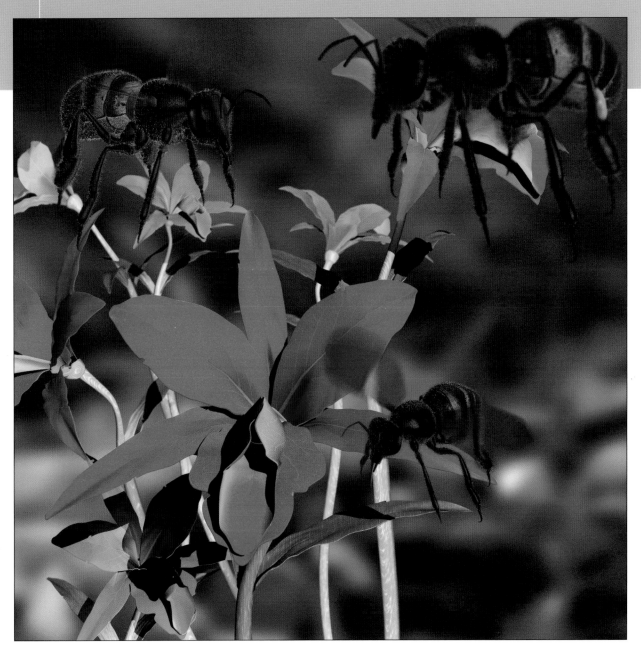

TITLE	Bees
ARTIST	Reed Kindt
COMPANY	Spectral Custom Art & Graphic Design
COUNTRY	Canada
SOFTWARE	Animation: Master, Photoshop

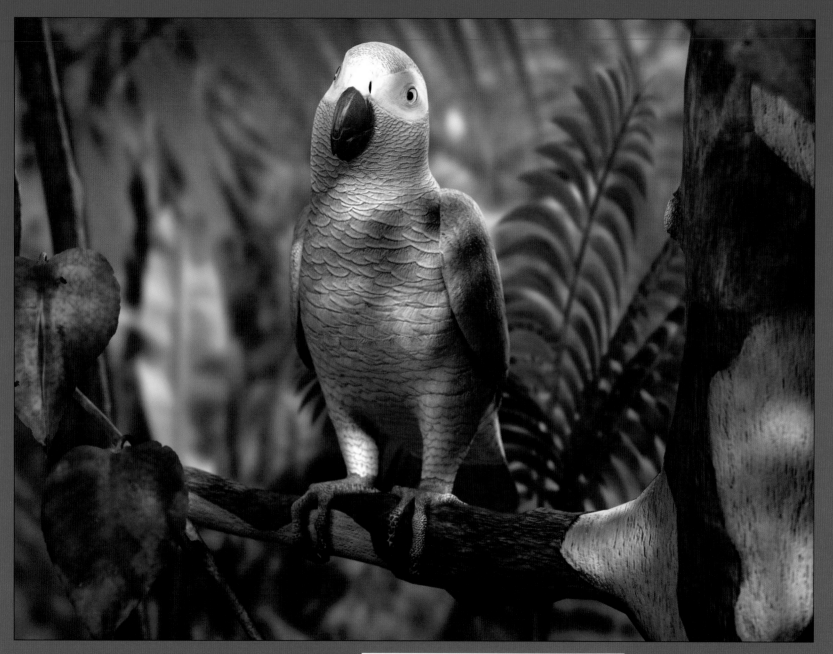

TITLE	African Grey in the Rainforest
ARTIST	Kim Oravecz
COUNTRY	United States
SOFTWARE	LightWave, Photoshop, Deep Paint

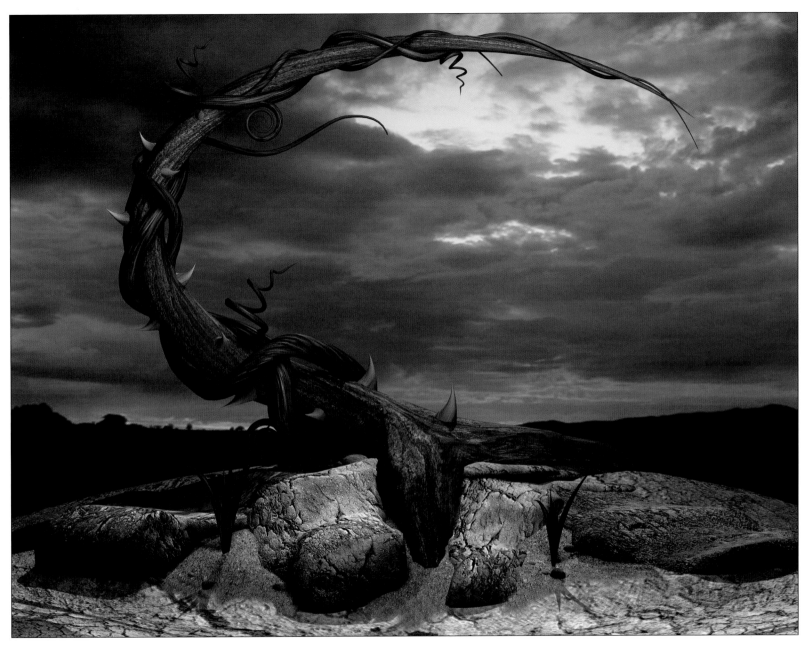

TITLE	The Tree
ARTIST	Shane Simon
COMPANY	3D Concepts.com
COUNTRY	United States
SOFTWARE	3D Studio Max, Photo Paint, Photoshop

TITLE	Soleil Rouge
ARTIST	Danielle Theoret
COUNTRY	United States
SOFTWARE	Bryce

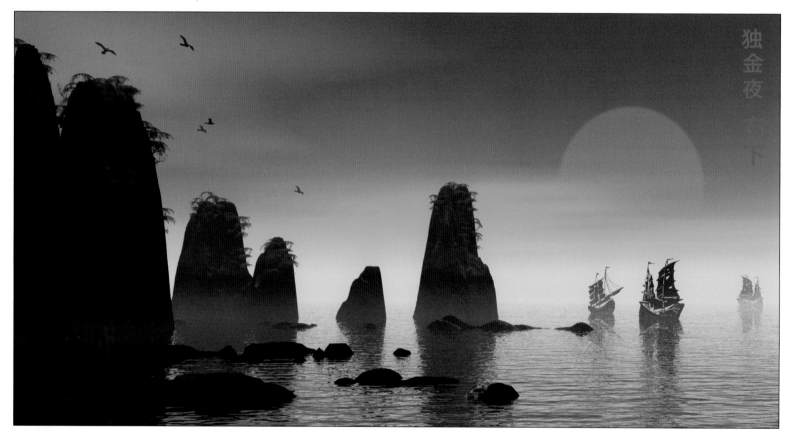

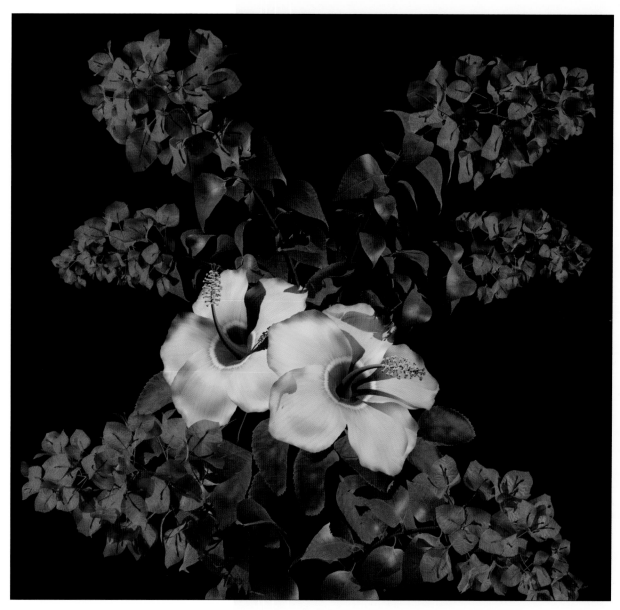

TITLE	Hibiscus and Bougainvillea
ARTIST	Frank Vitale
COUNTRY	United States
SOFTWARE	3D Studio Max, Photoshop

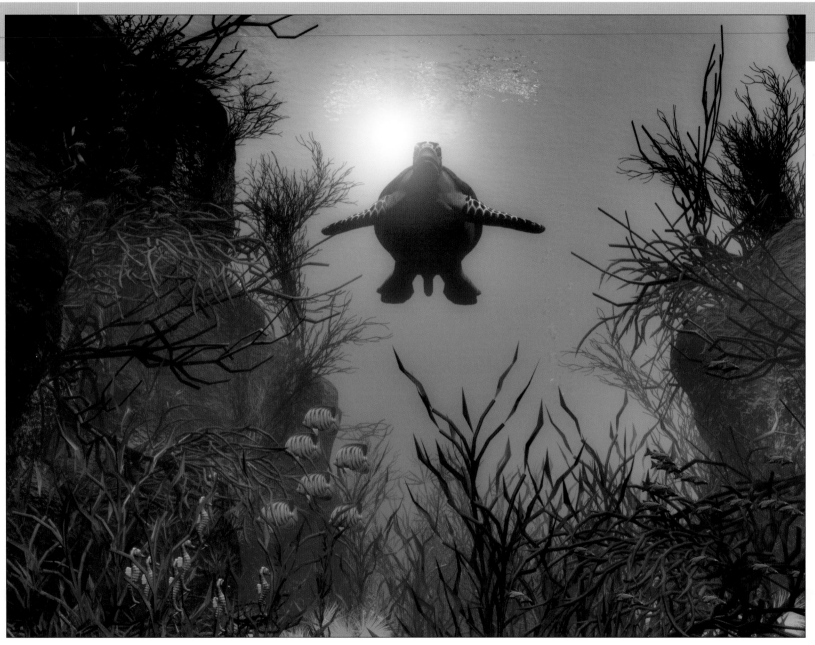

TITLE	Coral Reef
ARTIST	Isaura Simon
COUNTRY	United States
SOFTWARE	Poser, Bryce

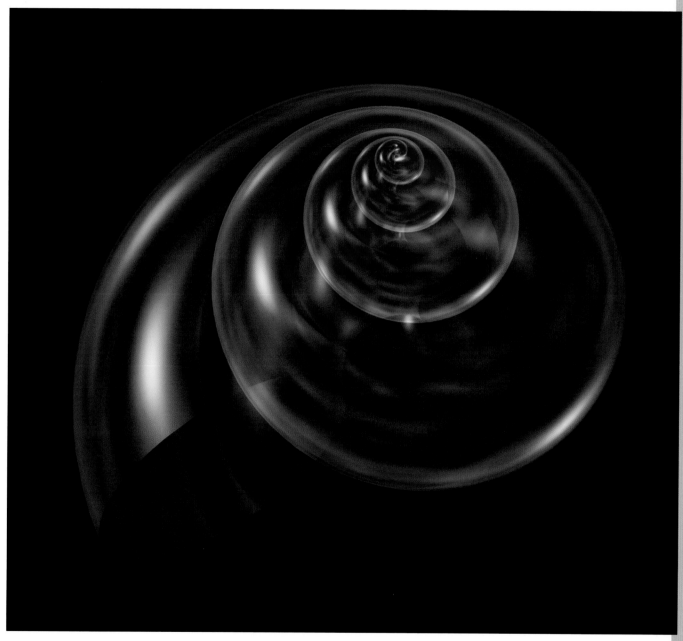

TITLE Perfecto Spira—Tapestry Turban I

ARTISTS Kamon Jirapong and Robert J. Krawczyk

COUNTRY United States

SOFTWARE AutoCAD, AutoLISP, 3D Studio Max

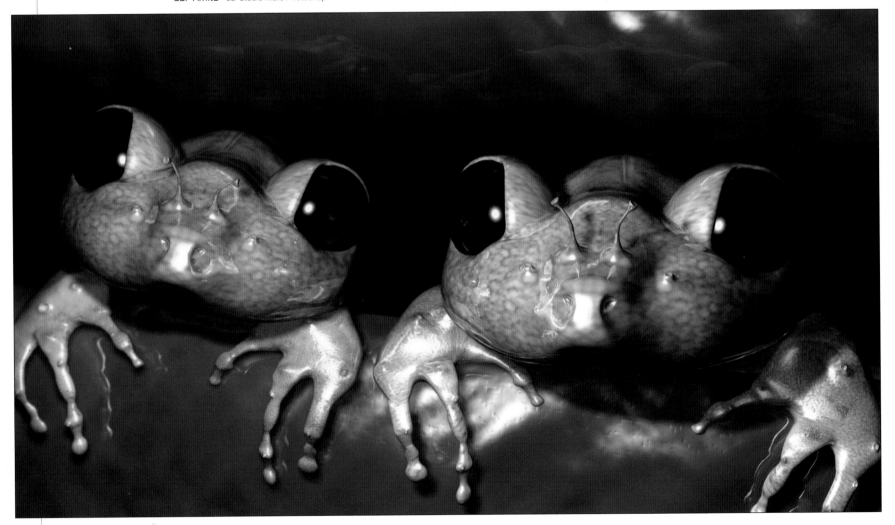

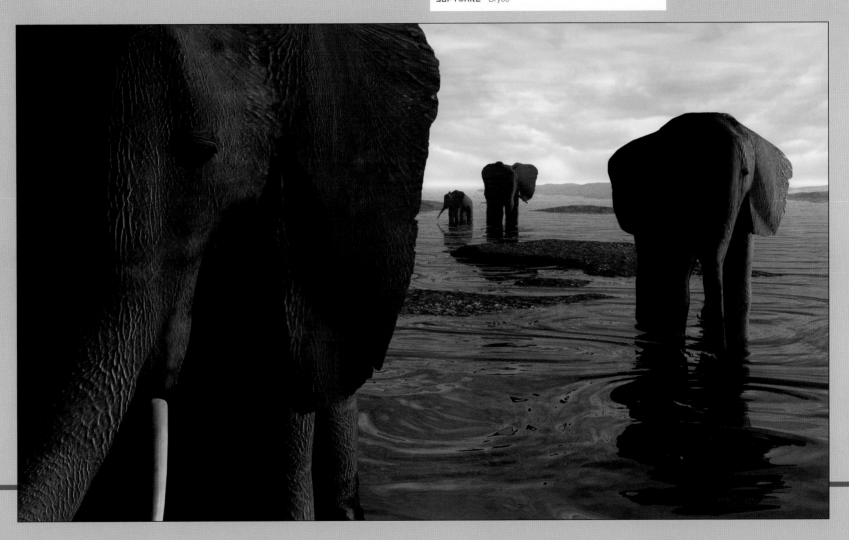

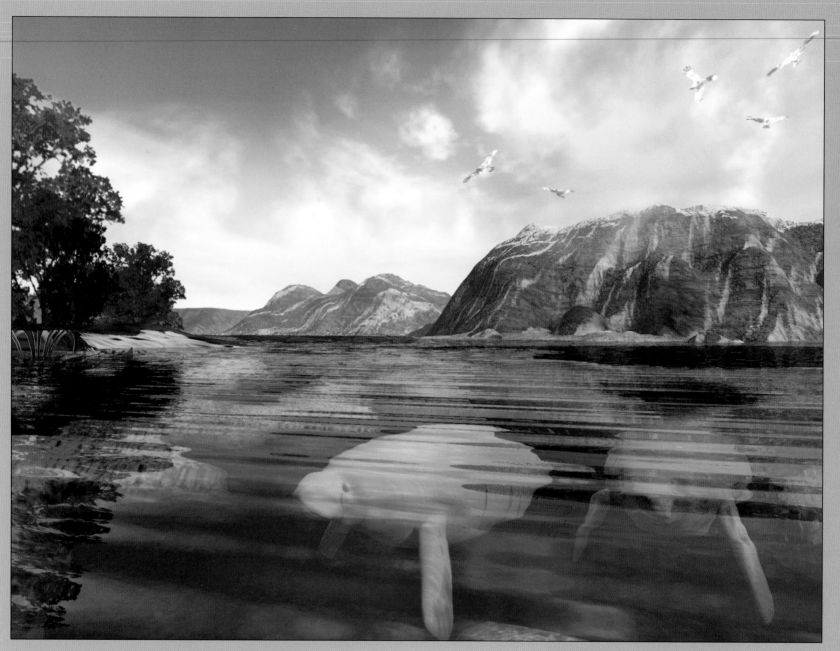

TITLE	Sea Life
ARTIST	Danielle Theoret
COUNTRY	Canada
SOFTWARE	Bryce

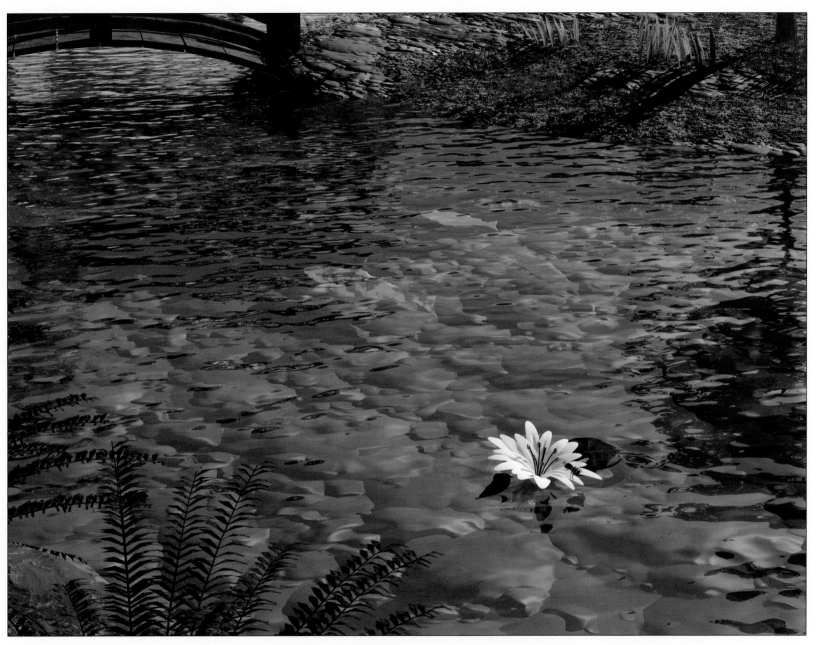

TITLE	Pond
ARTIST	Cynthia Frederick
COUNTRY	United States
SOFTWARE	Bryce

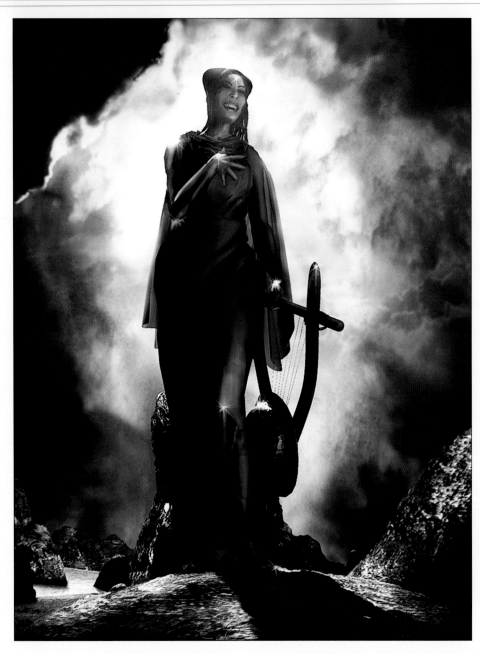

"Art does not
reproduce the visible;
rather, it makes visible."

Paul Klee (1879-1940)

TITLE	Sappho at the Whark Rocks
ARTIST	Jeremy A. Engleman
COUNTRY	United States
SOFTWARE	Softimage 3D

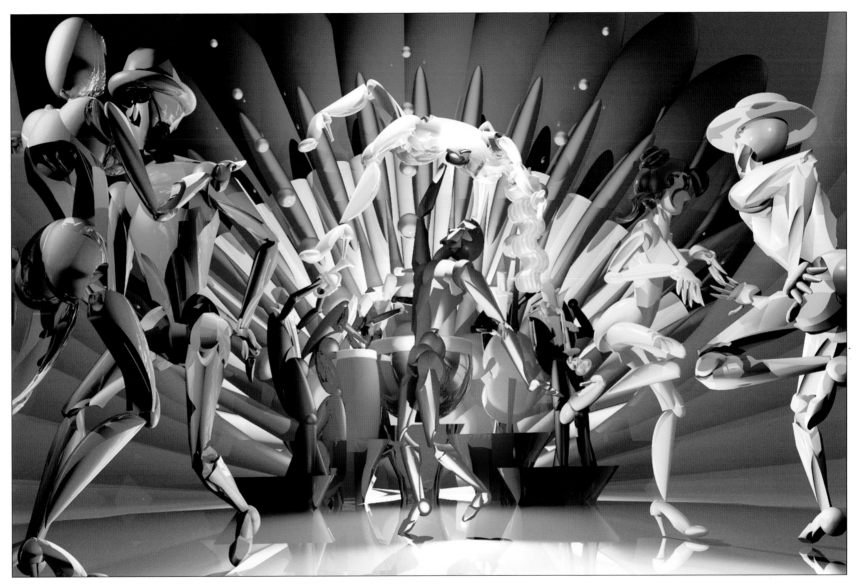

TITLE	The Dance of Colors
ARTIST	Avijit Das
COMPANY	Industrial Hieroglyphics
COUNTRY	India
SOFTWARE	Bryce

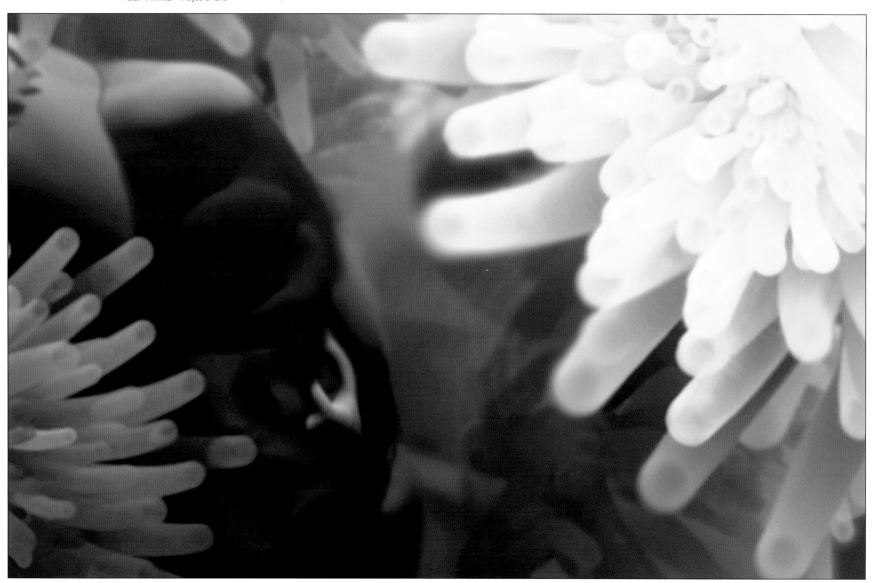

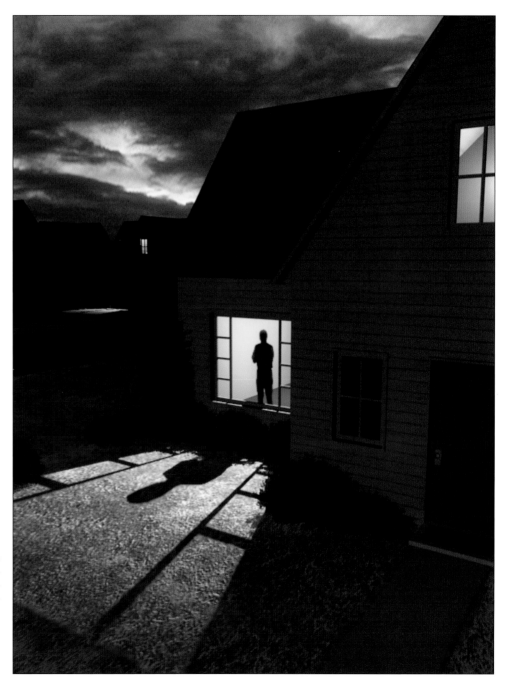

TITLE	Home Alone
ARTIST	Leonard Koscianski
COMPANY	Leonard Koscianski Fine Art
COUNTRY	United States
SOFTWARE	3D Studio Max, Photoshop

CONCEPT TO CREATION

"Art is only a means to life, to the life more abundant.
It is not in itself the life more abundant. It merely
points the way, something which is overlooked not
only by the public, but very often by the artist himself.
In becoming an end it defeats itself."

Henry Miller (1891-1980)

This image, the Biker Girl, will always have a special meaning for me. It's only the second finished 3D piece I ever did, and it's always been a popular favorite. There's just so much great CG art being produced now that this image is quickly becoming dated. Even so, it works well as a typical example of my workflow.

IDEA

It was 1996 or maybe early 1997—I was living in Hong Kong, working at a small 3D studio on Hong Kong Island. It started with an idea on the ferry home to Lantau Island; bang—it was love at first thought. I sketched it quickly on a piece of paper I kept around for just such an emergency. I thought, if you could take away the front wheel of a motor bike, what would be the most aerodynamic position for the rider?

I named the vehicle Monobike, and imagined it working with some kind of magnetic levitation, or artificial gravity. In this image, it's running on the outside of a tube several miles long, suspended in midair. (If you're wondering what the upside down text at the bottom is, it's just some quotes from Woody Allen I wanted to remember.)

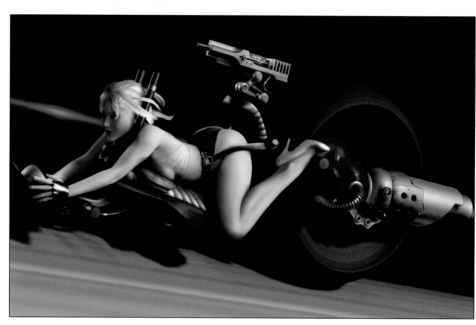

MODELING

At this time, I already had a virtual character that I could use, so I posed that into position. I'd already worked on that virtual character for over a year, I won't go into that whole process now. Legs, arms, torso, head, hands, are all separate pieces. Back then, you had to do it that way, if you wanted to use nurbs. This was before Maya, I was using Alias Power Animator, which basically only had one option to do stuff like this: nurbs, B-splines.

After posing, I deleted the skeleton, "freezing" the geometry in place, so I could continue to sculpt it. Then I painted a T-shirt texture, and some shorts, and projected these onto her body, a side planar projection for the T-shirt, and a top projection for the shorts. Piece by piece, following my sketch and some motorbike reference photos, I modeled the bike, also with nurbs—only on one side at first, later mirroring it. Most of the hair was done using the simple but efficient texture-mapped plane method (a relatively simple shape, with a relatively complex texture map, including transparency mapping). You can see some of the hair geometry here, but one big piece is missing, the piece used to create the bangs over the forehead—this was hidden here so you could better see her face.

CONCEPT TO CREATION

LIGHTING AND SHADING

If you're tracking a fast-moving object, by either traversing your eyes or camera or traveling next to it, the background and ground gets all the motion blur, which is why I textured these so streaky. She's a speed freak.

I imagined this to be some sort of commercially available vehicle, so I gave it a nice shiny paint job. The key spot is from the right, fairly horizontal, another weaker bluish spot opposing it, and an ambient light somewhere, I think it's on camera level, either left or right... the original lighting and shading of this file is lost to me now, only the geometry remains.

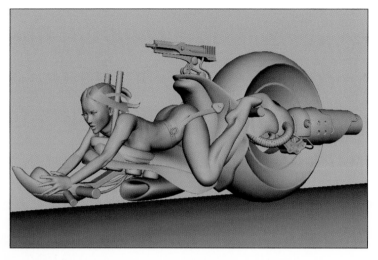

UNSOLVED PROBLEMS

As I mentioned, this image is among my earliest work, so now I see many flaws I didn't see at first. The high heels really don't work in this context, but at the time it was the only kind of shoe I had. The head and the feet and hands are a bit too big, and the lower legs are a bit too long. The bike itself is very simple, and lacks a lot of detail present on a real motorbike. So, recently I decided to refurbish the bike... and to the left is the result.

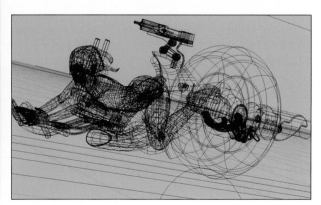

The image is a still frame from a three-minute animated short called *Frankenbaby*. It was based on a thirty-second piece we created several years ago for a contest held by Discreet Logic featuring the *Dancing Baby*. When the thirty-second film was done, we felt the story held much more potential, so we decided to expand it and put it to celluloid. Our main 3D software used for the project was 3D Studio Max with Character Studio. We also used Photoshop and Deep Paint 3D for texturing the characters and environments.

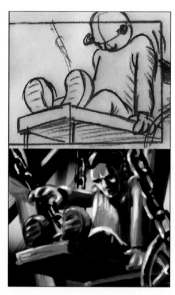

PLANNING AND RESEARCH

We decided that the visual style of our film would be a mixture of early expressionistic silent movies with the classic Universal style Frankenstein monster. We researched all the early German horror classics, as well as the James Whale Frankenstein films for their approach to props and architecture. In addition to these sources, our work was heavily influence by the Italian architect Piranesi along with more recent Frankenstein illustrations created by the American artist Berni Wrightson.

Having fully developed the story, we created storyboards and sketches, as very rough pencil sketches. Later, more elaborate Photoshop paintings were created to depict mood and lighting.

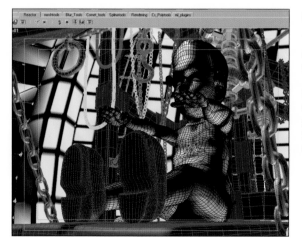

DESIGNING THE MODELS

The monster model was based on the original Dancing Baby that comes with 3D Studio Max. We remodeled most of it and created a completely new head that was supposed to look like an infant version of Boris Karloff.

For the backgrounds, we created a library of wooden beams and metal pieces to connect them in varying angles. Nails, chains, and hooks were distributed among lots of machinery and laboratory equipment. A high level of detail was needed since the final output to film was around 2,000 pixels wide. The full model of the laboratory including walls etc. was made up of almost one million polygons.

MODELING AND TEXTURING THE 3D OBJECTS

Most models were created using a method called boxmodeling, meaning you start with a very simple cube and develop your objects by extruding and moving faces while creating a more complex object. We took special care that all objects were beveled and contained no sharp edges for enhanced realism. Once the objects were created, we applied a tool called Quickdirt to them, this creates an initial layer of dirt and bakes it into the objects vertex colors. Some simple objects like the beams or metal parts connecting them were mapped using traditional mapping projections. The more organically shaped objects like the characters were unwrapped and painted on in Photoshop and Deep Paint 3D.

For every surface we created separate maps to control diffuse, bump, and specularity amount. Most of the painted textures were mixed with procedural textures created in a program called DarkTree Textures, a node-based tool that allows the creation of custom procedural shaders.

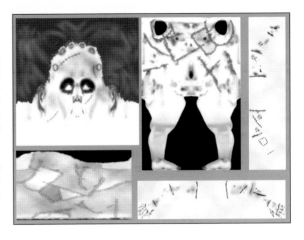

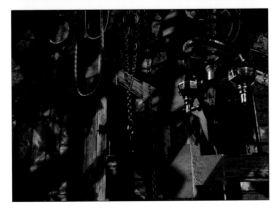

LIGHTING THE SCENE

We used a basic three light setup as a starting point for most of the scenes and for lighting the characters. For the backgrounds, we developed a lighting scheme geared to have a dramatic impact and create an interesting image. This was done on a shot-by-shot basis and the challenge was to give each shot a unique dramatic lighting while still maintaining a certain continuity. Almost all lights were made by using hand painted projector maps. We then added detail and variation to otherwise equally lit areas.

RENDERING THE SCENE

For each of the 4,200 frames in the movie, we had to render separate layers for foreground and background, *z*-depth as well as effects layers for both the atmosphere and lightning flashing. These layers were composited in Shake and Combustion. Next, we did the color corrections, added depth of field and film grain. Finally, we added dust and scratches to convey the appearance of an eighty-year-old movie.

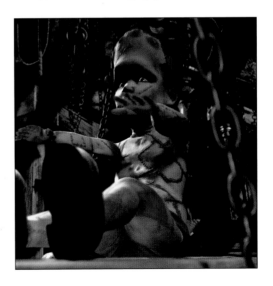

This is a character I had been developing for an animated movie. It had to be in a grotesque style. The character represents a formerly successful musician who now appears to be at the bottom of life. The animation project was suspended and I put the character aside for some time. When I received the entry form for this book, I decided the time was right to compete my work on The Artist.

PLANNING AND RESEARCH

To find an appropriate prototype I've decided to look through a large number of photo references. When I found something I liked, I started drawing the character. This resulted in a large number of sketches, and I had to select one to work from. This happened before the project was canceled. People can be very passionate about a character. Our character-development sessions were always filled with heated discussions along with interesting inventions and discoveries. Here, you can see a sketch of the character we decided on.

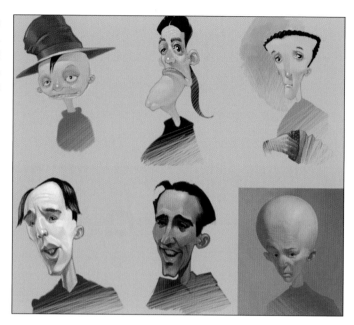

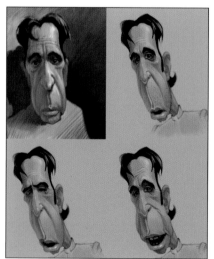

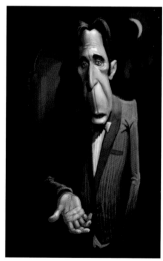

DESIGNING THE MODEL

I used Photoshop and a Wacom tablet for my sketches. It was necessary for the character to have a sad face and evoke pity. At the same time, we wanted the character not to be too offensive, but to evoke emotion. The face is asymmetric, deeply wrinkled and easy to remember. I took into account that it would eventually be transferred into 3D and animated. In spite of a caricature style this character called for a very distinct look which was part of the process right from our early sketches. For this book, I did a composition with character in night environment and I titled it The Artist. Here you can see preliminary Photoshop drafts.

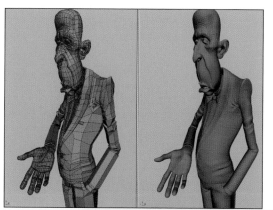

MODELING AND TEXTURING THE 3D OBJECTS

I started modeling based on the sketch. I used Maya with a split polygon tool. This tool makes modeling very easy—I just work polygon by polygon until I have something I am satisfied with. The part of the background—the building next to the character, also was created in Maya. The far background plane is a drawing made in Photoshop. For texturing, I used UV mapping for all the objects. The process of modeling and mapping took eleven days. I used a number of free textures and image references from the Internet at this stage. I also created a set of the reference textures in Photoshop. I did many test renderings until I had all the textures finished and adjusted. This took an additional three days.

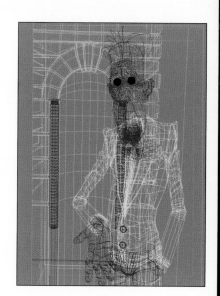

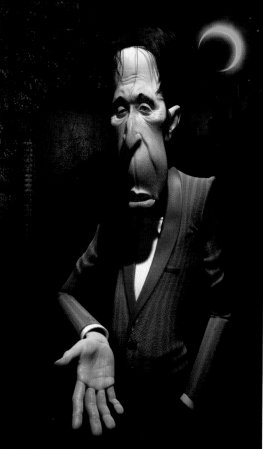

LIGHTING THE SCENE

I used a V-ray renderer and created one base light source for my scene. I worked on adjusting it for some time until all the shadow shapes were consistent with the original. There was an exclusive light source for hair that served to smooth the hair shading. I did not simply want to mimic real physical lighting but hoped to create a spot light effect. The hair was created at the same time using Shag Hair.

RENDERING THE SCENE

The final scene was rendered in 3D Studio Max with V-ray renderer. The scene has 379,000 polygons. Rendering was performed on Athlon 700 MHz with 256MB RAM and took 2.5 hours. After the sketching stage, the project-development time was right at two weeks.

This image was created for the Maxforum's Workshop. The assignment was to create a scene with a cyborg. The workshop covered modeling and texturing. The assignment was to be ready for review in sixty days, which was more than enough to create a good-looking image.

PLANNING AND RESEARCH

The first step was to gather resource materials and make several sketches of the scene. Cyborgs have a long history in sci-fi movies and in most cases they play the role of the bad guy. Following in this tradition, I created a cyborg with a laser gun and placed it inside an environment that looked like the interior of a very old spaceship.

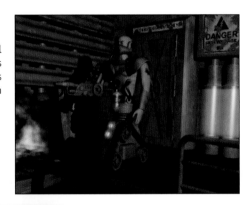

DESIGNING THE MODEL

To create an environment that would resemble the interior of an old spacecraft, it had to have many pipes and structural beams, like the interior of a factory or a power plant. Obviously that required a lot of metal with signs of wear and tear and oxide everywhere. To enhance the mood of the scene, I added some smoke and glowing lights along with a "danger" sign.

I wanted the cyborg to look like a soldier or a guard. A photo of a soldier riding on top of a tank gave me the idea of giving the cyborg a tanklike vehicle instead of mechanical legs. The inspiration for other elements of the cyborg came in part from Roman gladiators and jet pilots.

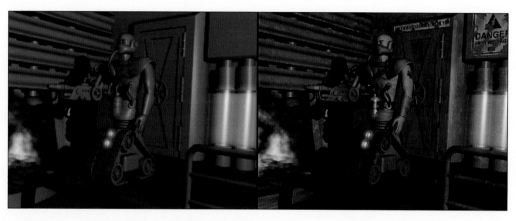

MODELING AND TEXTURING THE 3D OBJECTS

Although the environment may look complex, it is actually really simple. Most of the objects are cylinders and boxes, which helped to keep the face count as low as possible. For texturing the environment I used the box modeling technique for the cyborg's human body, mask, and armor. The rest of the model used primitive geometry. I split the model into parts then applied a planar or cylindrical UVW map to each of the objects.

LIGHTING THE SCENE

The mood of the scene would be further enhanced by using a single omni light. It was gray colored with ray-traced shadows to create an indoor fluorescent light feel. The rest of the lighting was simulated using glow effects and ambient lighting was simulated using self-illuminated materials.

RENDERING THE SCENE

The scene was rendered without using a camera, straight from the perspective view of a personal computer.

The picture to the right was a result of the production of the two-minute trailer called *Andor*. It shows the protagonists (from left to right): Andor, Talida, and Godem. The trailer could be an antepast of a longform project and was produced to give an impression of the look for this feature.

The story is set in a time long gone. Dark forces rule the country in which few dare to resist those powers and fight for a free world. Andor, a young peasant, lives in peace far away from the battlefields. But he has to accept his fate: his village has been destroyed and his wife abducted. Andor is not aware of the fact that his wife, Talida, is a mighty sorceress who could bring freedom to the world and, therefore, is a menace to the dark forces. Andor sets out to a long and arduous journey. He travels deserts, ice landscapes, mountains, and valleys.

DESIGNING THE MODEL

The characters have been produced in cooperation with Waldemar Fast, the designer. In the picture below you can see the rough sketches as well as the color templates for the characters.

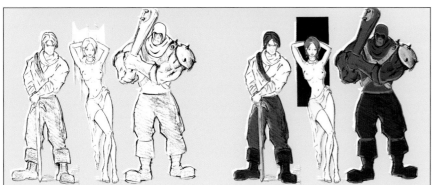

MODELING THE 3D OBJECTS

The characters have been modeled in Maya and consist of a combination of polygon objects and nurbs. All of the faces have been pre-modeled in nurbs to achieve a rough structure and have been converted to polygons afterwards. Then I worked on the face that resulted out of this process. The hair consists of nurbs, planes, and tubes, which are textured with images created in Photoshop.

CONCEPT TO CREATION

TEXTURING THE 3D OBJECTS

The textures are a combination of photos and painted textures. Photoshop is perfect for this task. The face textures are projected cylindrically. Afterwards, I created a reference object in order to keep the texture firmly in place on the face of the character while it is animated.

LIGHTING THE SCENE

At the lighting stage, I tried to create different moods with light. The first picture has been lit with four directional lights. As a result you get a pretty harsh light. The picture next to it has been hit by a dome light (twenty directional lights), which consists of two primary colors. It has a very soft quality.

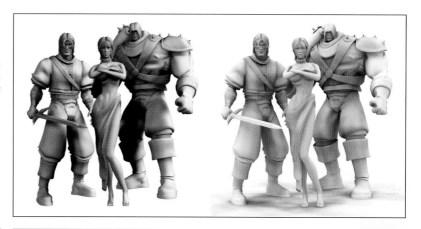

RENDERING THE SCENE

The third picture has been created with a light similar to the dome light except that each light has a different color on it: the colors of the background picture. It is a sort of global illumination fake. This lighting process is a good way to insert characters into their environment more organically. The first picture has been illuminated with a dome light. An Athlon 1,200 rendered it in 1.5 hours at a size of 3,000 x 2,500 pixels. The picture above (with a dome light and light adjustments) was rendered in 1.5 hours.

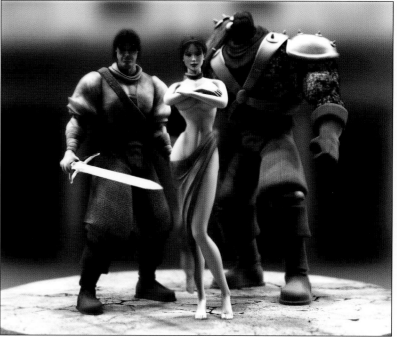

When preproduction began on the award-winning Myst III: Exile, Presto Studios wanted to stay consistent with what Cyan had accomplished with Myst and Riven in regards to the graphics, sound, and gameplay. The original Myst games portrayed worlds that felt surreal and intriguing, but at the same time they seemed somehow familiar. In them, the player would encounter objects that were perhaps medieval, or baroque, or simply juxtaposed in a way that made them impossible to find in our own world. This gave the art department greater flexibility of what an age could be, and was the starting point for the designers of Myst III: Exile.

PLANNING AND RESEARCH

The original idea behind Edanna, one of the six Ages of Exile, was to create an age that depended solely on itself for survival. The age was to contain only organic mechanisms that could be tampered with and controlled by the player to his or her advantage. However, with no manmade structures, this inverted tree was a steady stream of challenges—from the countless, custom organic textures to modeling twisting, intertwining pathways, to creating and solving game-play functionality for fantastic plant life. We started with the simple concept of a tree, and achieved the necessary abnormal aspect by turning the tree inside out. It ended up being quite a unique Age.

DESIGNING THE MODEL

The conceptual designer of Edanna had to come up with a way to convey to the modelers, texture artists, and animators some road map of the big picture of this 700-foot-tall inverted tree. He was no longer confined to a flat, two-dimensional map. The use of clay became the solution to the vertical challenges he encountered in design. Everything was organic, and there were twists and turns in every direction. The map was impossible to draw, so a 3D sculpture really was the only alternative. It became everything to the team during the modeling process.

Four different zones were built within the tree, partially for navigational purposes, and partially to solve our render predicament. The organic geometry called for a very high number of polygons, and that made rendering a view of the entire tree completely impossible. The solution came in the form of canopies that blocked the player's view vertically. Essentially, it gave us four times the number of polygons and texture space that we could use. We used 3D Studio Max for all the modeling, animation, rendering, and also for the application of textures.

CONCEPT TO CREATION

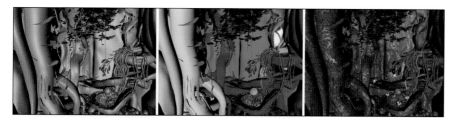

TEXTURING THE 3D OBJECTS

We wanted the textures of Myst III: Exile to provide a connection to the real world, while still dazzling and challenging the player. One of the more difficult tasks was creating photorealistic looking textures that you couldn't really find a source for. Because things that are hand painted tend to look painted, the approach to the texturing was to head outside into nature and shoot reference photographs of trees, ground covers, sand, plants, rocks, and anything else that may have proven useful. Those reference photos became the foundation for combined and created Photoshop maps and extremely complex shaders in 3D Studio Max.

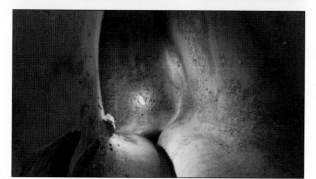

With geometry that twists down and hooks up into other areas, crosses canopy lines, and demands no seams, we had to create a shader that came in four parts (there are four major aesthetic changes in the age), each part blending smoothly into the next. The four parts of the shader have two parts of their own so the walls are differentiated from the walking surfaces. In addition, the insides of the walls required even more variation. But it works. No seams, just natural changes. Inside each facet of the shader are distance blend falloffs so that from close up, resolution is good, and from far away, the tree doesn't look plaid.

LIGHTING THE SCENE

The lighting of Edanna was definitely a challenge. Most of the age is enclosed, leaving us to find efficient, sensible solutions for illuminating the dark space found in the center of the tree. Remembering that everything in this world had to be organic, we created a bunch of fissures or cracks within the shell of the tree to allow huge beams of light to come through. We also designed a number of fungi and mushrooms that were luminescent. These plants not only acted as our light fixtures, but they helped define and adorn the winding walkways. The use (but not abuse) of lighting can be very powerful. We can pique the player's curiosity, hide important information, create mood, and even guide the player by the way we handle the lighting in a scene. Lighting in 3D Studio Max was an essential tool in creating the worlds of Myst.

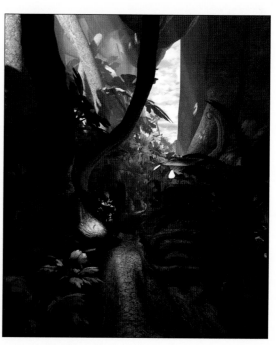

To the right is a final rendered image from the Age of Edanna.

The client had a specific story line that required a comfortable room with chairs and a fireplace. The style was to be wacky and whimsical, and I was given a great deal of freedom to design it. The color scheme included warm colors—with the exception of a few light blue areas to serve as accent points—to transmit a sense of coziness to the room. The blue on the fireplace also serves to contrast with the warmth of the fire.

DESIGNING AND MODELING

I wanted to use almost exclusively curves in the design of shapes, and with very few exceptions there are no straight lines. I rarely do any sketching before modeling, but in this case I made a very rough doodle of one of the chairs.

Even with such a primitive sketch, it is important to think how each part of the model will be created. Knowing the tools available in the 3D software helps a great deal—the sketch shows how each one of the parts of the chair were to be modeled.

The feet turned out to be too long for the concept and the whole chair was made much lower and wider. In the final project, this chair was not used at all, instead, two variations were created.

The rest of the room appeared as a result of this first grouping, following a similar style. This allowed intuition to play an important role in the design. Most of the objects were designed during actual modeling, instead of having all the work planned out ahead with sketches.

1) spline extrusion
+ meshsmooth
2) primitives: spheres
3) loft w/ square
profile
4) cube + meshsmooth
+ lattice deform
5) trims: slice + loft

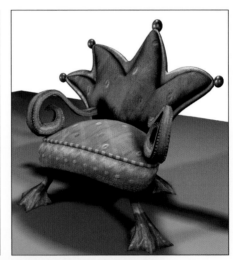

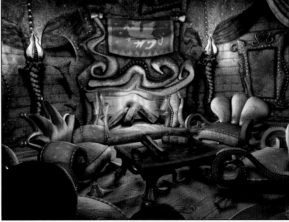

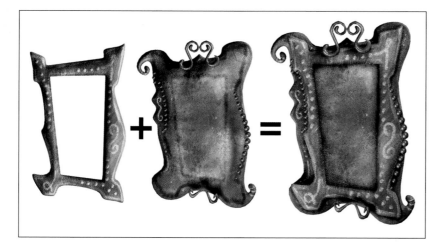

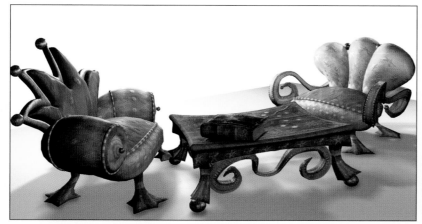

TEXTURING THE MODELS

Almost all the textures were hand painted with Corel Painter. In order to add to the intricacy and detail of the scene, I always try to use overlap of objects and textures. For example, this picture frame was made of two parts, each one with its own hand-painted texture. The same approach was used with the fireplace, with overlapping elements and textures.

LIGHTING THE SCENE

There are sixteen lights in this scene, most of them placed in the general area of the fireplace and wall lamps. As the models were being created in the scene, lights were added or modified accordingly to enhance each object. There are some strong, warm backlights to enhance the contour of the furniture against the background. Since this is a fantasy scene, there was not a lot of concern in making the lighting realistic, just in making the scene look interesting and inviting.

FINAL SPECS

Most of the objects were built using polygons and optimized to reduce the overall size of the file. The resulting scene only has 130,000 polygons, a relatively small size for a scene of this size.

There are, however, fifty-two textures and 184 objects in the image.

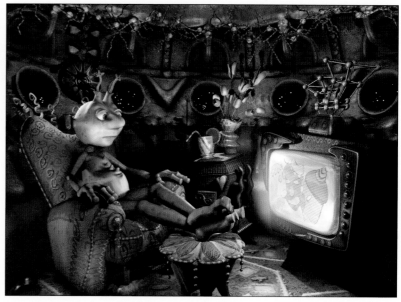

This computer-animated stereoscopic ride experience at Busch Gardens Williamsburg takes audiences on an adventure to an Old Ireland, populated with humans and mythical creatures. In the pre-show, the audience "shrinks" to fit in a magic box. Then they enter a motion base and are strapped into their seats for the main show: one continuous point-of-view shot from the box as characters carry it on a wild adventure.

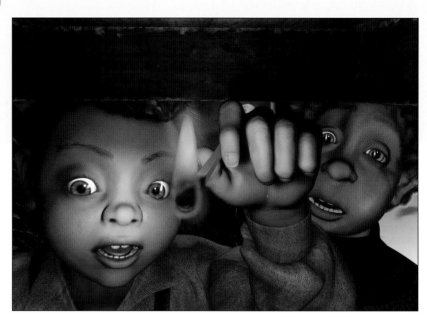

PLANNING AND RESEARCH

Kleiser-Walczak Production Designer Kent Mikalsen worked closely with the project's directors to develop a collection of reference images that would provide digital artists with critical information about the geography, people, and mythical creatures of Ireland. Since *Corkscrew Hill* required theatrical and scenic design for every character, location, and prop, Mikalsen's team gathered photos and illustrations of diverse items including costumes, scenic elements such as landscapes and buildings, and common objects such as bottles and chairs. They also conducted period research as they built an immense database of ref-erence materials for *Corkscrew Hill*.

As the art department was completing its research phase, Mikalsen began making fairly detailed drawings of environments and then took them to children's book illustrator Ruth Sanderson who created very refined scene paintings of the film's key locations. Mikalsen says, "Diana and Jeff wanted a storybook kind of environment for *Corkscrew Hill*. At first we planned on using Ruth's paintings for inspirational purposes, but then it turned out that her style was very consistent with what we wanted and so we used her paintings as reference throughout the process—even during the art direction phase." Director Diana Walczak adds, "We wanted the luminous sky you see after sunset when all the red is gone with dark scattered clouds and a full moon. Ruth Sanderson knew exactly how that would look and incorporated it into her sumptuous oil paintings."

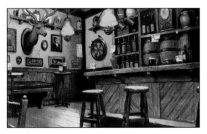

CHARACTER DESIGN

Leonardo Quiles sketched most of the main charac-ters. We chose 18th century Ireland because it was ancient enough, but no so ancient as to require a vast amount of research. We created character sheets for each character that showed the char-acter's size and shape from multiple views. The bodies and costumes were patch-modeled while the heads were haptically sculpted. Walczak sculpted every character's head using the SensAble Technologies' FreeForm modeling system, a tool that lets sculptors use their sense of touch while modeling in the computer.

MODELING CHARACTERS AND SCENES

van Ommen Kloeke says the greatest modeling challenges in *Corkscrew Hill* had to do with the level of detail required for the project. He says, "Paraform 2.0 is an advanced surfacing package that allowed us to convert the polygon version of each character head (1 and a half million polygons per head) to nurbs. The construction of the nurbs patch models for the heads had to be built in a way that allow for the deformation to follow the muscles. No muscle existed under our skin systems. We used traditional blend shape techniques for facial expressions."

Character rigging is another important process that was also performed by the modeling team. According to producer Molly Windover, "Rigging is like putting the strings on the puppet. Rigging is critical for models and, once in a while, a prop. It involves setting up a skeleton inside the model and setting up a character so it can be animated."

DIRECTING SYNTHESPIAN PERFORMANCES

According to Diana Walczak, "Directing an animator to create a digital performance is both similar and different to directing an actor. There are many more possibilities in animation, since one gifted animator can provide the performance of an ugly old witch, a cute little boy, or a goofy, fantastic creature. We do still rely heavily upon the voice talent of actors which provides an important base for the animation process."

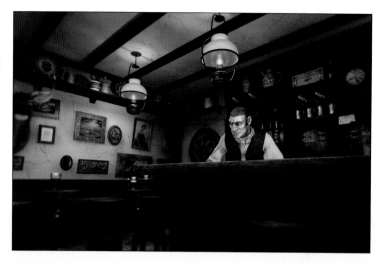

TEXTURING, SCENE LIGHTING, AND COMPOSITING

While the animators were working on *Corkscrew Hill*, another team of artists created and assigned appropriate textures to every character and object surface. Molly Windover says that two camps worked on the geometry at the same time: the animators lead by Dave Baas and the texture and lighting artists lead by lighting supervisor Leonardo Quiles.

Quiles says that Hurly and Archibald—the characters that required fur—were among the most demanding for his team. "However, since Archibald and Hurly are fantasy characters, there was some leeway." He adds, "Creating realistic skin and getting the boys to look like boys was difficult." The lighting and texturing team worked with many separate layers for each image. Visual effects were implemented toward the end of the process and include animated and lighting effects.

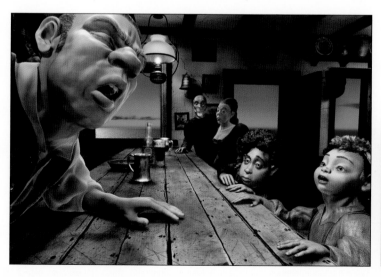

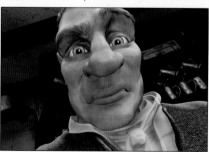

Eventually, the many layers of imagery were composited and rendered in large format stereo. After the imagery was composited, stereo was checked and data was provided to the programmers of the motion base.

Bf-109 is a famous Luftwaffe fighter from early World War II. The Bf-109 has been used as a subject by many Computer Graphic (CG) artists. For my work, the external appearance of the plane was important, but I really wanted to highlight the engine structure.

PLANNING AND RESEARCH

I began by gathering a number of different documents in order to create this image. Although there are many photographs of the DB601 engine, there are a limited number of images of its external structure. I referred to a photograph of a Ha-140 as a reference. The Ha-140 design was basically the same as DB601 and was made by Hien. Although it would have been wonderful to look at the real thing, sometimes a photo is all you have to work with.

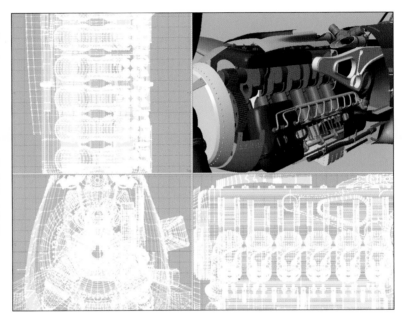

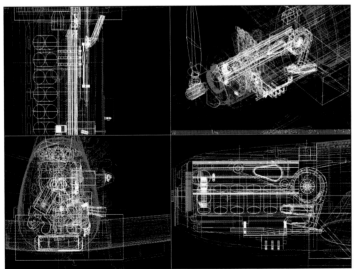

DESIGNING THE MODEL

I began by tracing a drawing with Adobe Illustrator, and that sketch was used as a template for the 3D software I work with, called Shade. Shade is a program made in Japan that I use for much of my modeling. Although I have experience with several kinds 3D software programs, I find Shade very flexible and easy to use. Its only weak point is a slow rendering engine. My technique is to convert the model I create in Shade into a DXF file, then import it into LightWave (Modeler). The 3D object will remain the same scale if I scale it to a factor of 0.1 percent in LightWave. I find LightWave really good for delicate work. I found it best to begin by making a part of a DB601 engine with Shade then finish it with LightWave.

MODELING THE 3D OBJECTS

I do not use any special techniques while working in LightWave. If I need to extend the edge of an object I simply select a series of points, move them to the new position, then copy, undo, and paste to create a new row of points. Sometimes I have to repeat this several times to get the shape perfect. If you must model an object precisely this is a good way to do it.

Without having good reference documents, sometimes you just have to be satisfied that the object looks like what you had in mind, even if it is not technically correct. The extra time it would take to attempt to make it technically perfect would be difficult to justify, and time is usually an important factor in the development process.

RENDERING THE SCENE

Next, I composed my scene in LightWave using the objects I created in Modeler. Working from photos as my reference source, I began the surfacing process. If I was unable to achieve the look I was striving for the first time, I would continue tweaking and testing it until I was happy. For the rotating parts I used Motion Blur, an effective means of indicating movement in a static 3D image. I used a Point Light to simulate combustion in the cut away view. When all settings were decided, I next selected a background image from a source where there was no concern of copyright infringement. Since rendering is often a time-consuming process, I use the time to think about my next project and enjoy a hot cup of coffee.

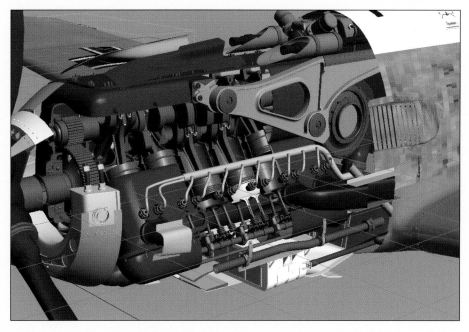

The image Fall—Changing Seasons illustrates how it would appear if man reduced nature to a modular building system and then changed the seasons from summer to fall. The concept for the image began as an emotion, which instantaneously transformed itself into a complete mental image. I grabbed the nearest pencil and started sketching.

I wanted the focal point to be a single modular tree, only partially clad, in the middle of changing plywood panels. To the left and right of the tree, the views extend out to infinity. There would be no human figures present in the image. This allows viewers to place themselves in the scene. After the sketch was finished, the next step was to design the modular system.

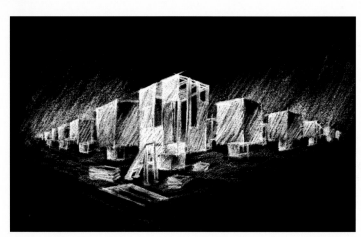

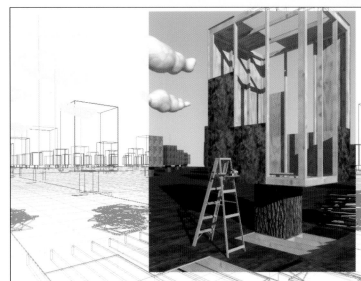

TOOLS USED

The modular system in this image is the same system utilized in contemporary wood-frame home construction and is based on the dimensions of a sheet of plywood. FormZ is a great 3D modeler to use when building modular systems because of its excellent dimensional accuracy and numerous grid and line snapping options. It also has a great layering system for easily managing scenes with many objects. The 144-tree objects spaced 40 feet apart in a 12 x 12 grid pattern established this scene. Enclosing the trees is an open top 100 percent reflective mirrored box. The placement of the box was crucial for ensuring a seamless repeating mirrored image. Also, the vertical height of the mirrored box had to exceed the final height of the camera for the scene to reflect properly. With the modular dimensions of the design determined, I then focused on creating the texture maps.

Photoshop was used to prepare the forty-five photographic texture maps used in this project. Usually great care is taken to create seamless maps for mapping onto 3D objects. In this project however, texture seams became an important part of the design, helping to accentuate the repeating modular patterns. To conserve system memory, I kept the maximum dimension of the texture maps to 512 pixels. With the maps finished, modeling was the next stage.

MODELING

Modeling the scene was fairly straightforward. Only the partially constructed tree has an interior, the others consist of an outer shell. Before placing all of the trees, I applied all of the texture maps using flat mapping. It was much easier to apply the textures once, before duplication, rather than having to apply mapping parameters to each tree individually. For easy placement, I then turned the trees into symbols and clicked the mouse once wherever I wanted one. The trees were finished and I turned my attention to the sky.

Originally, a simple blue gradient was planned for the sky. To add visual interest, I modeled some stitched inflatable clouds and tethered them to the ground. Metaball modeling was perfect for the creation of the clouds. The process involved grouping several spherical objects together, and then a skin was generated based on the outer boundaries of the group. The entire scene is composed of 51,483 polygons.

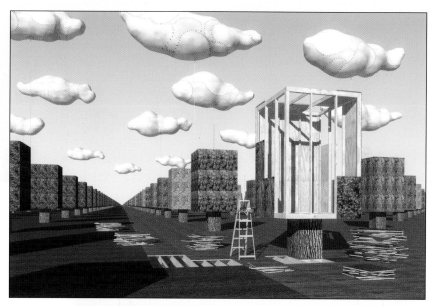

RENDERING

Lighting was the last stage before producing a final rendering. I wanted the scene to be evenly lit, so I chose a 100 percent intensity, distant light as my main source. Within the tree under construction I placed a second distant light (13 percent intensity), pointing up to simulate reflected light and reveal the structure within the shadows. Because all of the shadows in the scene are reversed when reflected in the mirrors, multiple renderings with opposite lighting angles needed to be produced and composited into a single image using layer masks in Photoshop. Raytracing was the method of rendering used in Renderzone. In the render settings I changed the number of recursive rays from eight to sixteen, which increased the number of times a ray could bounce between mirrors. Also, I matched the color of the mirror box to the color of the background sky gradient so that where the mirror box reflected itself, the color became blue.

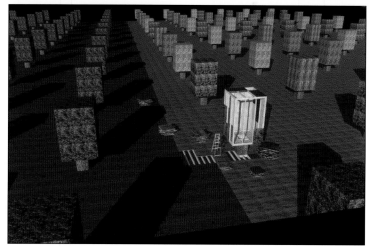

The main objective of this project was to illustrate the influence of natural light in an interior space. For this purpose, the reading room of a library was chosen, due to its particular lighting characteristics. Here, direct light is avoided and reflected light prevails, allowing for an optimal reading environment.

This specific library was structured in four levels and was topped by a high skylight. This skylight was the main source of natural light in the reading room, capturing the indirect and diffuse northern light (the building was situated above the equator). The white walls reflected the natural light, spreading it through the interior space, acting as secondary light sources.

This study was developed for a thesis on lighting in architecture for the completion of my degree in architecture. The architect is João Mendes Ribeiro, and the name of the project is the Library for the Medical Department.

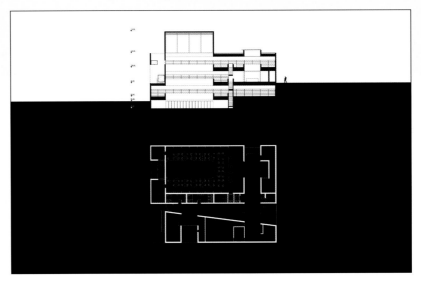

THE PROCESS

The orthogonal nature of the model influenced the decision of choosing a CAD software for the modeling. AutoCAD provided the straightforward process of modeling with Booleans, with the required precision. The model of the building was then imported into 3D Studio Max.

Some elements required special planning in order to optimize the performance. The chairs were modeled inside 3D Studio Max using a Surface Subdivision technique that allowed the adjustment of their polygonal density at any stage of the project. Before the final render, the density was optimized according to visual quality and render speed. Several instances were made from the first chair, so that when any modification was applied to one of them, it would reflect in all the others.

Lighting and texturing were done in 3D Studio Max in one common stage. Similarly to the real world, the appearance of the materials depends directly on the quality and quantity of the light and, inversely, light is only perceived from its contact with physical elements.

Mental Ray performed the rendering.

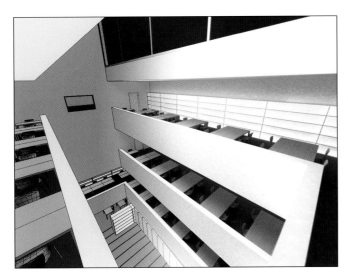

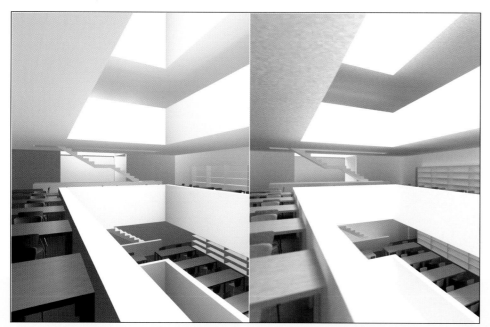

LIGHTING

The first lighting tests were made by placing more than a hundred lights, with different intensities and color values, all over the interior space of the model (left image). Some of them would simulate bounced light, while others would smooth the shadows and darken corners, according to the distance from the light source. Although the rendering times were relatively short, the end result was not satisfactory.

I then decided to apply a Global Illumination process, with Mental Ray (image below). Although Global Illumination implies longer rendering times, it also provides a more natural feel to the resulting images. This process handles light in a similar way to the real-world phenomenon, where each object is affected by its surrounding counterparts. While possible, it would prove very difficult to manually simulate with accuracy every bounced light effect and the resulting color transmission that happens in a relatively complex scene such as this.

RENDERING

Instead of slicing the model to reveal the cross section, the near clipping plane of the camera was adequately positioned, allowing the light to bounce from the invisible part of the model. Since this operation would reveal the inside-facing surface of the model, a pure black material was applied, creating the appearance of a sectioned 2D shape.

The computer-generated images played an important role on the final stage of the architecture project, allowing the architect to preview his building in a tangible way and, therefore, to apply final adjustments based on them (namely, the selection of the construction materials).

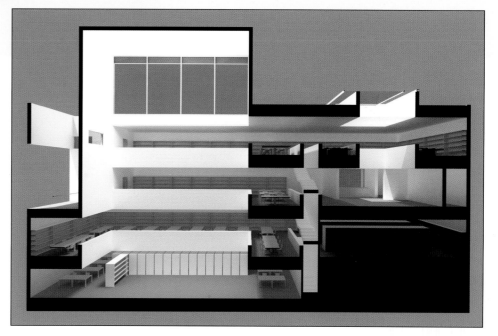

The Woodlands is a planned community located 30 miles north of Houston, Texas. The master plan called for the development of a 1.25-mile-long corporate, retail, and entertainment corridor known as the Woodlands Waterway. To presell the property, the developer wanted a virtual fly-through to highlight the features of the property. It was obvious from the outset that before I could get started, a great deal of research was going to be necessary.

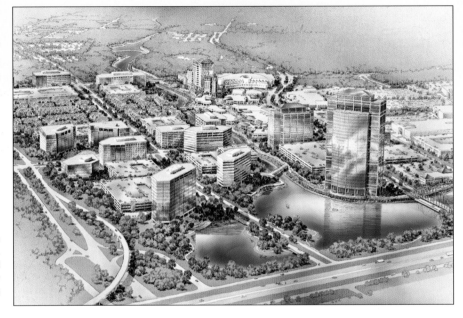

PLANNING AND RESEARCH

We began by collecting whatever visual material we could find. Reference material included artist's renderings from the client, maps of the development project below, and our own reference photos. Since the focus of the piece was to be the entire community, dozens of buildings both existent and imagined were modeled in LightWave 3D to populate the scene.

DESIGNING THE MODEL

The buildings were modeled to scale and placed in the layout of the scene according to a map supplied by the clients. A majority of the buildings are constructed as simple exterior shells, but a few have detailed interiors. The job called for a visualization of a couple of floors of the interior of one of the main buildings, so that was modeled and carefully detailed and the animation was rendered in a separate scene.

A black-and-white version of the same map was modified in Photoshop and used as a displacement map in order to accurately place the waterway itself in the scene. The map was also useful in the creation and placement of the streets in the area, as well as placement of proposed new construction, which was actually still in the planning stage.

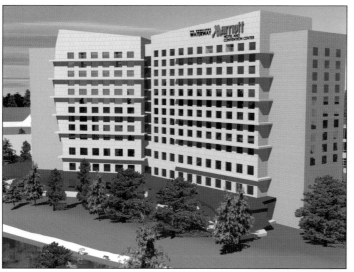

MODELING AND TEXTURING THE 3D OBJECTS

While many photographs were taken for use as textures, it became evident that in a scene as dense and complex as this, system resources would be at a premium. In order to make the most of the finite memory resources, procedural textures were used everywhere possible. One place where photographs were used was for the various species of trees. Since polygonal modeling of the trees was so geometrically heavy, single polygon clipmapped trees were used in order to keep an already huge task as manageable as possible. Since one of the key marketing features of the area was the fact that it is a forested community, a dense population of trees was considered a necessity.

LIGHTING THE SCENE

With all of the models in place, a single directional light source was set up to simulate strong morning sunlight. Ambient light was set somewhat higher to emulate the bounce and scattering inherent in daylight and set to a slightly bluish tint to cool down the shadows. Since the camera was to be animated in our virtual fly-through, it was crucial that the essentially two-dimensional trees stay perpendicular to the camera. The trees are set to track the camera's movement and rotate accordingly, so that the camera cannot see the flat polygons' edges.

RENDERING THE SCENE

The resulting scene took about nine full days of render time on a 400MHz dual-processor graphic workstation. Although this large project was literally months in the making, the payoff was evident in the final piece. The fly-through served as a very powerful introduction to a marketing piece that became a source of pride for both the client and the epic software group.

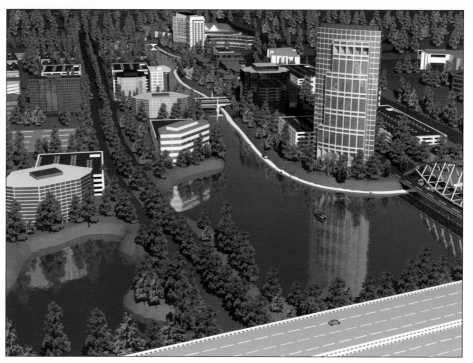

The project's purpose was to achieve a pedestrian-friendly station in the middle of a busy traffic circle, which would serve to link Cambridge and Boston as a gateway with its significant civic architecture. The newly renovated station would also provide easy access to the adjacent public and private abutters such as the Esplanade and the Charles River, as well as the Beacon Hill residents and nearby medical institutions.

The Massachusetts Bay Transportation Authority (MBTA) and designers, Elkus/Manfredi Architects-HDR Engineering Joint Venture, LLC invited Neoscape, Inc. to create a series of 3D renderings to present this new design to the public.

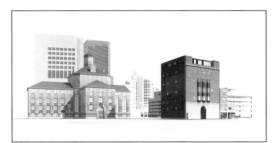

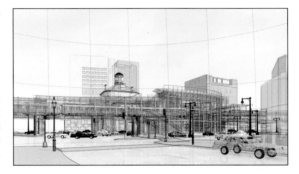

DESIGNING THE MODEL

To kick off our process, we met with the architectural designer to get a feeling for the project and understand approximately which vantage points would best depict the new station. We then collected CAD drawings from the architect as well as a preliminary 3D model they designed using AutoCAD. At this stage, we began generating a fully detailed 3D model containing the new station and vicinity.

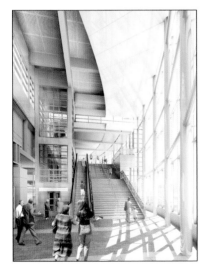

LIGHTING AND MATERIALS

Because this is a very warm, inviting area and a recognizable gateway to Boston, very special attention was paid to the specific lighting and materials of the scene. The lighting was generated solely in 3D Studio Max for the exterior rendering; several carefully positioned lights were added to capture the natural effects of indirect lighting in the scene. The lighting of the interior, however, was generated using radiosity in Lightscape to obtain very accurate lighting information.

The existing palette of materials from the Beacon Hill area was researched and well documented and then given a "fresh coat of paint" to show the newly revived look to the area.

The backdrop of existing buildings was generated by taking digital photographs of the area, manipulating the photos in Photoshop to create a series of texture maps, and applying them to 3D models constructed with a low level of detail. These were then rendered out separately and composited in behind the station itself.

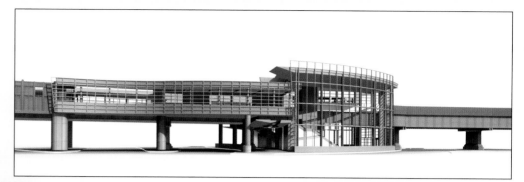

COMPOSITING

As with any 3D scene, breaking it into compositing levels of foreground, middle ground, and background allows the greatest amount of artistic flexibility. This process allows the application of subtle effects that would be more difficult or time consuming to achieve in a single-pass rendering.

For this project several compositing passes were rendered separately: the sky and background buildings, the T station and T station glass, the site, and the foreground buildings. These were then layered sequentially in Photoshop and adjusted slightly, if necessary, to create the final composition.

Also, using 3D Studio Max's render elements, special passes such as specularity, shadows, reflections, and *z* depth were generated and used throughout the compositing process.

ENTOURAGE AND FINISHING

Finally, the entourage such as people and trees were added by placing photographic elements into the scene. Careful attention to the lighting, placement, and finer details, such as shadows and reflections, combine for an added degree of finish and realism in the final image.

In this piece, one final adjustment in Photoshop was made to capture the right color saturation and balance necessary to achieve a final image that distinctly blends photorealism and illustration.

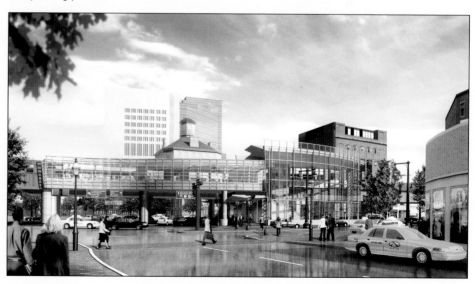

CONCEPT TO CREATION

It has been said that if you can find the right stone and remove it, a great cathedral can collapse like a castle of cards. This is just one of a large number of legends that surrounds cathedrals. Their origins of these great buildings have been attributed to Hiram's workers, the mythical architect of the ancient Jerusalem temple.

Cathedrals began to appear around the twelfth century when the Templar knights came back to France. Many were built on previously sacred places. In the crypts of some cathedrals it is possible to find some pits whose depth corresponds to the height of the higher spire. This was to create a sort of symmetry between the sky and the earth.

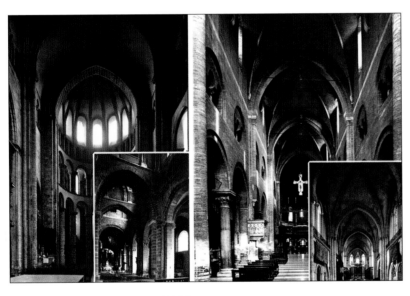

PLANNING AND RESEARCH

The idea to create the interior of a cathedral came to me after returning from a trip to Paris. Most of the documentation I used as a starting point for the design and execution of the project came from photographs of the more popular places around Paris. The detailed study necessary to get the geometry of the cathedral (dimensions, proportions) accurate, came from consulting several books of architecture.

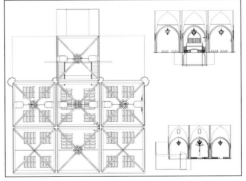

DESIGNING OF THE MODEL

The cathedral project began as an experiment in lighting. My original idea was to better understand lighting, specifically to study the interior lighting of the cathedral itself. To get the lighting perfect, It would be important to first get the geometry of the building right. My goal was to re-create a real kind of lighting system, similar to a radiosity rendering with the effects of volumetric light. I also wanted to achieve this without using a dedicated external plug-in.

MODELING AND TEXTURING THE 3D OBJECTS

Modeling of the geometries was not particularly complex. Using primitive standards, extrusions, Boolean operations, and a minimum of nurbs modeling, the execution step took just a few hours to complete. In fact, the most complex step was searching for detailed architectural representations and collecting the information I needed to better understand how the cathedral was originally planned.

The objects textures of the scene are very important since the upper part of the cathedral was composed using blend maps. For example, the vault maps are composed by a bitmap layer, which includes the real image, created using many digitized photos. The photos were reassembled with Photoshop, and by using a cellular layer with colors shading from gray to orange, which acts as dirty map. The mix of the two layers guarantees an antique effect that accurately reflects reality.

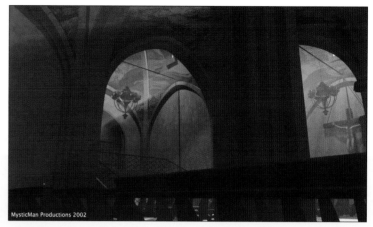

MysticMan Productions 2002

LIGHTING THE SCENE

As expected, lighting the scene was the most complex part of the entire project. Normally, for rendering interiors radiosity is used because this algorithm typically shows the interaction between the reflected light and the object surfaces. In order to obtain this expected effect, I used thirteen omni-lighting sources in the interiors of the cathedral, shading from light blue to pink and from red to yellow. I used a target direct source—lightly pale blue—from the outside, to reproduce the sunlight. All the shadows are shadow map, with variable map dimensions and density, according to the clearness of the requested shadow. The volumetric effect of the light—due to dust particles, smoke or steam, normally present in the air (as in real life)—applied to the target direct source, was decisive in the final rendering of the scene.

RENDERING THE SCENE

The rendering of the final scene was made with 3D Studio Max. Lighting the scene required about thirty-five minutes for rendering due to the massive calculations required for the volumetric light effects.

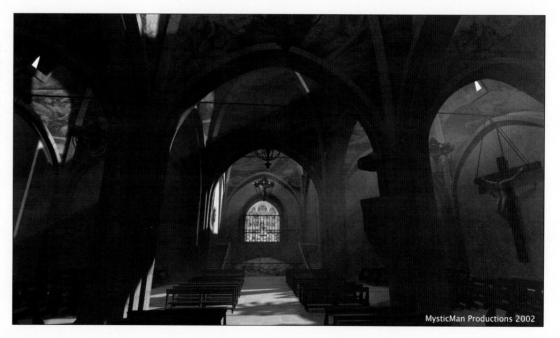

MysticMan Productions 2002

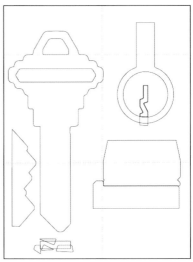

I've always been fascinated by the inner workings of mechanical objects. Being an illustrator, I had long wanted to do a cutaway image to include in my portfolio, something different from the usual aliens, spaceships, and robots. Writers often say, "write what you know." I decided to model something I knew about. In college, I worked summers as a journeyman locksmith, so I was very familiar with the inner workings of locks. Also, a lock cylinder was an interesting shape that would prove challenging to model accurately.

The first step of a good illustrator is to gather good reference materials. I obtained several locks and disassembled them fully to assess what I was getting into. Originally, I had planned to do an entire knob, but decided early on that I really wanted to illustrate how the lock mechanism itself worked. With so many small details inside the cylinder, I felt they would get lost in an image of an entire knob cutaway.

TOOLS USED

Accuracy was the main goal for this image, so the first tool I used was a dial caliper, a measurement device used by machinists to accurately measure small parts to within a thousandth of an inch. As I measured each piece of the lock cylinder, I created silhouetted 2D versions of each in Adobe Illustrator. The easy numerical input, alignment, and pathfinder tools excel at speedy creation of complex shapes. After I had all the measurements recorded, I created the silhouettes that I would use to lathe, extrude, and otherwise manipulate in 3D. I then imported the file into my 3D program of choice—LightWave 3D. I prefer LightWave for its powerful control over polygons and masterful set of modeling tools, as well as its high-quality rendering engine. I was able to import the native Illustrator files directly into Modeler and control how it converted the curves into polygons.

MODELING

I considered several possible ways of modeling the object, including subdivision surfaces. I wanted to capture all the minute rounded edges and surface details, but not go overboard in polygon count. Due to the complex interactions of the shapes I had created in Illustrator, I decided that Boolean operations would be best. Besides, a freshly manufactured lock has pretty crisp edges anyway. In LightWave's modeler, I extruded and lathed the shapes. I made a couple of trips back and forth between Illustrator and Modeler to get everything I needed. Then I made sure foreground and background elements lined up properly for the Boolean operations. Boolean operations tend to create oddly shaped polygons that, in turn, cause rendering errors. I was able to merge points and touch up the intersecting areas thereby minimizing or completely eliminating the offending errors altogether.

CONCEPT TO CREATION

RENDERING

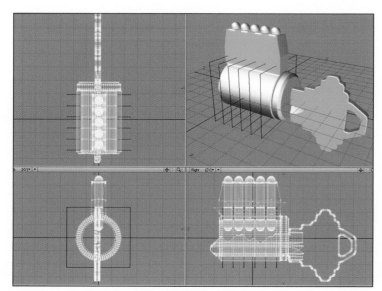

My initial idea was to create a simple cutaway view. As I thought about the final image I began to think it would be more interesting image as a ghosted x-ray view of the inner workings. It also proved to be more challenging to create. First came the surfacing; my reference was covered with nicks and dents as well as a zillion microscopic scratches which I felt would only add visual noise to the rendered image, had I chosen to replicate them. I imagined my 3D cylinder was more like a proof coin. This decision helped simplify the surfacing, and added to the stylized look I was after. The next step was to light the object. I love LightWave's radiosity features. I chose this method to light the scene, creating a dome type lighting scheme with a High Dynamic Range Image (HDRI) map projected onto it. This not only provided the lighting, but the reflections for the polished brass as well.

Originally, I tried using gradients in the transparency channel to get the ghosted x-ray look, but I came across a limitation of the radiosity technique. I was not able to light the inner working of the lock through the body. I could easily remedy this problem by excluding the body from the radiosity solution. Unfortunately, that caused the body to render solid black. My only option was to compose the final image in Photoshop. So I rendered each object separately, carefully excluding others, so they would still show up in the reflections but wouldn't block the lighting. With image render times that varied between ten and fifteen hours per layer on my dual 1Ghz system, I painstakingly built up the final image, layer by layer, over a three-week period. The benefit of this method afforded me much more control over the final look than I would have ever gotten in 3D space. The final file ended up having nearly forty layers, including custom mask channels, and weighed in at almost 200 MB.

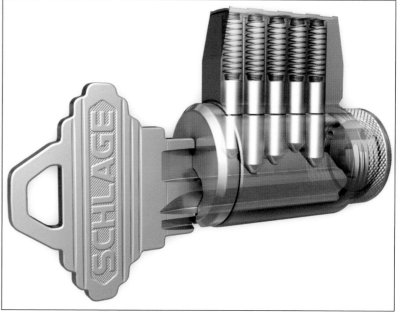

http://www.cgchannel.com - CG Channel is a popular on-line magazine and portal for computer graphic artists and professionals. This site is a great source for information and news in the industry.

http://www.cgtalk.com - Want the latest buzz in the world of 3D? Brave enough to have your work critiqued by others? Looking for a job? Well this is the place to do it. You will also find extensive forums with topics such as 3D techniques, game development, visual effects, texturing, and so much more.

http://www.cgfocus.com - Founded in late 2000 by Jean-Francois Lepage and Andrew Smallwood. CG Focus is dedicated to the realm of computer graphics. Here you will find images, animations, tutorials, articles, forums, and downloads. Cgfocus is 650 members strong.

http://www.3dtotal.com - With over 4 million page views per month, this popular site is filled with eye candy that has fans returning on a regular basis. Check out the free stuff section where you will find models, textures, and tutorials.

http://www.3dbuzz.com - With a tagline of "Look, Listen, and Learn," this portal site has an excellent Power Search feature that will help you search the Web for tutorials by author, keyword, date, or category.

http://www.renderosity.com - Renderosity (previously known as PoserForum.com) is an enormous online community of artists. This is truly an international site with over 83,000 members in 134 countries. Renderosity's MarketPlace provides a venue for artists to market and sell their 2D/3D graphic creations and has over 3,700 products in the online marketplace available to its members.

http://www.3dsite.com - 3DSite has been serving the 3D community since 1994. While not as glamorous as some other 3D sites, the content and the manner of presentation is streamlined. "Our goal is not to entertain you but to help you further your career and fulfill your professional needs."

http://www.3dcafe.com - 3D graphics demands the most technologically advanced hardware and software, and 3Dcafe was created as a resource to assist and inspire 3D designers. It offers tutorials, product reviews, focused feature articles, and boasts the industry's largest database of free 3D geometry.

http://cgw.pennnet.com/home.cfm - This is the Web site for *Computer Graphics World* magazine. Not only can you can you search previous articles and product reviews, but be sure to check out the Web Exclusives section for late breaking news, opinions, and surveys. You can also request a free subscription of their excellent publication.

http://webreference.com/3d - Owned by Jupitermedia Corp, WebReference is one of the oldest and most respected Web development sites with great information on authoring, multimedia, programming, and promotion. Their 3D Animation Workshop is comprised of over 100 Lessons and hours of learning for those new to 3D as well as seasoned pros.

http://www.animatricity.com - Animatricity.com is a premiere portal. This site is a fine resource for 3D art and free related content. Animatricity.com not only offers original content and information, but also acts as a gateway to hundreds of other 3D related sites around the world.

http://www.howstuffworks.com/3dgraphics.htm - If you want to understand the nuts and bolts of 3D, click on the How 3D Graphics Work link. Marshall Brain, the genius behind the scenes, will help you learn thinks like: Making 3D Graphics Move, Fluid Motion for Us Is Hard Work for the Computer, Transforms and Processors: Work, Work, Work, and How Graphics Boards Help.

http://www.3dark.com - 3D ARK is a free on-line archive of quality 3D related content and resources for 3D enthusiasts. Over 3,500 members make up this community where you can visit for free to get advice, showcase your work, or just make a new friend or two.

http://www.planet-3d.com - If you work in Bryce 3D & 4, Amorphium, Rhino 3D, or Poser, Planet-3D is loaded with resources such as tutorials, models, and textures. Check out the 3D wallpaper and galleries section where you will find everything from Pokemon to Star Wars Art.

http://www.3d-ring.com - 3D Web Ring is a completely free service that lets user quickly, easily, and reliably navigate thousands of 3D related Web sites. Web rings pull related sites together into easily explored groups. Pop-under ads allow the company to keep this as a free service, and the site developers have done a good job to keep these as unobtrusive as possible.

http://www.raph.com/3dartists - If it is 3D art you crave, the Gallery section of this site features over 350 artists from 30 different countries and over 840 individual pieces of artwork. In order to make browsing easier, you can sort entries by artists name, country, date, or on rating values. 16 in-depth interviews with world-class 3D artists are inspiring and educational.

http://www.3dlinks.com - Something for everyone, 3dlinks is the "Encarta" of 3D content on the Internet. Visitors include 3D cine-matic producers, game developers, Web content creators, and 3D ani-mation hobbyists. Need a link to a 3D Software company? You'll find it here.

Abraham, James
Optigon Studios
9959 South Cicero Avenue, Apt. 2A
Oak Lawn, IL 60453
optigon@mindspring.com

Barr, Molly
Dragon Tree
280 Stageline Drive
Vallejo, CA 94591
barr@dragontree.net
www.dragontree.net/

Baumberger, Scott
BaumbergerStudio
321 East 75th Street, #2FE
New York, NY 10021
scott@baumbergerstudio.com
www.baumbergerstudio.com/

Bevan, Joshua
Convacent
123 Oak Creek Drive
Charlotte, NC 28270
jabevan@shistudios.com
www.shistudios.com/

Bishop, Steve
P.O. Box 175
Philmont, NY 12565
thunder90_90@yahoo.com

Blausen Medical Communications, Inc.
Various Artists
7660 Woodway, Suite 599
Houston, TX 77063
bblausen@blausen.com
www.blausen.com/

Blevins, Neil
13920 Old Harbor Lane #201
Marina Del Rey, CA 90292
neil@soulburn3d.com
www.neilblevins.com/

Brochu, Louis
251 8th Avenue
Ste-Marthe-sur-le-Lac
Quebec, Canada J0N 1P0
louisbrochu@ca.inter.net

Bukowsky, Jens Ole
Ludwigshof 10
Templin, Germany 17268
Jens-Ole.Bukowsky@T-Online.de
www.nova-graphics.de/

Camenisch, Andrew
494 Bennett Road
Powder Springs, GA 30127
andrew@camenisch.net
www.3dluvr.com/andrewtc

Cameron, Tim
Tim Cameron Design
48 Rawson Street
Haberfield, Australia NSW 2045
tcdesign@talent.com.au
www.timcamerondesign.com.au/

Cameron, Tom
Cameron & Company, Corp.
1977 East Laguna Drive
Tempe, AZ 85282
tom@camerondesigngroup.com
www.camerondesigngroup.com/

Carlson, Gary
Gary Carlson Illustration
25 Kinnicutt Road East
Pound Ridge, NY 10576
gary@gcarlson.com
www.gcarlson.com/

Carriger, Irina
Camber Corporation
212 Gate House Road
Newport News, VA 23608
imcarriger@aol.com
www.startechservice.com/

Cybulski, Peter
PC Graphic Design, Inc.
3450 North Lake Shore Drive
Chicago, IL 60657
peterc@ais.net

Darknell, James
Mutant-Pixel Digital Labs
2173 Carobwood Lane
San Jose, CA 95132-1213
Typeboy@aol.com
www.mutant-pixel.com/

Das, Avijit
Industrial Hieroglyphics
14 B Camac Street, 5th Floor
Calcutta, WB, India 700017
dasavijit@hotmail.com
www.indusglyphs.com/

de Barros, William Watson
Rua Alipio de Miranda, 180, Apt. 202
Teresopolis - RJ, Brazil 25964-040
watson@thepixelhp.com

DreamLight Incorporated
14 Union Street, Suite 2R
Woburn, MA 01801
info@DreamLight.com
www.dreamlight.com/

Eckman, Dean
DME Drafting Service
431 Water Street
Honey Brook, PA 19344
dme@dmedrafting.com
www.dmedrafting.com/

Emery, Philip
26 River Street, Wilmslow
Cheshire, UK SK9 4AB
philip@emcorp.freeserve.co.uk
www.emcorp.freeserve.co.uk/

Engleman, Jeremy A.
5929 Troost Avenue
N. Hollywood, CA 91601
jeremy@art.net
www.art.net/~jeremy

epic software group, inc.
Robert Bailey, Danny Duhon, Derek Hughes
701 Sawdust Road
The Woodlands, TX 77380
epic@epicsoftware.com
www.epicsoftware.com

Evers, Petra
122 Kealepulu Drive
Kailua, HI 96734
petranella_evers@hotmail.com
www.petraevers.com/

Fabbri, Gabriele
Via Zucconi 1
Bologna, Italy 40133
gabriele@insanelight.com
www.insanelight.com/

Francou, Alexis
Parque de Cadiz 140-6
Parques de la Herradura
Huizquilucan, Edo., Mexico 52786
afrancou@hotmail.com
www.freewebz.com/af3dworld

Frederick, Cynthia
125 Pine Dale Road
Asheville, NC 28805
cynthia@curious3d.com
www.curious3d.com/

Gaushell, Charles
Paradigm Productions, LLC
5124 Poplar Avenue, Suite 106
Memphis, TN 38117
gaushell@2dimes.com
www.2dimes.com/

Gedrich, Mark
15 Ives Street, #39
Beverly, MA 01915
mgedrich@earthlink.net
www.home.earthlink.net/~mgedrich

Geiger, Jr., Ralph
7809 Horseshoe Trail
Huntsville, AL 35802
71530.2136@compuserve.com

Giubelli, Marco
Via Pasquaro, 26
Varallo/Vercelli/13019, Italy
mysticman@libero.it
www.mysticman.net/

Grohs, Lon R.
Neoscape, Inc.
700 Massachusetts Avenue
Cambridge, MA 02139
lon@neoscape.com
www.neoscape.com/

Grzybowski, David
6633 Harvard Drive
Franklin, WI 53132
davegriz@dmg3d.com
www.dmg3d.com/

Hanson, Eric
Digital Fiction
12818 Dewey Street
Los Angeles, CA 90066
ehanson@loop.com
www.members.loop.com/~ehanson

Harada, Kyoshi
D.A.C
2-17-21, Kannondai, saikiku
Hiroshimasi, Japan 731-5157
harada@cc22.ne.jp
www2.cc33.ne.jp/~harada/

Hilyard, Stephen
317 Humanities, U.M.D., 1201 Ordeon Court
Duluth, MN 55812
shilyard@d.umn.edu
www.d.umn.edu/~shilyard

Holly, Brent
37849 Lakeshore Drive
Harrison Twp., MI 48045
brenthollyusa@netscape.net

Holt, Fran
Thoughtcam
112 Bellevue Avenue East, #404
Seattle, WA 98102
fran@thoughtcam.tv
www.thoughtcam.tv/

HUSH Design Limited
Matt Wynne, Chris Grew
17 Dorset Square
London, UK NW1 6QB
info@hushdesign.com
www.hushdesign.com/

Jarman, Joseph
Planet 3 Animation Studio
1223 North 23rd Street
Wilmington, NC 28405
jarman@planet3animation.com
www.planet3animation.com/

Kamon Jirapon and Robert Krawczyk
3360 South State Street
Chicago, IL 60616
kamon_jirapong@hotmail.com
www.iit.edu/~krawczyk/shell01/shell01.html

Killian, Rosina
5531 SW 82nd Avenue
Davie, FL 33328
rosina@rosina-artist.com
www.rosina-artist.com/

Kindt, Reed
Spectral Custom Art & Graphic Design
132 Oxford Road West
Lethbridge, Alberta, Canada T1K 4V4
kindt@uleth.ca
www.home.uleth.ca/~kindt/spectral/spectral.html

Kinetic Vision
Chris Ruggiero, Jason Williams, & Rick Schweet
4221 Malsbary Road, Suite 201
Cincinnati, OH 45242
sales@kinetic-vision.com
www.kinetic-vision.com/

Jeff Kleiser & Diana Walczak
Kleiser-Walczak
6315 Yucca Street
Hollywood, CA 90046
santo@kwcc.com
www.kwcc.com/

Koch, Michael
mindworx
Akazienweg 16
Mainz, Germany 55120
mike@mworx.com
www.mworx.com/

Koscianski, Leonard
Leonard Koscianski Fine Art
217 Hanover Street, #9
Annapolis, MD 21401
lkoscia@yahoo.com

Kramer, Kort
PDI Communications Inc.
6353 West Rogers Circle, Bay 6
Boca Raton, FL 33487
kort@pdi-eft.com
www.pdi-eft.com

Kuczera, Robert
3D Characters
Kaffeberg 10/1
Ludwigsburg, Germany 71634
rkuczera@3dcharacters.de
www.3dcharacters.de/

Laboratore Alkay s.r.o
Jiri Plass, Petr Horak, Martin Melichar,
Richard Jirsak, Vlastimil Stejskal
Kuninova 1700
Praha 4, Czech Republic 149 00
petr@alkay.cz
www.alkay.cz/

Maloney, David
Avatara Studios
2724 West Vera Avenue
Glendale, WI 53209
maloneyd@mero.com
www.avatara.com/

Manis, Ralph
Infinitee Designs
10 Ocean Drive
Rehoboth Beach, DE 19971
mach1@infinitee-designs.com
www.infinitee-designs.com/

Martyna, Andrae
Uetzenpfuhl 19
Hameln, Germany 31789
alihahd@dreamlandworks.com
www.dreamlandworks.com/

McCarthy, Adam
10089 Zapata Avenue
San Diego, CA 92126
adam@rapideyegames.com

McWhinney, Meg
118 City View Drive
Daly City, CA 94014
www.meg-art.com/

Miraldo, Miguel
Rua Octaviano de Sa - 56
Coimbra, Portugal 3030-027
mmiraldo@hotmail.com

nbbj
Phu Duong, Jin Ah Poark, Jonathan Ward,
Daniel Ayars, Gummi Byrnjarsson, Yumiko
Fujimori, Eric Phillips, Li Qui, Alec
Vassiliadis, Patricia Yi, Mike Amaya, Paul
Davis, Jamie Gaskins, Andy Ku, Dom Dies,
Ted Ngai, Duncan Patterson, Sanam Simzar,
Nnamdi Ugenyl
19 Bolsover Street
London, UK W1W 5NA
jpark@nbbj.com
www.nbbj.com/

Neale, Kim & James
Promotion Studios
GPO Box 7027
Sydney NSW, Australia 2001
james@promotionstudios.com
www.promotionstudios.com/

Norgren, Nils
Neoscape, Inc.
700 Massachusetts Avenue
Cambridge, MA 02139
nils@neoscape.com
www.neoscape.com/

Oken, Eni
11800 Goshen Avenue, #302
Los Angeles, CA 90049
eni@oken3d.com
www.oken3d.com/

Oravecz, Kim
25382 Stevens Boulevard
Eastlake, OH 44095
kimo@en.com
www.kandsdesign.com/kim

Owens, Justin
1531 South Highway 121, Apt. 2414
Lewisville, TX 75067
Justin_owens@hotmail.com
www.bluebionics.com/

Poitra, Matt, Ann, and Jessi
Poitra Visual Communications, LLC
206 South Lookout Mountain Road
Golden, CO 80401-7002
mpoitra@poitra.com
www.poitra.com/

Presto Studios, Inc.
5414 Oberlin Drive, Suite 200
San Diego, CA 92121
susan@presto.com
www.presto.com/

Radvenis, Eugene
E.V. Radvenis, Inc.
410-1639 West 2nd Avenue
Vancouver, BC, Canada V6J 1H3
evrinc@evrinc.bc.ca
www.evrinc.bc.ca/

Riedel, Kyle
Gustavus Adolphus College
800 West College Avenue
Saint Peter, MN 56082
Kyleriedel@hotmail.com
www.gac.edu/~kriedel

Ries, Ali
Casperium Graphics
4868 Camelot Court, N.E.
Salem, OR 97301
myalicat@attbi.com
www.cg3d.net/

Robinson, Ruairi
Zanita Films
Ardmore Studios, Herbert Road
Bray Co. Wiclow, Ireland
ruairi@3dluvr.com
www.3dluvr.com/ruairi

Short, Christopher
Cyr Studio
75 Fairview Avenue, Suite 46
Jersey City, NJ 07304
short@awi.com
www.chrisshort.com/

Simon, Isaura
37-53 62nd Street, Apt. 5D
Woodside, NY 11377
isauras@aol.com
www.isauras.com/

Simon, Shane
3D Concepts.com
225 Hollow Ridge Road
Durango, CO 81301
svs@3dconcepts.com
www.3dconcepts.com/

Skyscraper Digital
1050 Lakes Drive, Suite 275
West Covina, CA 91790
info@skyscraper-digital.com
www.skyscraper-digital.com/

Slama, Dave
Bombardier Aerospace
1255 East Aero Park Boulevard
Tucson, AZ 85706
Dave.Slama@Learjet.com

Stahlberg, Steven
9801 Parmer Lane West, #722
Austin, TX 78717
stahlber@yahoo.com
www.optidigit.com/stevens

Steiner, Michael
1319 Edwards Road
Cincinnati, OH 45208
msteiner@charlson.com

Still, Les
Mystic Realms
Lower Narracott, Ashreigney
Devon, UK EX18 7NH
les@mysticrealms.org.uk
www.mysticrealms.org.uk/

Sumner, David
David Sumner Design
405 Fifth Avenue
Brooklyn, NY 11215
david@davidsumnerdesign.com
www.davidsumnerdesign.com/

Syomka, Peter
16.12 Vavilovih Street, #75
Kiev, Ukraine 04060
syomka@i.com.ua
www.3dluvr.com/syomka

Termrattanasirikul, Montree
Apt. Blk 10, #06-69 Teban Gardens Road
Singapore 600010
easyyong@hotmail.com
www.geocities.com/smokestudio

Theoret, Danielle
4575 Hamilton Avenue, Apt. 17
San Jose, CA 95130
daniella@homepet.com
www.3dartist.ca/

Townsend, Frank
fTown Design
23 Friends Avenue
Haddonfield, NJ 08033
ftown@earthlink.net
www.home.earthlink.net/~ftown/

Tretiakov, Serge
895 34th Avenue, Apt. 5
San Francisco, CA 94121
s1001t@yahoo.com
www.temenanki.net/

UPSTART! GmbH
Bodo Keller, Frank Rueter, Maria
Boeckenhoff, Michael Koch, Arvid Landgraf,
Martin Gessner, Piet Hohl
Frankfurter Str. 28
Wiesbaden, Germany D-65189
info@upstart.de
www.upstart.de/

Velleco, Anthony
Evolution Design
19 Green Street
Marblehead, MA 01945
tony@evogroup.com
www.evogroup.com/

Vitale, Frank
11205 North 26th Way
Phoenix, AZ 85028
vitalef@cox.net
www.vitalef.com/

Waltz, Donna
Pierian Piaffe
204 Hatchet Drive
Eaton, OH 45320
daio@pierianpiaffe.com
www.pierianpiaffe.com/

Yazijian, Michael
Insomniac Games
600 E. Olive Avenue, #301
Burbank, CA 91501
yazstudios@hotmail.com
www.yazstudios.com/

Youssef, Amir
Swift-Render
40, Ahmed Fakhry Street, Nasr City
Cairo, Egypt 335
admin@swift-render.com
www.swift-render.com/

Yamaguchi, Heiichi
Yamag's Garage
3-13-1-610/Kaigan.minato-ku
Tokyo, Japan 108-0022
yamag@ga2.so-net.ne.jp

Zuanazzi, Massimo
Via S. Rocco 5
Orbassano/Torino, Italy 10043
maxreal@tiscali.it
www.web.tiscali.it/maxreal

From all the characters at the epic software group, inc.

For the past twelve years, the artists, animators, and programmers at the epic software group, inc. have been helping their clients use the power of the computer to tell their stories in ways that are not possible with traditional media. Epic creates applications such as multimedia presentations, electronic catalogs, computer-based training, interactive brochures, and touch-screen kiosks. The company's work is distributed on CD-ROM, DVD, and the Internet.

In 1997, the epic software group entered the world of publishing when the company was chosen to create over one hundred 3D illustrations for the *Happy and Max* series of children's books. In 2000, epic authored *Macromedia Flash 5—from Concept to Creation*, followed by *Macromedia Director Game Development—from Concept to Creation*. In 2001, epic produced *LightWave 6.5 & 7 Applied*, and *Excel 2002 Plain & Simple*. In 2002, epic authored *Macromedia Director 8.5 Shockwave Studio Interface Design* published by New Riders.

Think your 3D art is good enough for a future edition of *The Best of 3D Graphics*?

If so, visit www.epicsoftware.com/3dgraphics to check and see when the next "Call for Entries" is scheduled to begin. Who knows, with a little luck and hard work your 3D images might find their way into a future edition of *The Best of 3D Graphics.*

Vic Cherubini
Editor
The Best of 3D Graphics

epic software group, inc.

701 Sawdust Road

The Woodlands, TX 77380

281-363-3742 (phone)

281-292-9700 (fax)

www.epicsoftware.com (Web)

epic@epicsoftware.com (email)

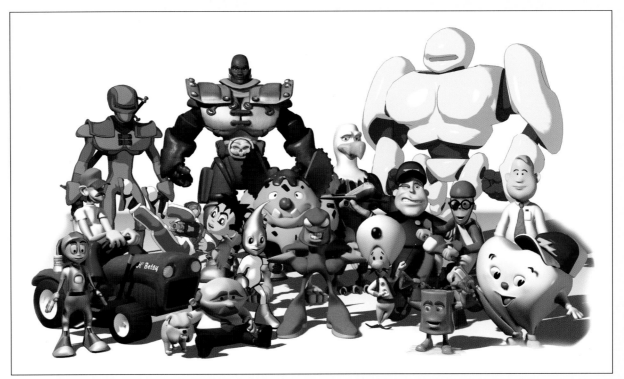